NEW TRENDS IN
VISUAL MERCHANDISING

Retail Display Ideas that Encourage Buying

NEW TRENDS IN
VISUAL MERCHANDISING

Retail Display Ideas that Encourage Buying

JUDY SHEPARD

RSD PUBLISHING, INC. NEW YORK, NY

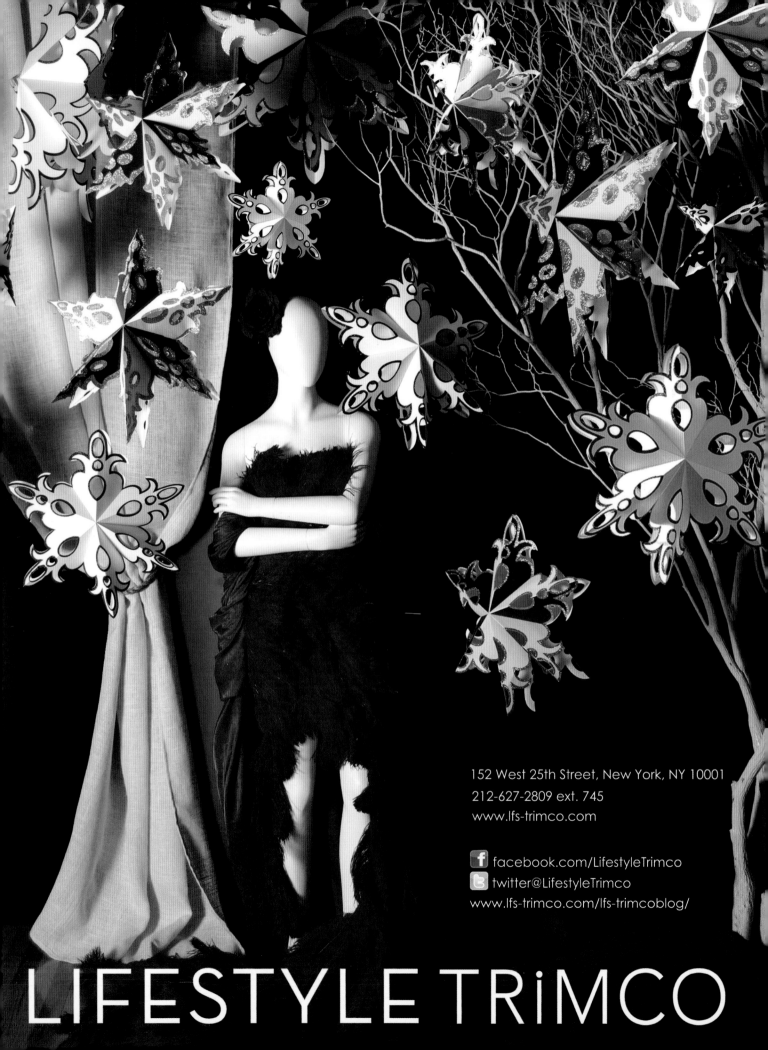

Table of Contents

Inside the Store

Specific Retail Sectors

In the Window

Interviews

RSD Publishing, Inc.
302 Fifth Avenue
New York, NY 10001
212-279-7000
CS@rsdpublishing.com
www.rsdpublishing.com

Distributors to the trade in the United States and Canada
Innovative Logistics
575 Prospect Street
Lakewood NJ 08701
732-363-5679

Distributors outside the United States and Canada
HarperCollins International
10 East 53rd Street
New York, NY 10022-5299

Library of Congress Cataloging in Publication Data:
New Trends in Visual Merchandising:
Retail Display Ideas that Encourage Buying

Printed and Bound in Hong Kong
ISBN: 978-0-9854674-0-1

Foreword

I remember as a child, going to the mall with my parents, shopping and staring at the various retail display windows. I vividly remember being inspired by the presentations that I saw. Of course, as a child, I could not truly understand what I was experiencing... only how it made me "feel." As I wandered through the different department stores, I noticed that what drew me in from the windows was carried throughout the interior... allowing me to create my own unique imaginary adventure.

As a second-generation visual veteran, I had the pleasure of growing up in the industry and gaining an understanding of all the intricacies involved with creating a successful visual program. Beyond the trends, designs and execution, I also learned the hard realities from the business side... budgets, in-store dates, production lead-times, and the all-important ROI.

In the nineties and well through the first decade of the new millennium, I noticed a swing—and not for the better as it pertained to visual presentation and execution. Everything became vanilla, bland and homogenous. It appeared to me that the "fun" was sucked right out of the visual presentations. The bean-counters who had to report to the shareholders took complete control. They could not "quantify" the return of their visual merchandising efforts... and through their lack of understanding of its effectiveness, made cuts in the wrong places.

We've all heard that Visual Merchandising is the first to cut and last to get approved... but if those who hold the purse-strings took the time to educate themselves, they would realize the importance visual merchandising has, and how it plays an incredibly vital role to the success (or failure) of a company's performance. It is very easy to determine visual merchandising's validity... without it every store looks the same. It is one of the competitive advantages a company can have over its rivals. It reinforces brand identity and supports its marketing message by setting its company's personality. Quantifying that visual merchandising is, in fact, effective, is a rather simple task. Simply pick two stores with the same exact demographics, same performance, and traffic. Dress one up with a comprehensive visual package and leave the other barren. After one month compare the relevant data (sales, foot traffic, dwell time, etc.). Without a question, the one that was dressed up will outperform the other. How much better will be determined by the level of creativity and execution... but there will be a spike in performance.

What is encouraging is that over the past few years I have seen new, fresh and innovative visual presentations that inspire. Creativity does not have to cost a fortune, but it has to start with a great idea. Kudos to the creative talents we have today, who have learned to work around the "system." Budgets do not have to pigeonhole creativity or execution.

It is wonderful to walk the malls with my children and have them point to various window displays and say, "daddy, look at that!!!" It brings a smile to my face and to theirs... because daddy can't resist pulling out his credit card.

– Ken Stolls, President, Lifestyle/Trimco

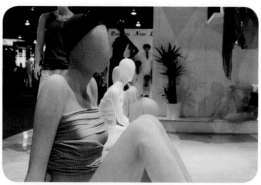

retailconnected

Sponsored by: A·R·E

globalshop.org

Presented by

DDi contract

Produced by Nielsen Expositions,
a part of the Nielsen Company

nielsen

Sponsored by

 A·R·E | Association for
Retail Environments

 POPAI
THE GLOBAL ASSOCIATION FOR MARKETING AT RETAIL

 ★★★★★ NARMS
INTERNATIONAL

Introduction

What can visual merchandising accomplish? Can retail displays influence shoppers and encourage them to purchase merchandise and return to the store again and again, month after month and year after year? This book is here to illustrate that visual merchandising, when approached with creativity and intelligence, can accomplish much.

It surprises. Consumers can be shown something new and exciting every time they enter the store. In an industry that now demands constant change and reinvention, display is a powerful tool, simply because it *can* be changed with relative ease and frequency. Building a new store, or even an architectural remodel, is a major undertaking that few retailers can afford with frequency. But displays can be rethought and reworked as needed. Risks can be taken and experiments made. Boredom, the archenemy of modern retailing, is banished.

It guides. Today some retailers are eliminating traditional aisles, choosing instead to utilize displays, merchandising and signage to create an atmosphere of exploration and discovery. Stores with and without aisles can use displays as signposts, beckoning shoppers to further enticements and rewards, making sure no part of the store is overlooked.

It reflects. Display shows the consumer an idealized version of themselves and their lifestyle. This is not a new concept, store windows have been doing just that since the grand old days when the unveiling of the department store windows was an event that drew crowds. Today, that reflection is as important as ever—dreams and fantasies are the eternal lure.

It educates. Display not only shows customers what is new and hot, it also provides information about products and brands and a retailer's endeavors in the wider world. Technology is the tool of choice, and an increasing number of retailers have fully integrated their in-store and online presence.

It brands. Display is the in-store component of a comprehensive whole. At its best it is connected to the retailer's marketing, websites and social media strategies. And, it has an advantage over its sibling branding elements: its physical presence. It exists in the store, where the wallet comes out.

It appeals. Then there is the sheer joy in a beautiful display. It tempts the eye with color and form, and attracts from near and far. It can have humor or grandeur. It can be sweet or hip. It's many moods and guises bring excitement and energy to the retail store.

New Trends in Visual Merchandising is divided into chapters for convenience and to provide structure, yet with the full awareness that the contents overlap and commingle. The best displays fit under many headings and others defy easy categorization. Be sure to read the interviews found throughout—the insights shared are enlightening and truly valuable. Enjoy your journey through the world of visual merchandising and display.

– Judy Shepard

Graphics, Communications and Technology

Connection. That is the word that sums up this collection of visual merchandising displays grouped under the heading, Graphics, Communications and Technology. All of these retailers are connecting themselves and their products to their customers through signage and communications, both high and low tech. Computers and hand-held digital devises are placed throughout the store, most of it connected to the retailer's online presence. The shopper can access as much, or as little, information as they please. Especially—but by no means only—those retailers targeted to the young are getting aboard the in-store tech train in a very assertive manner.

Some of the communications speak softly, occupying small sections of the store or referencing specific segments of the retailer's offering. Others stretch store, or even brand, wide. They make bold statements that involve everything a customer sees or touches. There are also tie-ins to marketing and advertising campaigns. Institutional and seasonal messages first encountered elsewhere are reinforced with in-store imagery, words and props. All of these retailing efforts ensure that the customer connects the store to the overarching brand—the two become one.

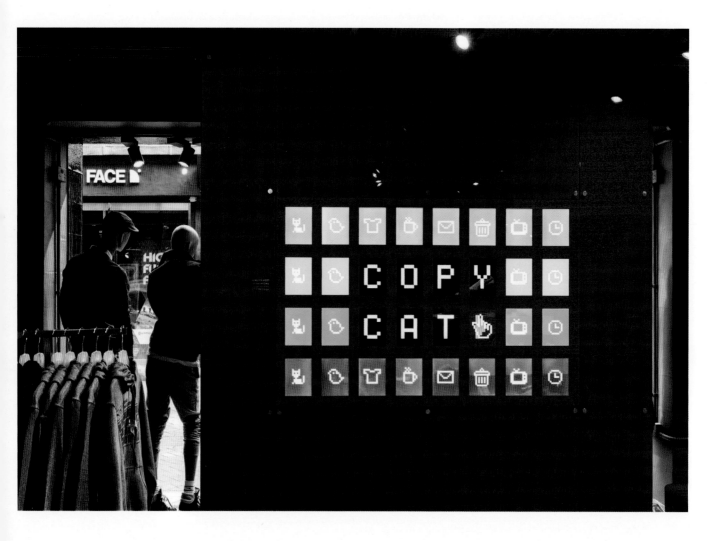

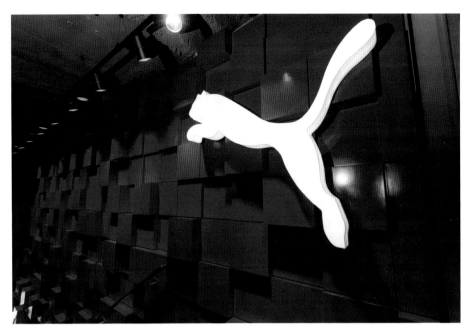

THIS PAGE AND OPPOSITE: PUMA has all manner of communications in its stores, from new technology to tried and true branding techniques. They have digital tablets and old-fashioned phones for customers to pick up—and explore the brand. They have peep-show boxes in the dressing rooms to peep into and interactive walls to poke and prod—and explore the brand. And, all of this is visually linked to the already powerfully established leaping PUMA logo.

PUMA Munich, Amsterdam, London

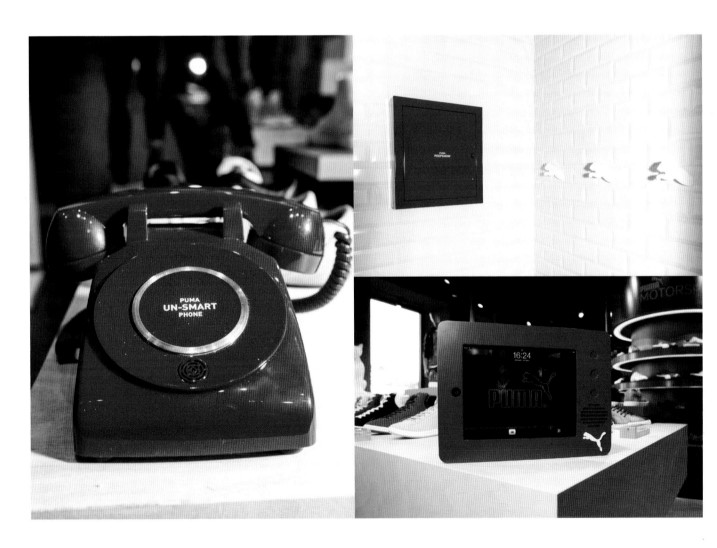

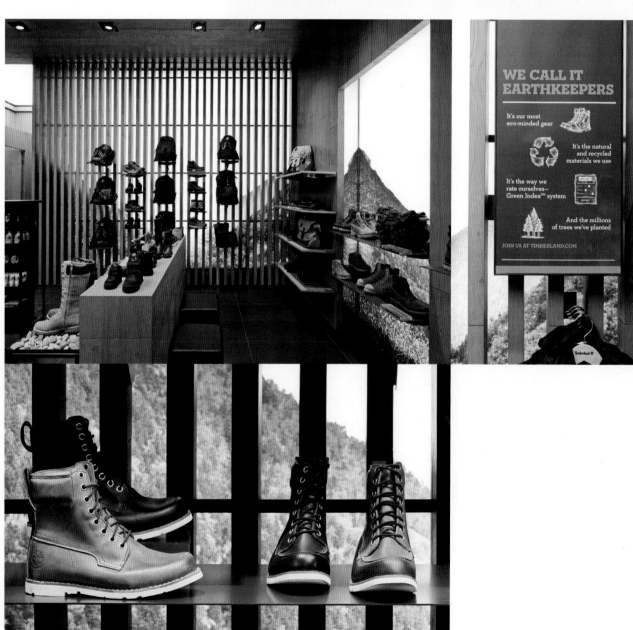

WE CALL IT EARTHKEEPERS

It's our most eco-minded gear

It's the natural and recycled materials we use

It's the way we rate ourselves— Green Index™ system

And the millions of trees we've planted

JOIN US AT TIMBERLAND.COM

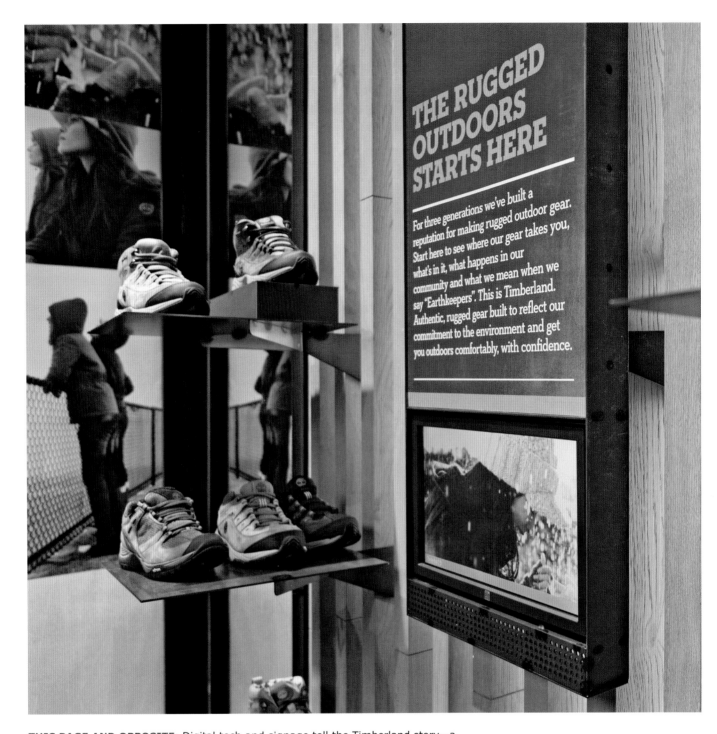

THE RUGGED OUTDOORS STARTS HERE

For three generations we've built a reputation for making rugged outdoor gear. Start here to see where our gear takes you, what's in it, what happens in our community and what we mean when we say "Earthkeepers". This is Timberland. Authentic, rugged gear built to reflect our commitment to the environment and get you outdoors comfortably, with confidence.

THIS PAGE AND OPPOSITE: Digital tech and signage tell the Timberland story—a story of the great outdoors and the importance of preserving it. Basic signage and the newest in digital technology communicate the message—even the kiddy shoes get special treatment. Included in the mix are wow-I-what-to-be-there photos that are backlit and located behind shelving, creating a stunning out-of-doors backdrop for the merchandise.

Timberland London. UK

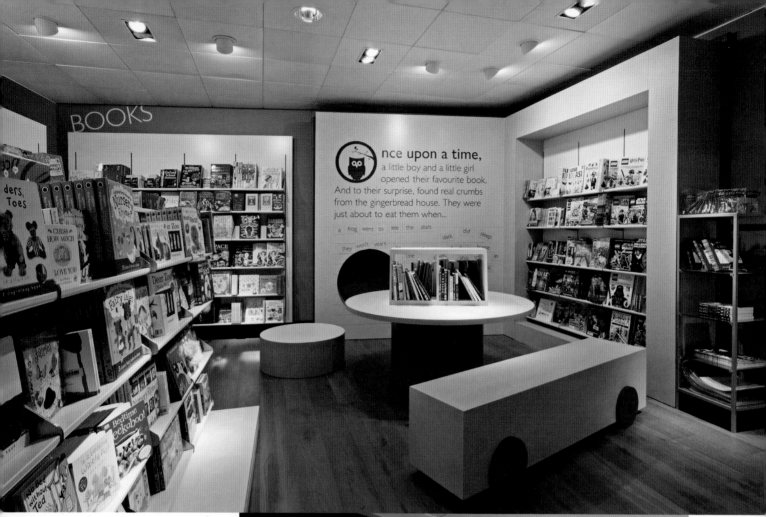

THIS PAGE: A book display that is, literally, an open book invites kids and their parents to sit down and browse the offerings. The oversized storybook symbolically reminds parents that all great life journeys begin with "Once upon a time…" In other displays the retailer explains its children's mattress selection and, in the school uniform department, offers computers on which parents can research a particular school's required style. Throughout the store, the various displays maintain consistency and humor.

John Lewis Kids London UK

Rain trees, mounted to platforms and accompanied by monitors, showcase wet weather apparel and footwear in Mark's Work Wearhouse in Vancouver. The display's designers at Eventscape describe it best: "The challenge was to create an immersive rain environment without the use of water. To achieve the essence of a rain environment, visual elements, graphics, video and scent technology were all integrated and synchronized to create an innovative, in-store experience. The result allows customers to experience the theater of a sunny day changing to a quick rain shower through sight, sound, and smell. At set intervals, the sunny day video on the 18 integrated monitors suddenly changes to images of a storm accompanied with the sounds of thunder, lightning and rain. The damp scent of fresh mown grass is emitted—bringing drama and some fun to create a multi-sensory experience. The integrated digital signage provides product knowledge specific to wet weather gear." Sight, sound, smell and technology join to attract customers from the entrance to the center of the store and teach them about the product.

Mark's Work Wearhouse Vancouver, BC Canada

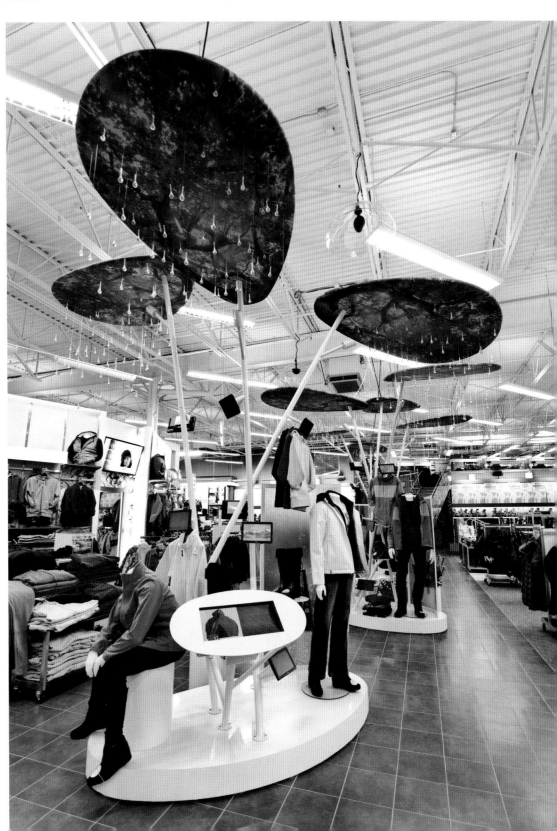

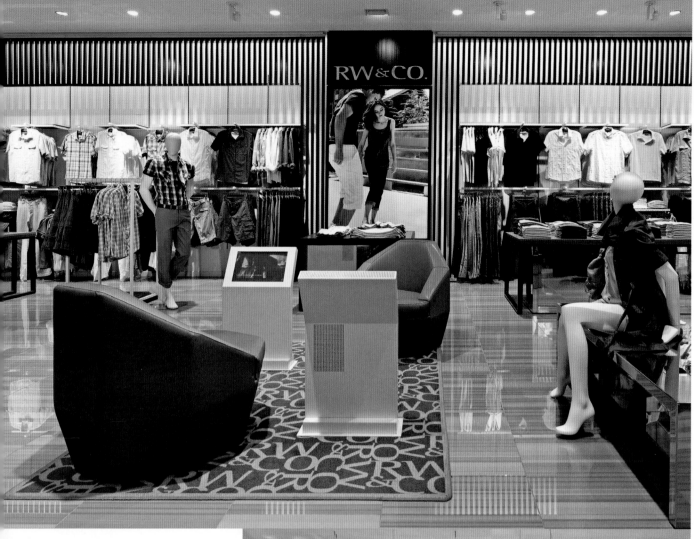

THIS PAGE: RW & Co. provides a prominently located seating arrangement with accompanying digital displays for shoppers to explore the retailer's products and brand. Mannequins placed nearby keep the customers company. Located throughout the store are large, backlit lifestyle photos, inviting customers to envision themselves in the retailer's world.

RW & Co.
Toronto, ON, Canada

THIS PAGE: Tally Weijl targets the young, the hip and the oh-so-sexy. It's spelled out in words and pictures behind the escalator and the checkout counter. The message is clear: you can't be too sexy to shop here. Browse our pink shelves and play with our pink bunnies.

Tally Weijl Basel, Switzerland

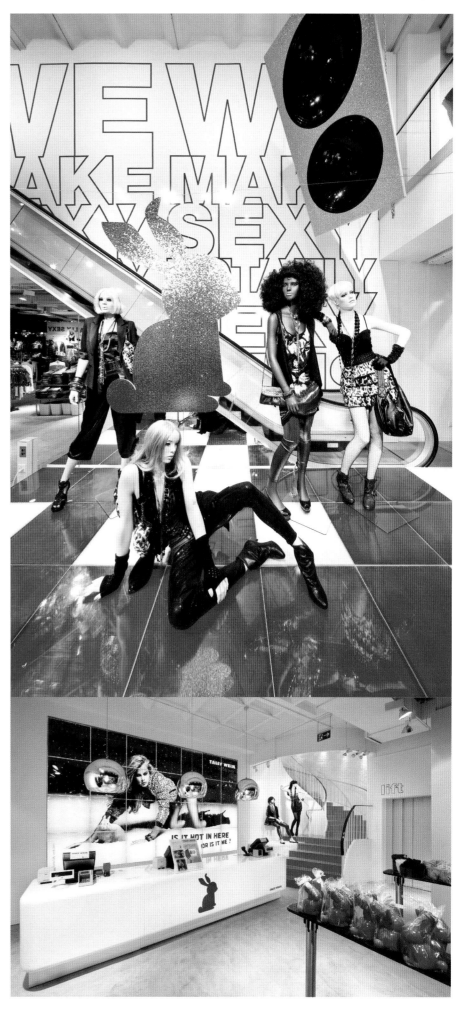

THIS PAGE AND OPPOSITE: Short-term displays can have big impact, especially ones that simply stun by going above and beyond normal standards. Uniqlo's light show was a celebration of the holidays and the retailer's Heattech collection. Created by Mike Brown and his talented design group, Lot71, the display takes its visual cues from the vibrant color range of the Heattech collection. Brown explains, "Inspired by the epic glass façade of the Fifth Avenue flagship, as well as the vast interior height atrium, we sought methods to envelop and amplify the architecture with pulsing lines of color and light— as though the entirety of the space is infused with rays of sunshine and warmth evoked by Heattech itself." The expansive installation incorporated cutting-edge LED technology and color-changing fluorescents that emphasized the interior architecture while guiding shoppers through the open space. Mike Brown adds, "These temporary sculptures appear to unfold and reveal themselves from day to night as customers enter, engage and experience the spectacular new store."

Uniqlo New York, NY

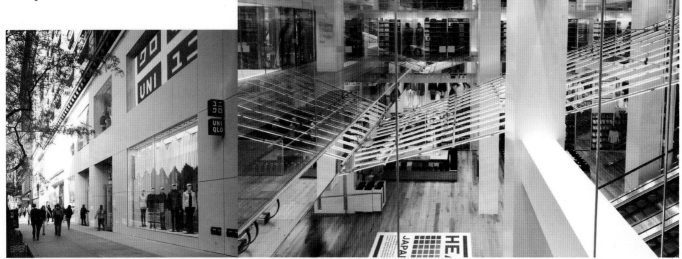

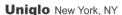

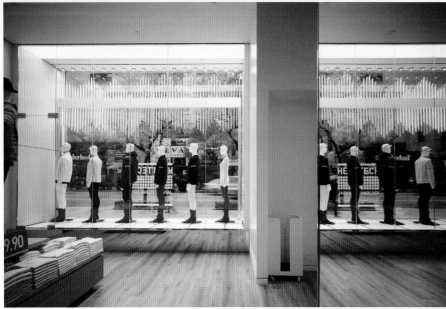

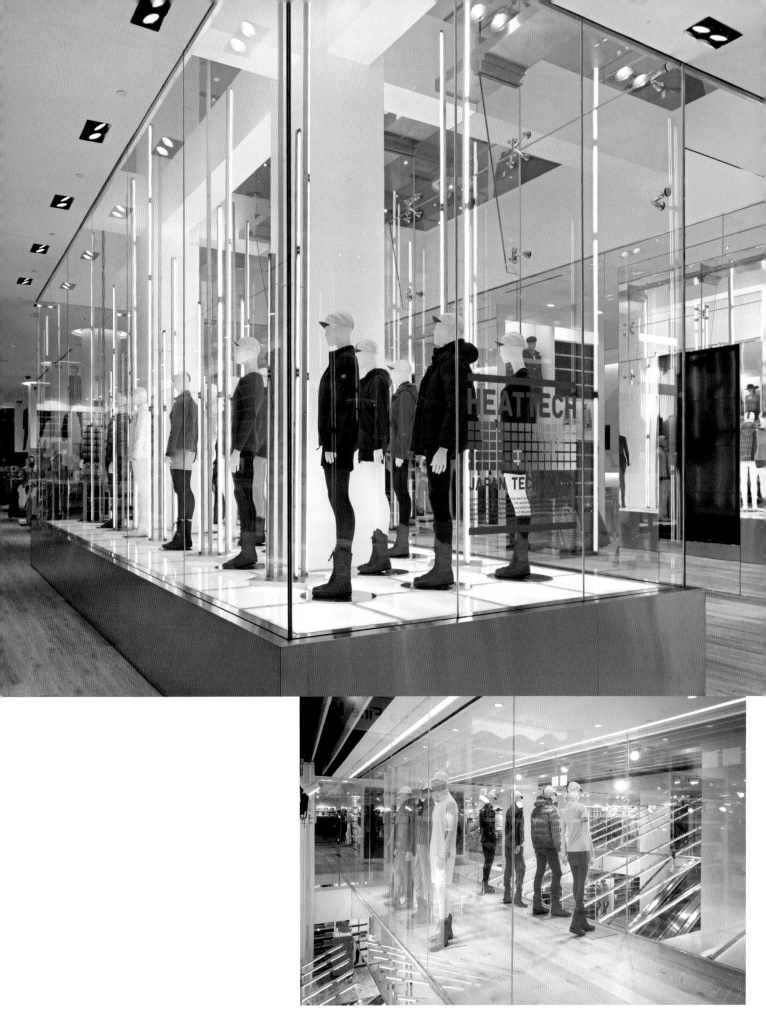

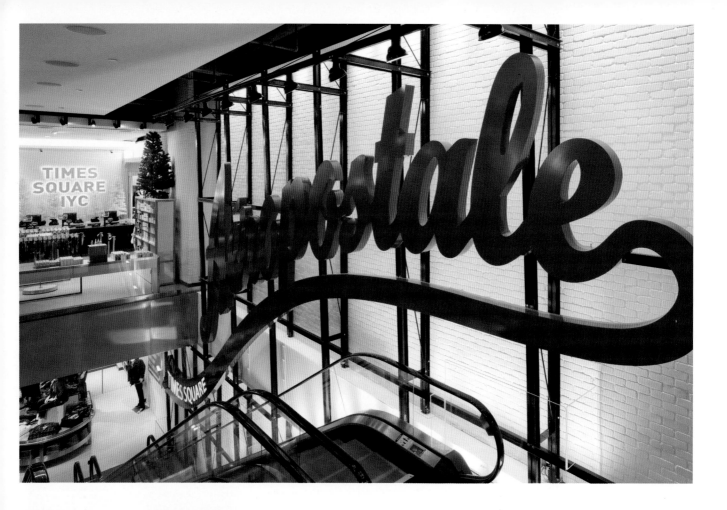

THIS PAGE: Times Square and iconic symbols of New York City are incorporated into the mix at Aéropostale's Time Square store. Beside the escalator, the retailer's name blazes out in a reinterpretation of a famous and long-standing sign in Queens (across the East River) that can be seen in much of Manhattan. Elsewhere in the store, customers are invited to dance in front of a camera, with lights flashing and views over Times Square. They can then watch themselves on a large LED billboard. The ambience of the store matches the mood of its location and its customers, a goodly percentage of whom are tourists.

Aéropostale Times Square, New York, NY

THIS PAGE: Large lifestyle images are shown at s.Oliver in both the fashion and children's departments, even though the departments have vastly different styles. The kids get bright colors and swirling graphics while the tone in the grown-up's area is subtle and without swirls. In each case, however, customers are "lead" to the photos via flooring and ceiling designs.

s.Oliver Munich, Germany

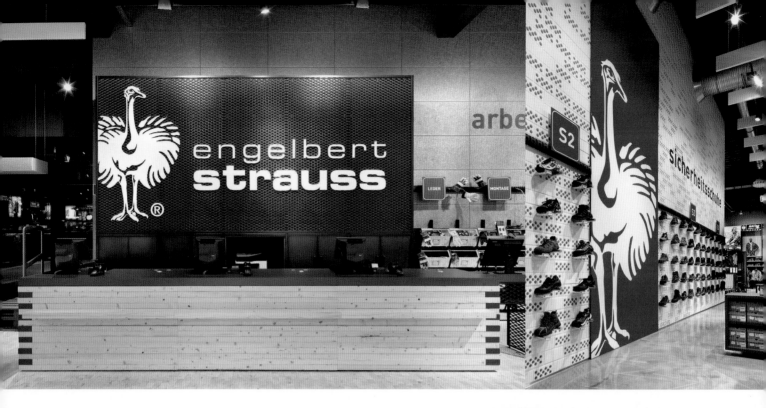

THIS PAGE: An ostrich is the logo and mascot of Engelbert Strauss (Strauss, the name of the brand's founder, also means ostrich in German), and the giant bird appears throughout the store and at the top of the nearly 60-foot high pylon outside. The bird shines into the night and can be seen from miles away

Engelbert Strauss Hockenheim, Germany

THIS PAGE: Horses play an important part in Horsefair, Bristol, where this store is located. Therefore, the store designers chose to have the animal also play an important role in the store, including asking customers to walk under a horse's belly to enter the shop. Inside, a life-size statue of a horse stands next to the checkout counter. The oat bag around the horse's neck gives the retailer the opportunity to send messages to the shopper. Although the merchandise—sports shoes and sportswear—and mascot have little connection, location and mascot do, and local residents probably choose "in front of the horse" as a place to meet.

Size? Horsefair, Bristol, UK

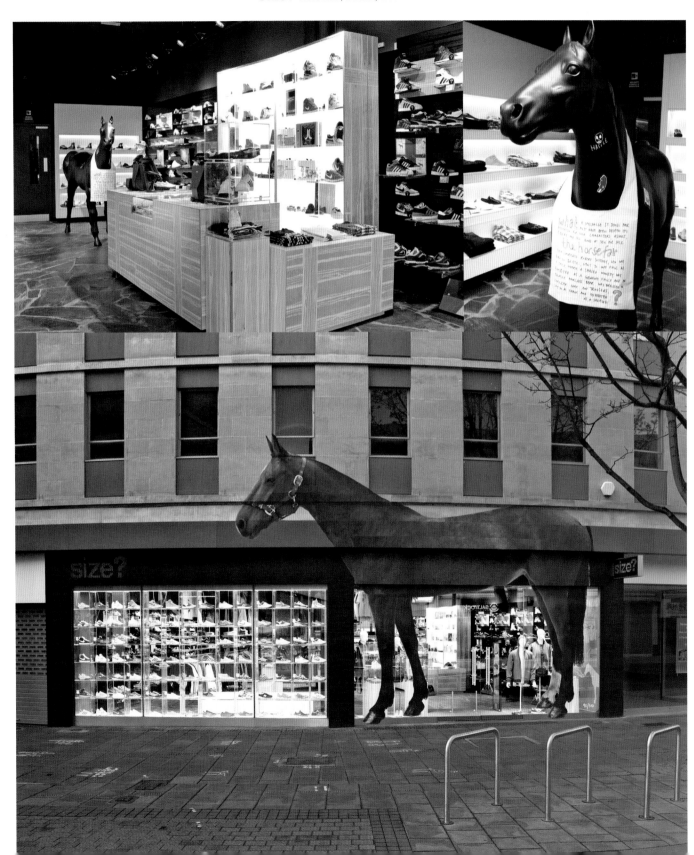

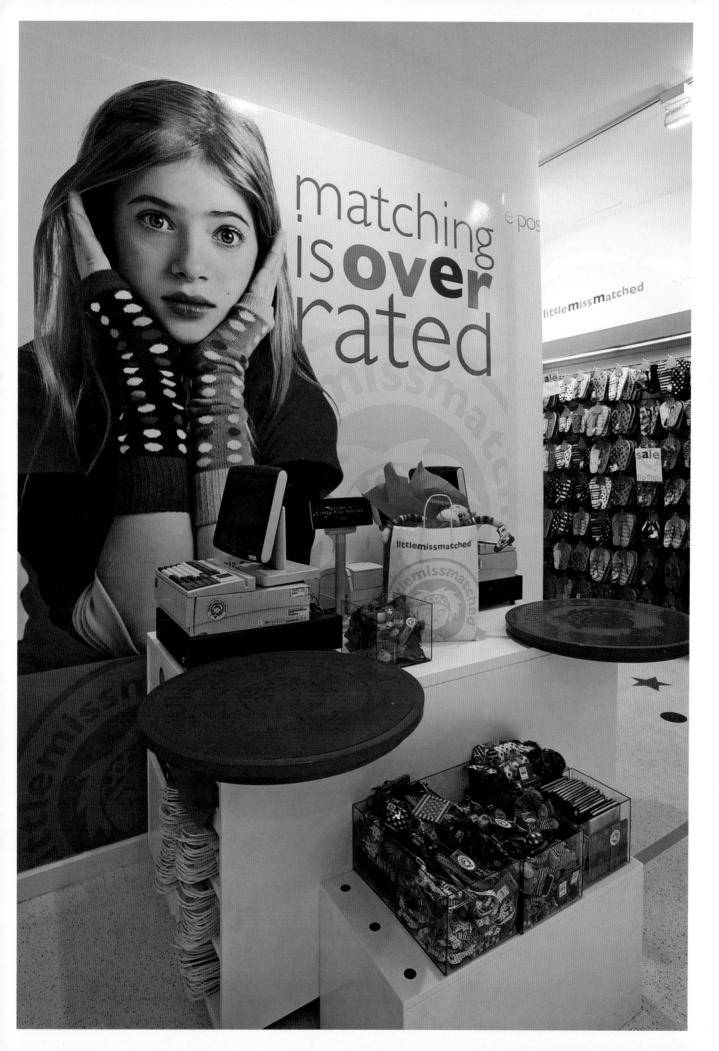

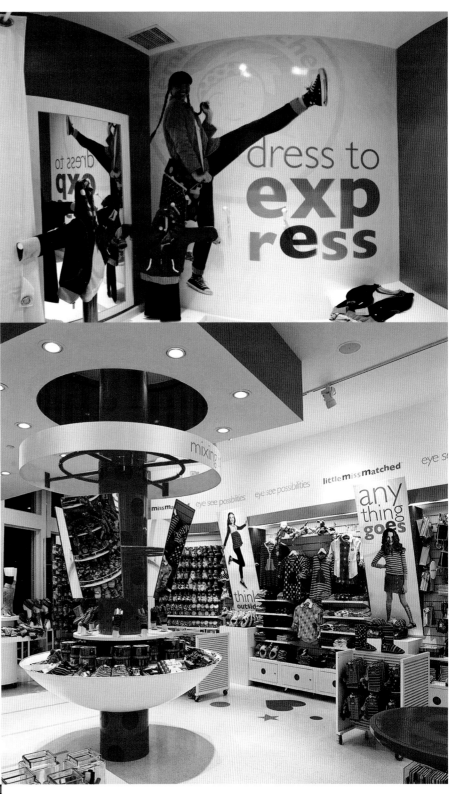

THIS PAGE AND OPPOSITE: LittleMissMatched is awash in fun, colorful graphics that tie into the color scheme of the fixtures and overall store design. The result is an environment in which the boundary between signage and product display breaks down and a single entity emerges—one promoting product and brand equally.

LittleMissMatched
Downtown Disney, Anaheim, CA

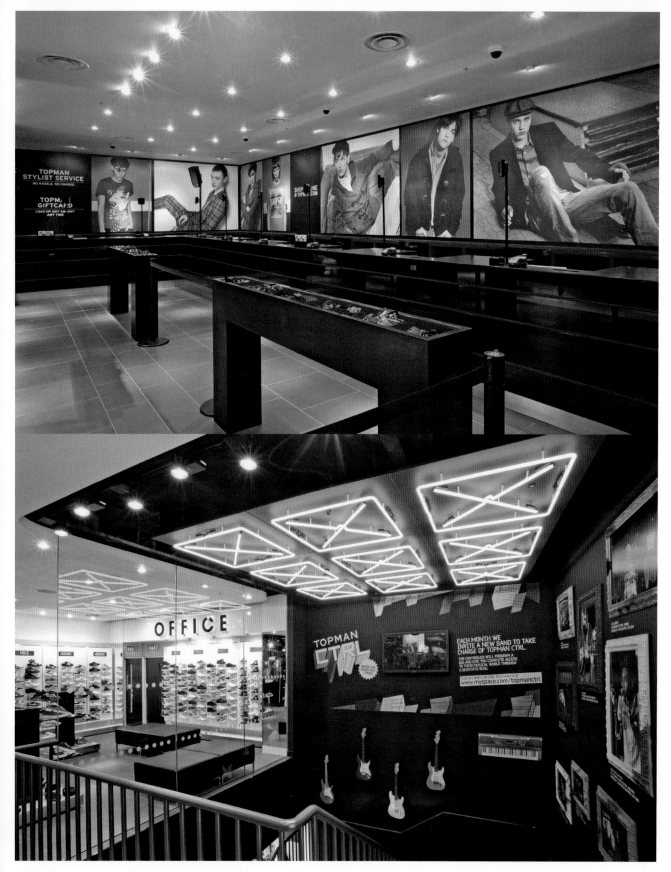

THIS PAGE: Lifestyle photos completely cover the walls behind the long checkout counter at London's Topman. The message sent to the captive audience is indeed positive, rewarding those who wait with images of what they will look like as soon as they put on those nifty new clothes. Elsewhere in Topman a stairwell is decorated in bright lights and bright guitars.

Topman London, UK

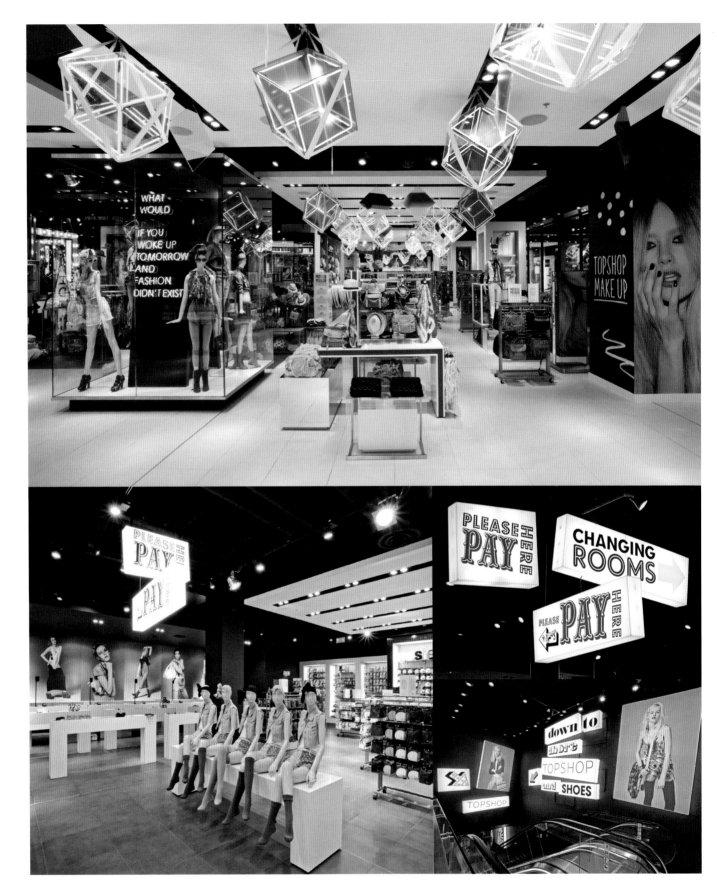

THIS PAGE: Meanwhile the gals in Topshop get their own bright graphics, signage and the existential question, "What would you do if you woke up tomorrow and fashion didn't exist?" Elsewhere directional signage takes on new interest with funky fonts and illuminations. And, if you look behind the row of neatly seated mannequins to the checkout counter beyond, you will see that the ladies get their own wall of won't-you-look-good photos.

Topshop Oxford Circle, London, UK

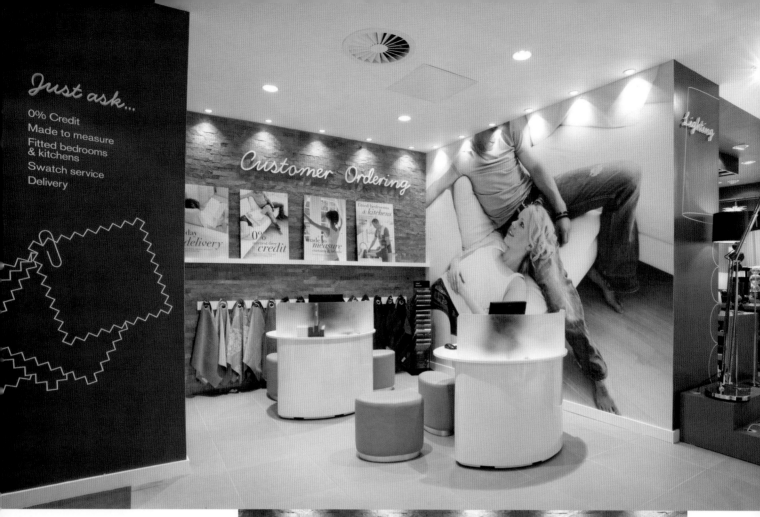

Just ask...

0% Credit
Made to measure
Fitted bedrooms
& kitchens
Swatch service
Delivery

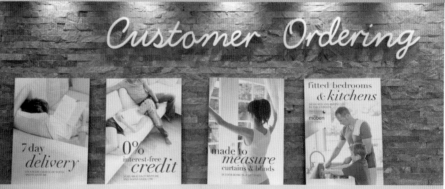

THIS PAGE: Next Home dedicates a cozy corner for custom orders, adding seating and computers for client/sales associate meetings. Fabric samples hang from the back wall and signage explains the available benefits in words and pictures. Throughout the store, departments are identified with the type and simplified graphic imagery found here.

Next Home and Garden Cambridge, UK

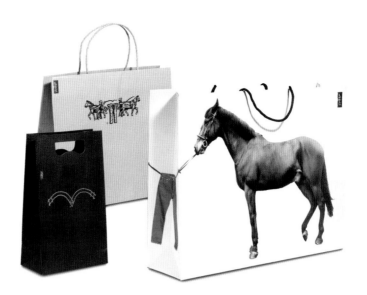

THIS PAGE: Levi's Revolution displays consistent imagery across multiple in-store touch points, including the checkout counter, fitting rooms and shopping bags. The horses may be indicative of the retailer's heritage in the American West, but these are horses for a modern consumer, without cowboys or the trappings of Western gear, leaving it up to the shoppers to imagine themselves heroes.

Levi's Revolution Brussels, Belgium

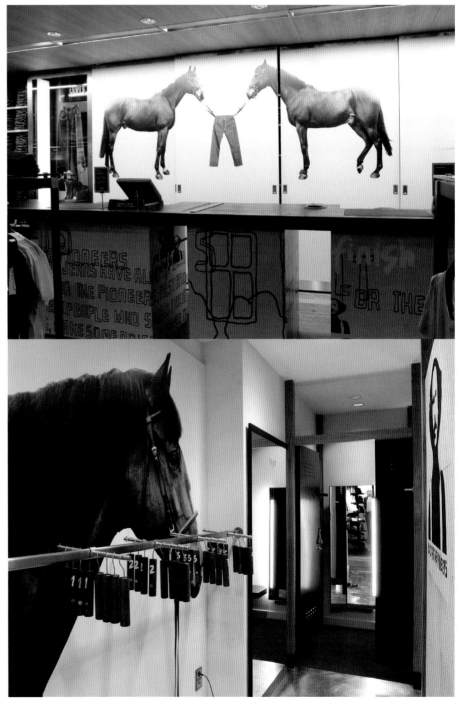

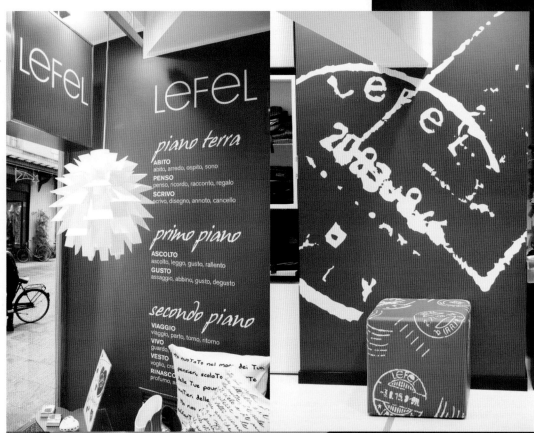

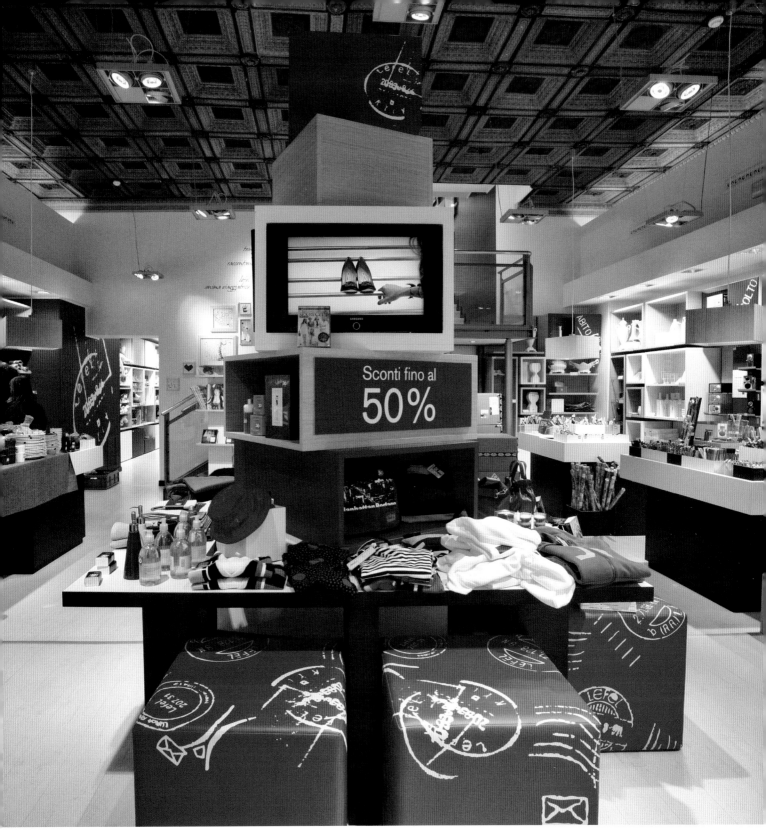

THIS PAGE AND OPPOSITE: Lefel wastes no opportunity to brand itself within the store. The bright red signature is on walls and boxes, shelves and cushions. A central focal point stacks branded boxes, monitors and products almost to the ceiling.

Lefel Parma, Italy

Minimalism or Maximalism

Extremes can be fun. Why stick to the middle ground when slimming down or packing it in can be so absorbing? With maxed-out displays and visual merchandising comes the desire to dig for buried treasure, or half buried treasure. Many shoppers will find the compulsion to search through every article in the store irresistible, and the smart maximalist retailer will provide the perfect playground. What goodies lie beneath?

The minimalist strips down the store to only what's absolutely necessary. A few select items are displayed, each one presented in serene splendor. The retailer has sorted and sifted through the choices, and deemed only a few items worthy of the customer's notice.

Both extremes walk a tightrope. The maxed-out shop may be too confusing, and too much trouble. The shopper in the minimal environment may loose interest if the selection is not to his or her liking. Which is best? Making each product stand out as unique—a single, bright star in the sky—or packing it in and inviting customers to choose for themselves which are the select items. Much depends on price points and target markets, of course, but it's fun to compare, as we do on the next few pages. In the end retailing is richer because of the extremes.

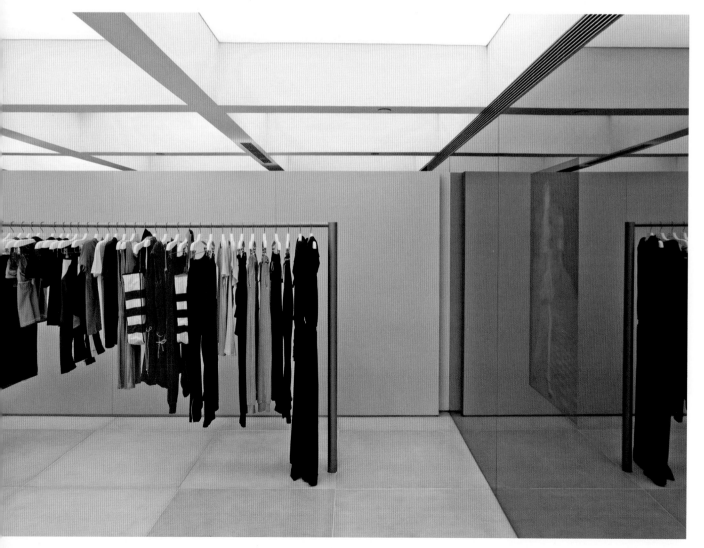

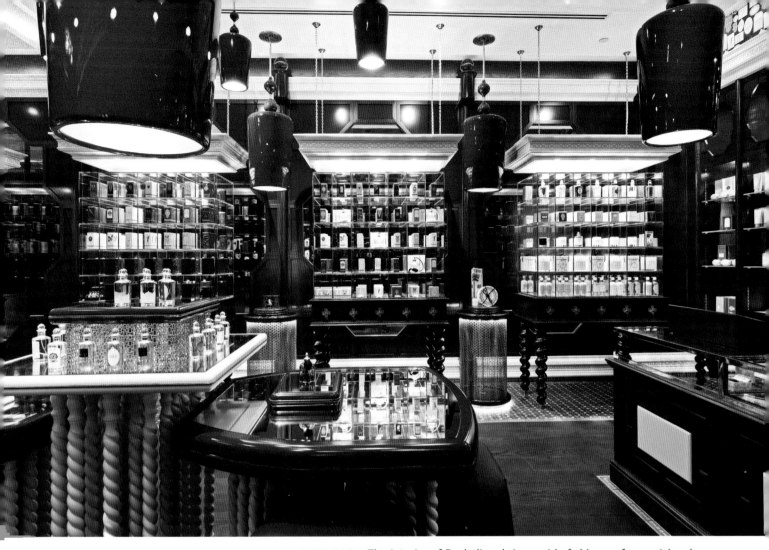

THIS PAGE: The interior of Penhaligon's is a swirl of shiny surfaces, rich colors, ornate details and an abundance of products, perfumes and scents. In this mass of visual information the bottles and small boxes are all beautifully lit in their clear, cubic shelving. The ornate display tables are topped with mirrors on top of mirrors, and then products, adding to the reflections bouncing around and seeming to multiply the already numerous offerings.

Penhaligon's Singapore

OPPOSITE PAGE: What meets the eye at Rosa Cha is limited to a mirrored wall, a low ceiling and a simple rod of merchandise. The bare background ensures that the single row of clothing is the center of attention. The result: a shopper browsing the merchandise will feel like the center of the store's focus.

Rosa Cha Rio de Janiero, Brazil

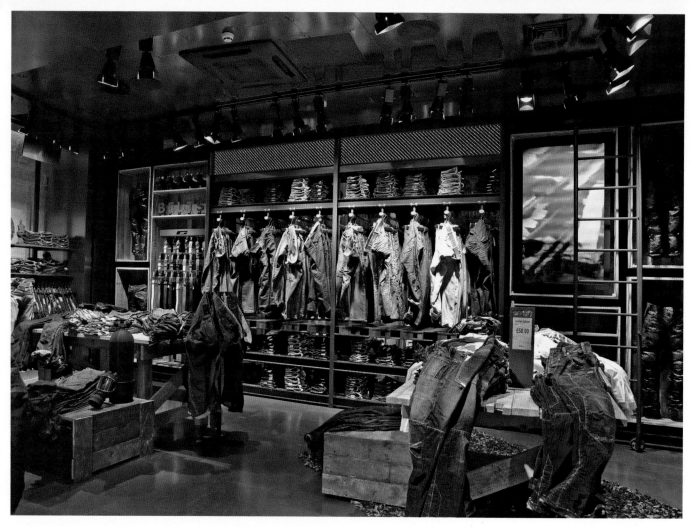

THIS PAGE: A profusion of jeans and casual menswear fill the rooms of Jack & Jones. Rustic display tables are running over, and wall units are full. Jeans are hanging by single hooks, allowing for more rows of items than a face-out hanging would. Mannequins are added to the mix in some displays and every wall is covered. This must create the desire to find not one, but several pairs of perfect jeans. All is blue and black.

Jack & Jones London, UK

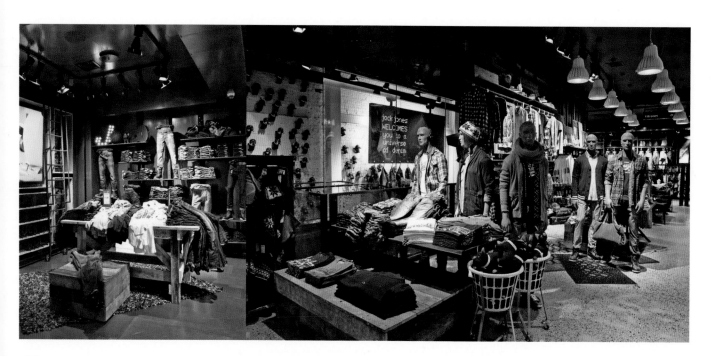

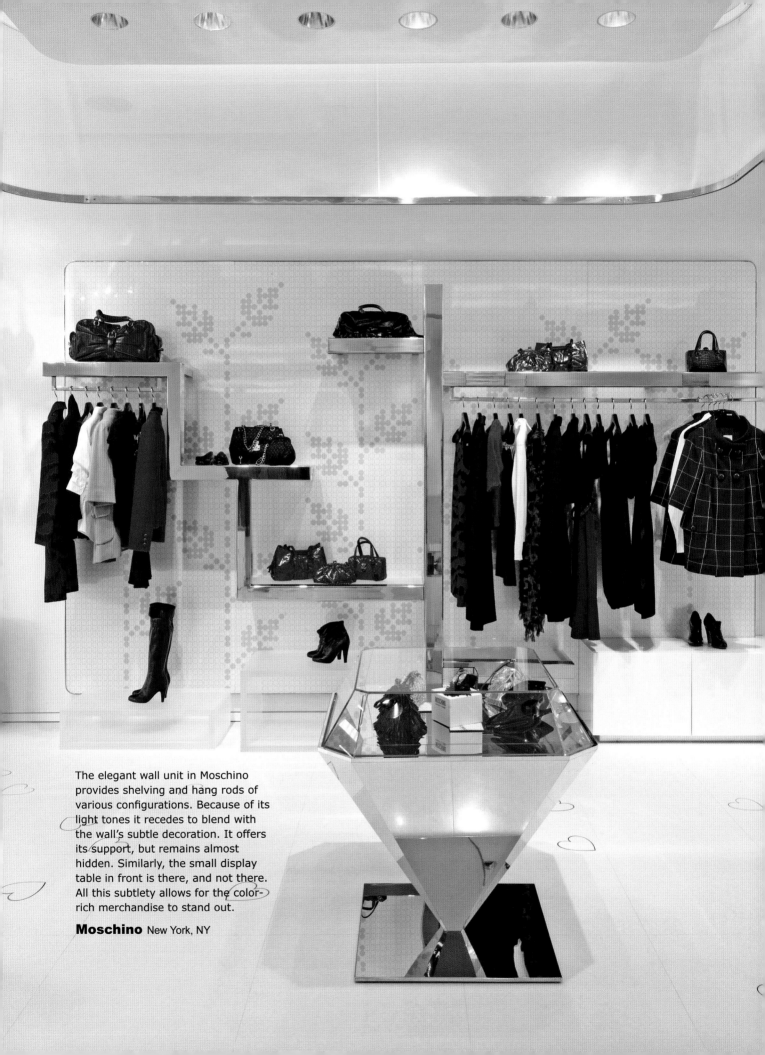

The elegant wall unit in Moschino provides shelving and hang rods of various configurations. Because of its light tones it recedes to blend with the wall's subtle decoration. It offers its support, but remains almost hidden. Similarly, the small display table in front is there, and not there. All this subtlety allows for the color-rich merchandise to stand out.

Moschino New York, NY

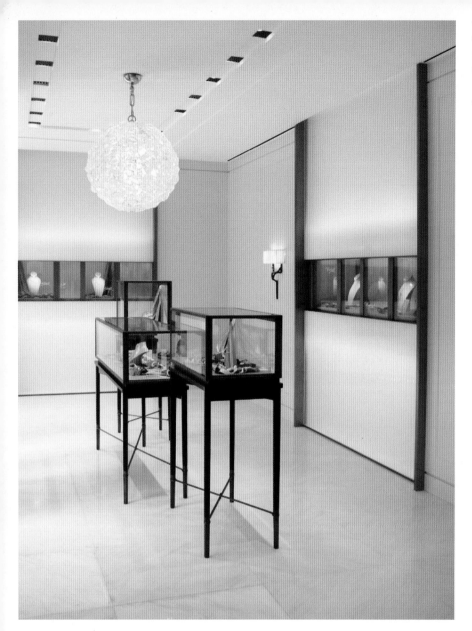

Tiffany & Co. Shanghai, China

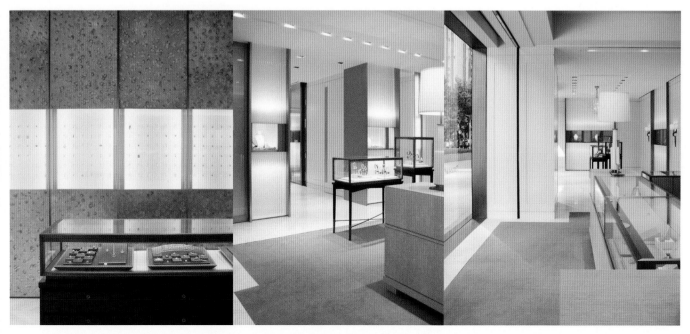

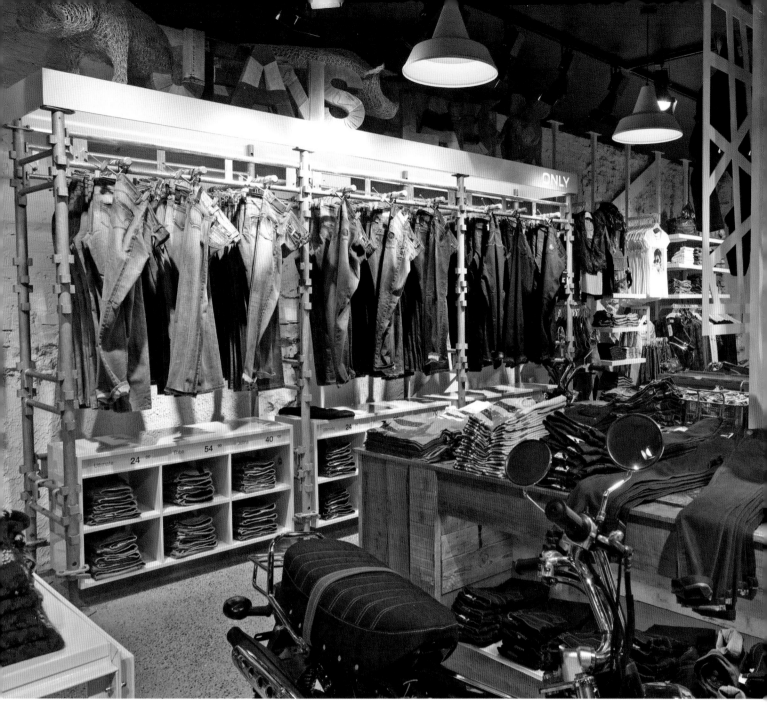

Light woods, and lots of it in the form of tables, shelves and wall units, provide the backdrop for the ample amount of casualwear on display at Only. Near the ceiling are stacked decoratives and assorted display items, and a motorbike is parked in the one spot of what would be open space. The effect may be a bit chaotic, but it's also fun and perfect for the young target market.

Only London, UK

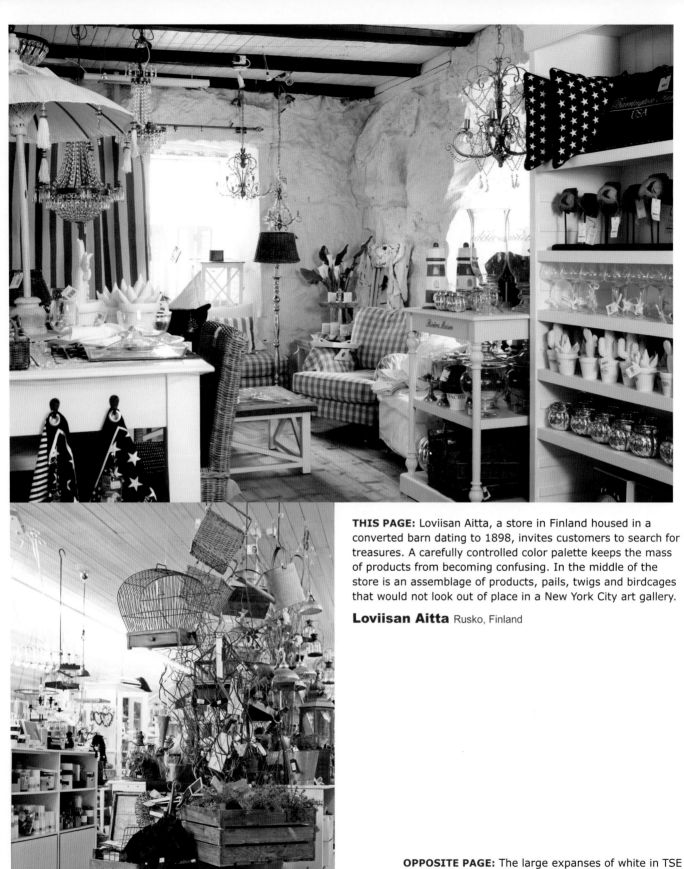

THIS PAGE: Loviisan Aitta, a store in Finland housed in a converted barn dating to 1898, invites customers to search for treasures. A carefully controlled color palette keeps the mass of products from becoming confusing. In the middle of the store is an assemblage of products, pails, twigs and birdcages that would not look out of place in a New York City art gallery.

Loviisan Aitta Rusko, Finland

OPPOSITE PAGE: The large expanses of white in TSE are interrupted by elements of natural wood and the colorful merchandise. The wood adds warmth and the minimal arrangement of clothing makes each item seem special. The details of the architecture are minimalized with a coating of white, but they are there, nonetheless, adding interest to the setting.

TSE Cashmere New York, NY

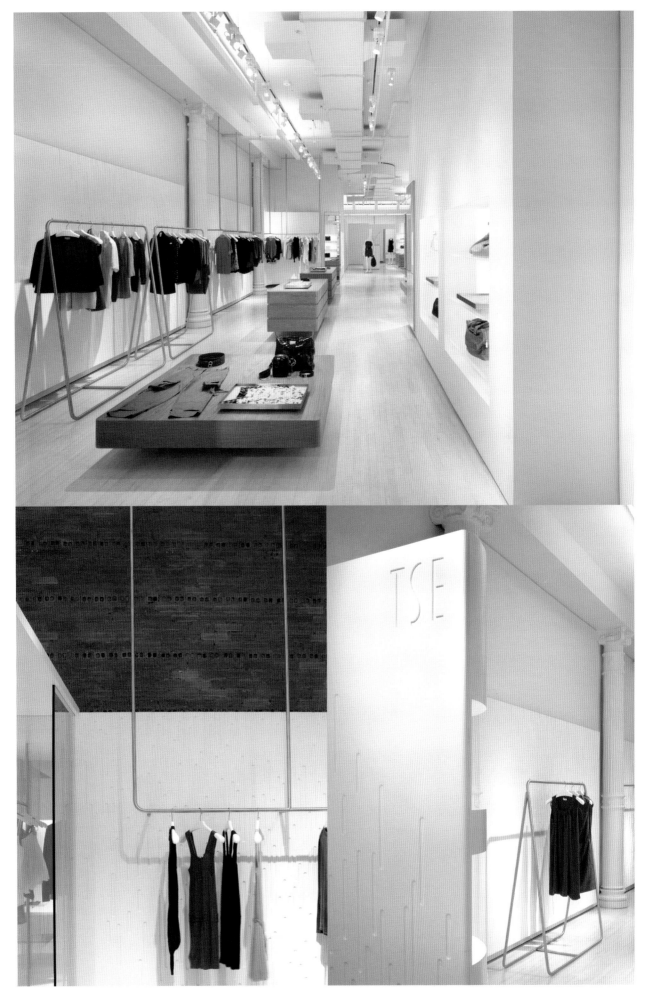

INTERVIEW:
Fanny Schuller
El Palacio de Hierro

Fanny Schuller, heads the visual presentation team at El Palacio de Hierro, Mexico's prestigious department store chain. Her creativity and skills have been instrumental to the retailers successful redefinition of the customer experience throughout its 11 locations, including the stunning and award-winning new store in Interlomas. Judy Shepard, of Retail Design International, recently sat down to talk with Fanny.

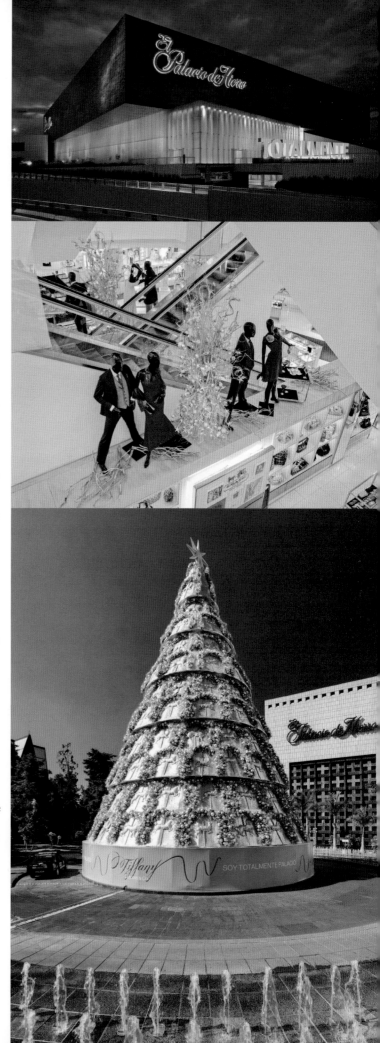

How did you get started in visual presentation?
I'm a graphic designer and I have a masters degree in arts. When I finished school it was still the pre-technology era so we had to draw and make things by hand. Do you want to hear a very funny story? We had a subject at school, display and POP, and I failed that course. The teacher was very picky and he even told me, "You are not a designer, you should change careers."

That is funny. How did you get to El Palacio?
I had been working for several years in another field and I wanted to make a change. A friend who was a headhunter told me about her client, El Palacio, who were looking for someone. So I went to El Palacio 20 years ago but I really did not know anything. I was very creative, very open minded and I loved to make installations because of my visual arts background but I was not involved with stores. But I began to learn. I studied all the magazines and I began to watch and to talk to people.

Did you have mentors at Palacio?
We had someone consulting for us in the 90s who just showed us the basic rules of display. I have always believed that display is more about creating an environment. If you know the ABCs you can handle it. What's happening in retail today is that as long as you focus on the customer you can do almost anything. It's about creating an experience. It's about, this is my point of view, changing the perception of customers when they go into the store.

Near the beginning of my career we began to talk about virtual reality. This was in the 90s and 3D graphics were beginning to transform video games. I began to think, "How will we compete with that kind of technology, because it will continue to develop?" We had to create an experience in the store similar to, or even stronger than, the experience being offered by 3D technology, which was very intense.

Today we also have to find a way to involve the customer in the retail environment when they can shop the Internet. What store designers really are doing now is competing with the online experience and to do that we have to create another kind of perception. You can't create in the store what people are used to seeing everywhere else.

On my team we have several rules: One is, if you think black, it has to be white. Think the opposite. I don't want to see things that we have already seen before. Ok, you have to have inspiration, you have to know what's going on and you have to learn from it. But I don't want to see in our store what has been done already. That's our great challenge.

How big is your team?
Only 17 people, and have some outsourced people who help us.

Do you work closely with the fashion buyers?
Very closely to them. We listen to them and then we try to understand what they are truly looking for and what their deepest concerns are.

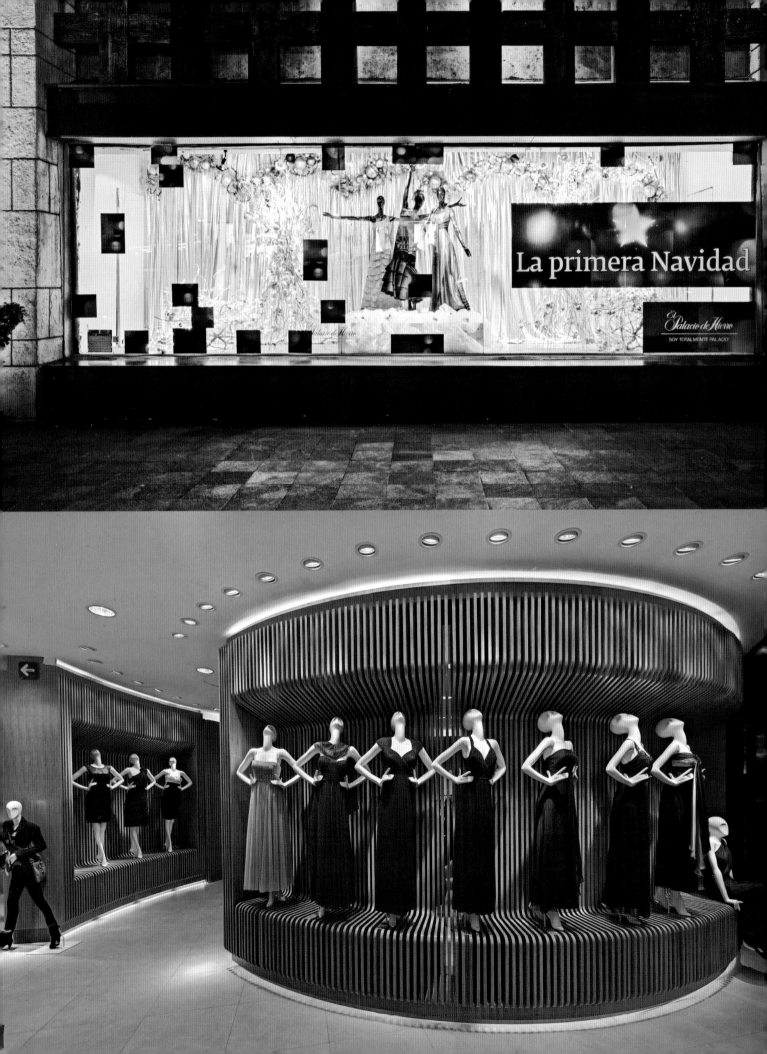

La primera Navidad

El Palacio de Hierro
SOY TOTALMENTE PALACIO

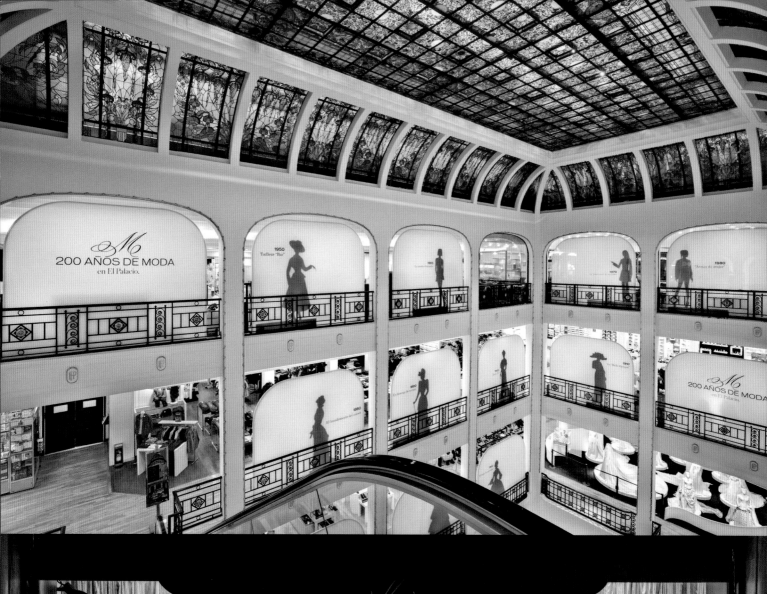

They only see what was in another store, they don't understand what is different about the experience that we are trying to create. We give them what they do not expect to see. They come in and show us a small picture, "I want it like this." We act like a coach and help them to understand that we can do it better.

I understand that in 2008 El Palacio de Hero decided that the best way to create meaningful, relevant and memorable shopping experiences was to "start from the very beginning" and by this they meant that your visual merchandising team would be the conceptual and creative leaders in the development of new store designs. Yes. And then the stores began to change.

How do you approach a new store or project? How do you even start to think about it?
Well, we have that rule about not repeating ourselves and we also need to think about approaching a new and younger consumer. To engage younger people you have to make it entertainment. Recently we began to understand that the aisles and circulation paths are just like highways in that they don't actually take you anywhere. That old paradigm that you have to have circulation and that you have to have focal points at the end of the aisle — that's a great mistake. What Anthropologie is doing is great, I love them. You find the merchandise everywhere. But, if you take out the aisles your creative work has to be even stronger because the only way to drive people through the store without circulation is visually.

For instance in your new store in Interlomas…
We don't have any aisles. In the beginning when we presented the project the general manager said, "Whoa, we can't go along with that." But I have a great colleague, Carlos Salcido, in fact he's my boss; he's our marketing director and a very bright guy. He is the one who brought about the change. When he first started at El Palacio, he and I traveled to New York, to Europe and we had a lot of time for conversation. We found that we were in the same frame of mind, we didn't want aisles, we wanted more conceptual stores, we wanted more feelings and more experiences.

You describe the new store as having "worlds"?
Yes, worlds. Because as you move from one to another — one may be white, the next one only wood, the next one gray — you really feel like you are going into different worlds. The customers are really enjoying it. Even my mother who lives close to that store goes there every day. Everyday customers discover something else because the merchandise is in front of them and around the space. You end up with 30 percent more square meters for display.

More? Because the aisles aren't taking up space?
Yes, and because you have the merchandise in front of you so you really follow your emotions. You see something and it's attractive to you, but there have to be focal points here and here and here. We spend a lot more money on display and on mannequins and props.

There are displays all over your store and grouping of mannequins that seem to be chatting.
Yes, that's in the atrium. We like to have a lot of mannequins and body forms because you can't have just fixtures. That's another of our rules: you have to have the mannequin and next to it has to be all the merchandise. You have to have a focal point and it has to be very attractive. That's what people appreciate about our store. It guides them. In a store you have to guide the people without words — only with visual elements, and that's another language. You have to understand what kind of language to use and what you need to communicate. I see people in the store, they touch the displays, they take pictures. That means that they are looking at it.

You have different stories you tell throughout the year? Do these take a long time to plan?
I wish we could have more time, but it's very fast. It takes at least three months and I wish we could have six. But I'm thinking about what's coming next all the time.

I talked to an architect recently who said that's what he likes about retail design versus other sorts of projects is it's quickness. I like the quickness also, even though you live life in stress and you have to have a special attitude to handle that. But the other thing that I love about display and store design is that it's so diverse. You can use anything. You can use mannequins, you can design fixtures. You are involved in everything in fashion and in interior design and communication; in digital signage, technology. It's everything and you have to talk with everyone.

In the Interlomas store it's all digital signage?
Yes, we had wanted to do that three years ago in the store in Guadalajara but Palacio was not yet really prepared for it. So we dreamed about it and when we begin to plan the store in Interlomas we decided that we didn't want any more printed things, we just wanted digital, so we designed the store with that in mind.

We are now beginning to place digital signage in the other stores, but you have to transform the architecture. I don't like screens that are just hanging there as you would see at a football game. Digital signage has to be integrated into the architecture. In the Interlomas store you see the screens from everywhere but it's not intrusive. And there are different levels of communication. We have some that are hard sell promotions and branding and others are just immersive, just to create a mood, like water falling, like flowers.

Perhaps in the States it's not unusual to see screens but in Mexico we were the first ones to do it. Now you begin to see screens in that format in some other buildings. I'm very proud that we were the first one, but we had to make it happen. You know how it is, you have an idea and you have to go to the directors and then you have to go to somebody else and you have to have the suppliers in place. You have to have all the elements interwoven and you have to know how to present it. And when you present it and everybody says, "Wow," then you say, "Wow. We're done."

Your job entails very different aspects, you need to manage, you need to convince and you have to be creative. How do you balance the creativity with the business skills?
I talk in the plural all the time, because I direct my team and I have a great team. I couldn't do what I do if I didn't have them. They are designers, they are architects, and even the outsourced designers are a part of my team. We know, as the El Palacio de Hierro team, what we want to achieve and that's creative because that's a vision. But it also takes creativity to design the strategy for how to get it approved. Because it's not enough to have the vision, the idea, the image — you have to take the steps to make them come true. And that's also creativity. It may be that someone is very creative but they don't know how to device a strategy to make that dream come true.

There are a few promotions that I want to talk about in particular. One is the 200 Años de Moda (200 Years of Fashion) that corresponded with the celebration of 200 years of Mexican independence.
Two years ago Mexico celebrated 200 years of independence. Everyone was doing something, the government, all the cultural institutions, and we wanted to do something at El Palacio as well. So what were we going to do? It happens that El Palacio's home director, Rodrigo Flores, the man who buys all the merchandise for home, also owns antiques and he had this huge collection of vintage dresses. He's like a brother, so he said, "Ok, I can lend you my entire collection." We displayed them in the store as if it were a museum. But I was careful to keep it very contemporary. In addition to the dresses from over 100 years ago, he had dresses from the 50s and 60s and I didn't want the exhibit to be exclusively about the older dresses. I wanted it to be more like "That was then, now here we are 200 years later." When you have different levels of history, it's very interesting.

And this was just in the central store.
Yes, in the original building in the central part of the city. Traffic and sales increased so much, everyone was talking about it and the fashion schools came to see it. He had a great collection.

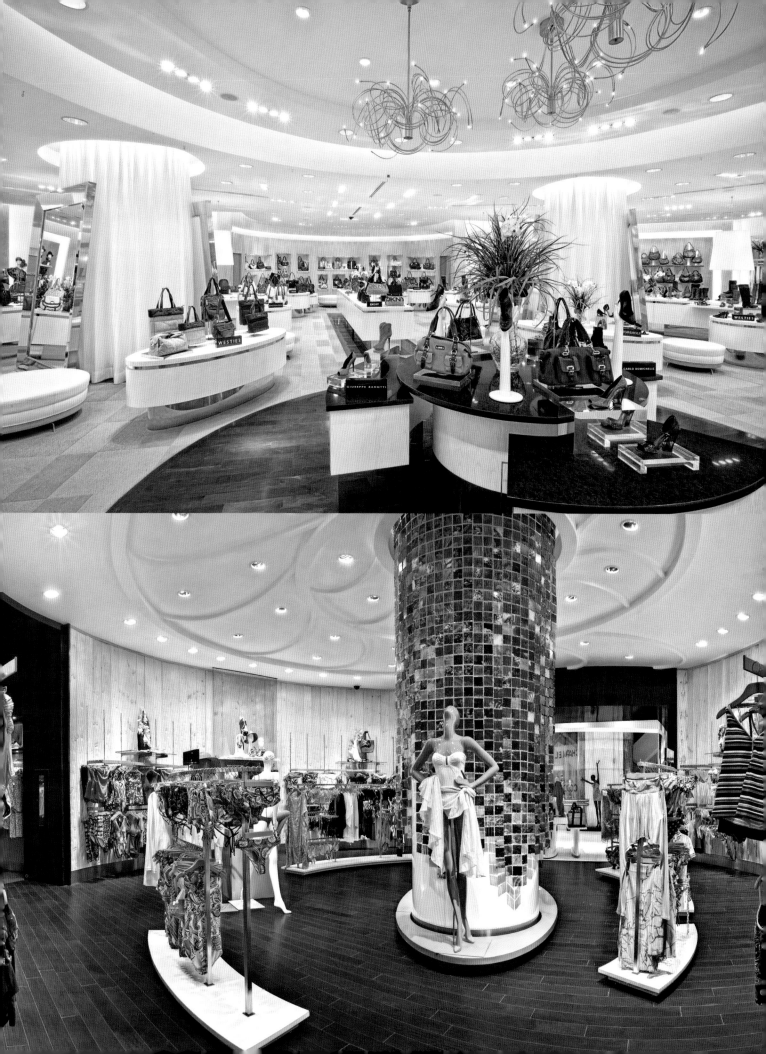

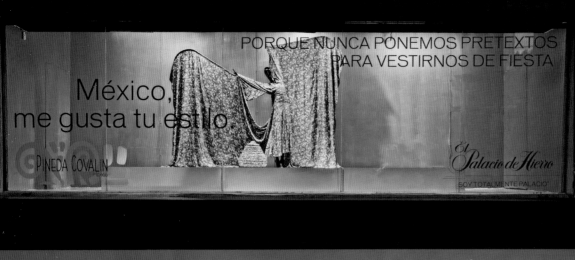

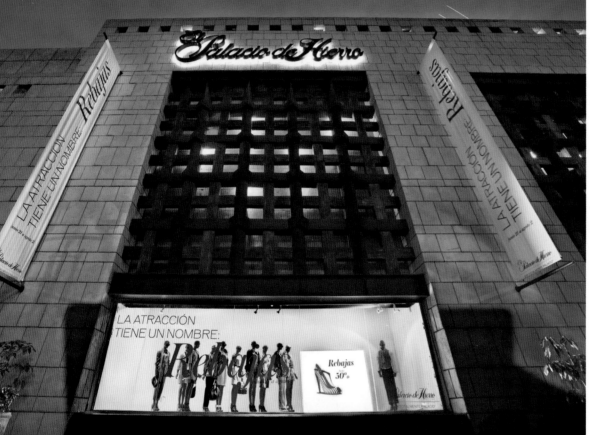

Tell me about the Tiffany Tree that you did last year for Christmas. This was in partnership with Tiffany. How did that work?
They gave us the guidelines and 10 percent of the cost of the tree. This was at our store in Moliere. It was a great job, but it was difficult. The tree was 24 meters high.

That's almost 79 feet!
And the tree was just as exciting during the day as during the night. But there were challenges. Tiffany is used to having natural trees but in Mexico we don't have that kind of tree and you cannot cut trees, it's forbidden. So we had to make it in another way. We had the structure from the year before so we took the guidelines, the idea, the colors that they sent and we arranged it in our own way. A 24 meter tree takes a lot of ornaments, a lot of lights. It was very interesting to work with Tiffany and experience how they think and how they develop concepts.

Are you involved in advertising, too? One of your promotions, "Mexico I Like Your Style" is based on an advertising campaign.
I'm not involved in advertising. The agency developed the campaign and gave me the guidelines. We talked about how we were going to express it in the store. Advertising is about pictures and we needed to translate the complex nature of the images into the whole experience of the store.

They can be very creative but I think advertising people just think about media. They don't understand retail. You have to live in the store to understand the customer, it's a different kind of perception. When you read a magazine or your iPad you are sitting down and it's just you and your magazine. But when you are in the store you have so many visual and sensory inputs and capturing the interest of the customer is very different. Advertising people do very creative things that work well in magazines, but the store is so complicated and crowded with visual input that the communication has to be straight, clean and focused.

Do you have any advice for someone who may have just a small store or one or two windows.
It doesn't matter the format, it can be small or large, but you need to have a very clear idea of what you want to communicate. Even in a small store you have to change the perception and to surprise the consumer. If you really think about that, you will get it. I don't know if it's easier in a small store or not, because perhaps you have a smaller budget and have to do everything yourself. But if you have clarity, everything will be focused. Be clear, be concrete. And don't copy. Create your own language. The consumer sees so many things, so if you copy they will know you are copying. You can get inspiration, yes, but you have to translate it into your own language, in your own store.

Is there anything I haven't asked that is important?
I think that we are living in a very interesting new era for retail, it's amazing what's going on with the Internet and all the new media we have. The challenge that we have as store designers and visual merchandising people is really to engage the customers in our store and the only way to do that is to cause them to change their perception, to have new feelings that they didn't have before and to surprise the customer. If you keep on doing everything the same way you did it two years ago — you are old. There's a book I saw someone reading on an airplane and I got it. It says change the way you see things and things will change. So I think that in display, in visual merchandising and store design we are the ones who can change the way people see stores. We are the only ones who can drive retail, the real stores, to another level. Not the buyers. Not the financial directors. We are the ones who have to drive the change to another kind of store.

To bring retailing into the future?
The future is now. Don't think about the future. Think about what's going on now.

Very well said. Thank you very much Fanny.

Tableaux and Decoratives

Decorating the store. That's what the retailers on the following pages are doing, however diversely. Some of the examples are clearly focal points and promoting the offerings. They mix products with decorations to draw in the shopper. Others have no clear relationship to the merchandise, yet speak to the target audience through items and images of interest. They set a mood and project a lifestyle. They reach out to the consumer and tempt him or her to linger. Still other examples provide seating for the tired shopper. These rest stops add comfort while permitting the retailer to reinforce their brand image though props and products. You will see vignettes and storewide decorations—all inviting the customer on a voyage of discovery.

THIS PAGE: O'Neill, a store in Amsterdam, evokes the spirit of a faraway California surfing lifestyle—an appeal to all the Dutch surfer dudes and would-be surfer dudes. The rustic store even resembles a beach shack, complete with salt-air eroded wood, a shark jaw, a tiny Buddha statue and, of course, surf boards.

O'Neill Amsterdam, The Netherlands

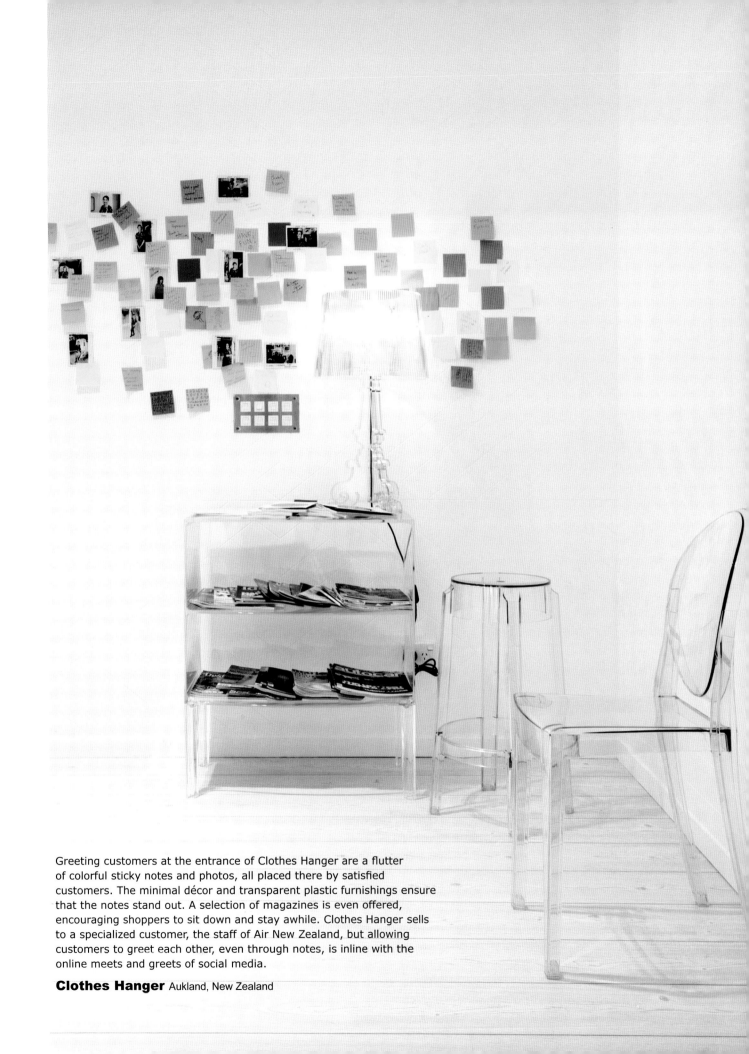

Greeting customers at the entrance of Clothes Hanger are a flutter
of colorful sticky notes and photos, all placed there by satisfied
customers. The minimal décor and transparent plastic furnishings ensure
that the notes stand out. A selection of magazines is even offered,
encouraging shoppers to sit down and stay awhile. Clothes Hanger sells
to a specialized customer, the staff of Air New Zealand, but allowing
customers to greet each other, even through notes, is inline with the
online meets and greets of social media.

Clothes Hanger Aukland, New Zealand

Chez Jean is a convenience store, but a convenience store in Paris. One corner is decorated with items from a kitchen. It's simple and clean, yet communicates the idea of home. Meanwhile Rockford in Santiago creates an in-store backyard. Walls and partitions of live plants freshen the air and soothe the mood, while complementing the spring colors of the merchandise. Natural wood on the floor and ceiling completes the look. This is back-to-nature, but in a very sophisticated guise.

Chez Jean Paris, France (above)

Rockford (RKF) Santiago, Chile (below)

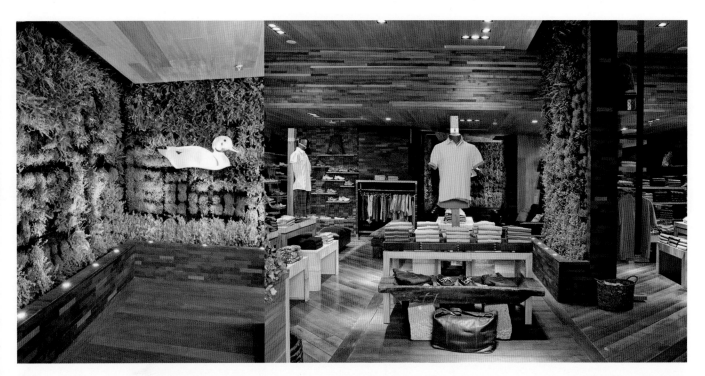

H&M tempts consumers with an airy space, bright colors and fun graphics. An outdoor retreat is effectively evoked with just a few chairs and bright items. In this relaxing summer scene, just how many pillows and towels will a customer need for the upcoming hazy, lazy days?

H&M Home Store Amsterdam, The Netherlands

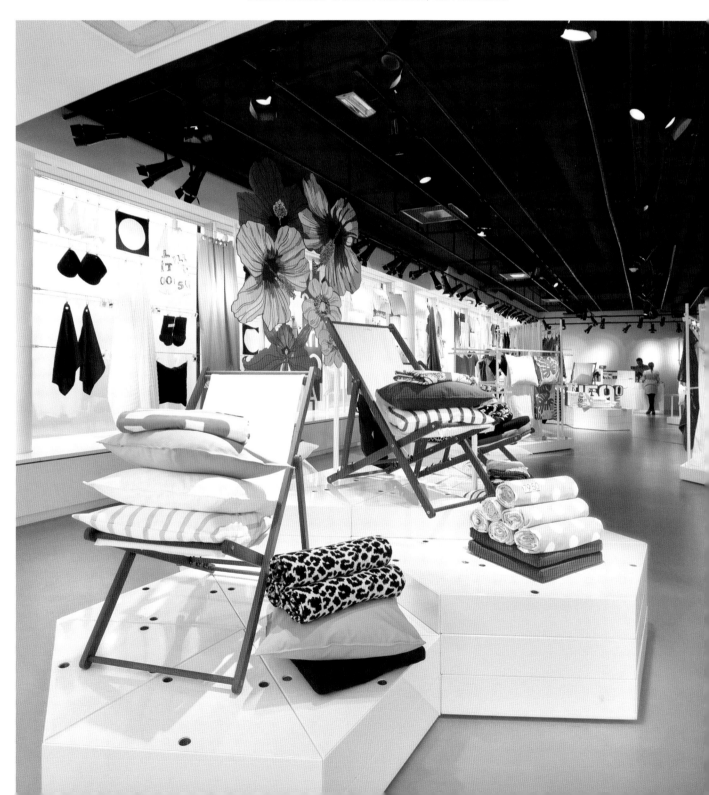

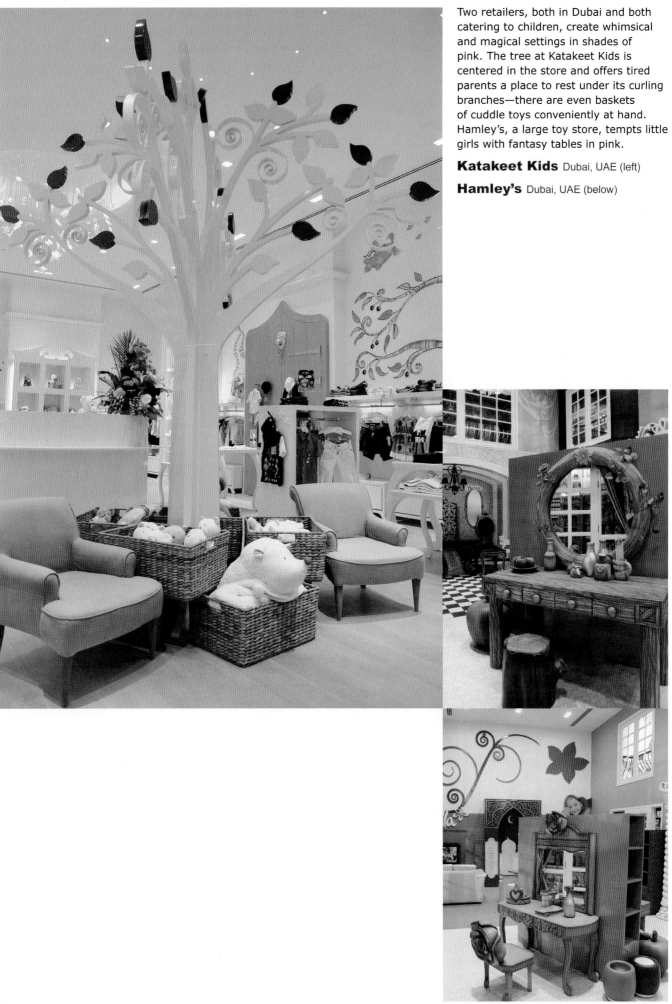

Two retailers, both in Dubai and both catering to children, create whimsical and magical settings in shades of pink. The tree at Katakeet Kids is centered in the store and offers tired parents a place to rest under its curling branches—there are even baskets of cuddle toys conveniently at hand. Hamley's, a large toy store, tempts little girls with fantasy tables in pink.

Katakeet Kids Dubai, UAE (left)

Hamley's Dubai, UAE (below)

C&A in Brazil devotes a corner of the store to an assortment of items of interest, including references to pop culture, games, sports and even a bike. Many a shopper must get "caught" in this corner. Mexico City's Liverpool increases the pace with a collection of racing helmets. Shiny and bright they are the perfect accompaniment to the sleek outfits in front.

C&A São Paulo, Brazil (top)

Liverpool Polanco, Mexico City, Mexico (bottom)

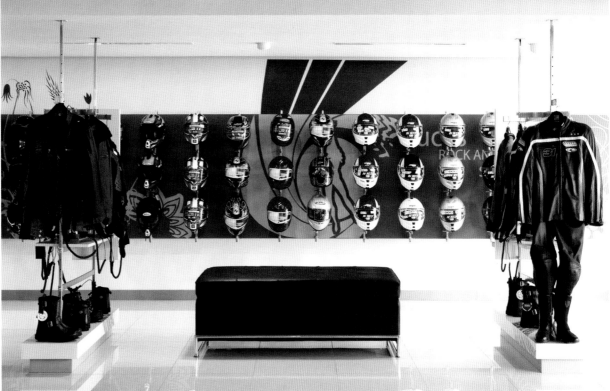

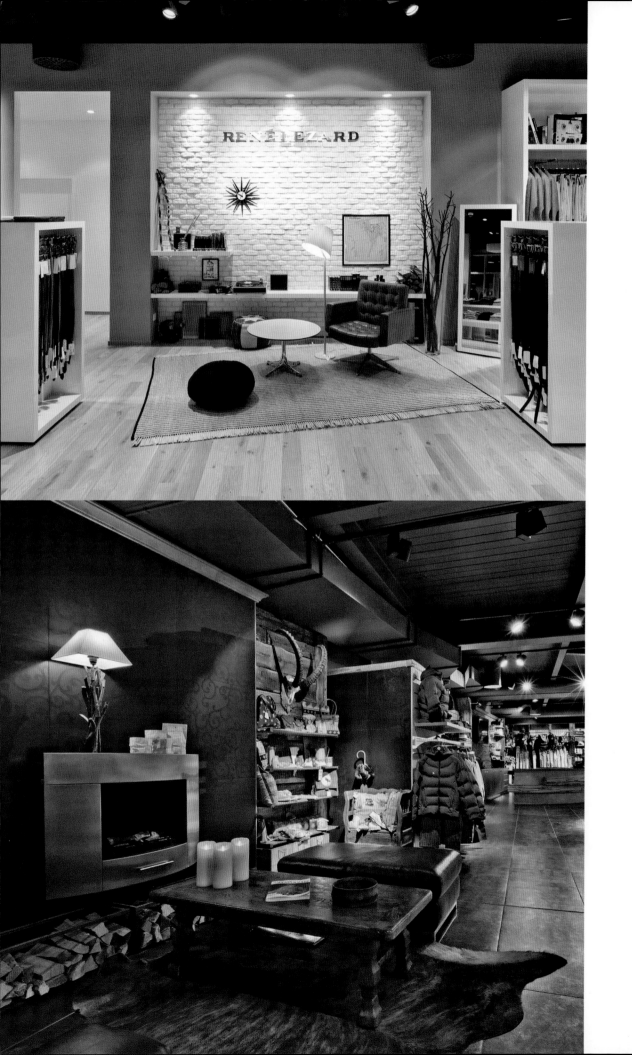

Both Rene Lezard and Bayard include settings from home, in each case fitting to the design of the store—contemporary at Rene Lezard and rustic at Bayard. Both settings communicate an attitude and image without saying a word, and illustrates the benefits of providing practical places to sit—always welcomed by shoppers.

Placed on low platforms, the room settings at Mr. Price Home suggest product pairings while acting as focal points, drawing attention to the center of the store.

Rene Lezard Zweibruken, Germany (opposite page, top)

Bayard Zermatt, Switzerland (opposite page, bottom)

Mr Price Home South Africa (above)

THIS PAGE: The college and dorm lifestyle, a bit cleaned-up, is referenced in the lounge area of Campus by Marc O'Polo. The target market is young men and woman and the offering is casualwear and accessories. The vignettes include memorabilia and retro items, and draw customers into the retailer's brand without including merchandise.

Campus by Marc O'Polo
Dusseldorf, Germany

One playful wooden structure serves as both display table and room-filling decoration. Included are a bike, a tree, a number of headless forms and, of course, suggested outfits. The raised bench draws eyes upward and gives interest to the vertical space.

Cecil/Street One Dortmund, Germany

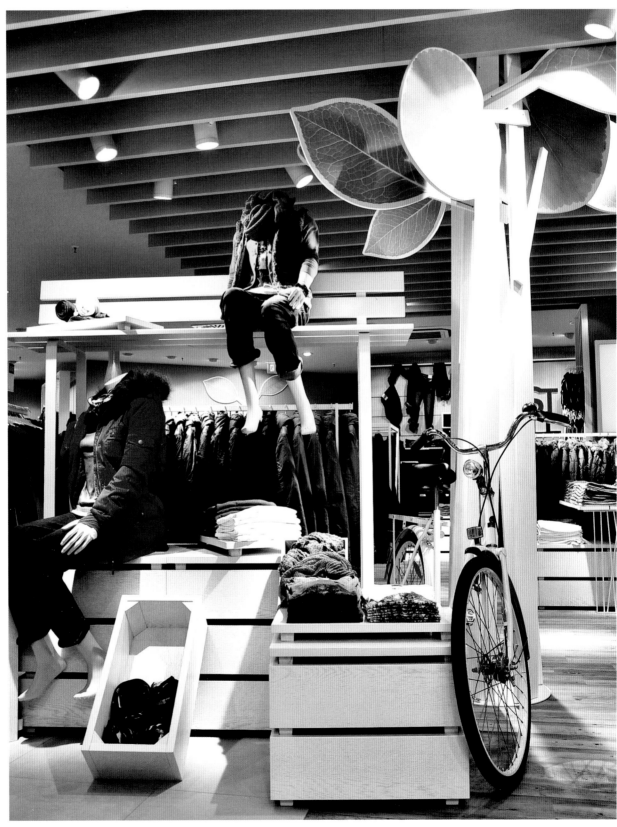

THIS PAGE: PUMA, while always mindful of its international brand image, is also mindful of an individual store's location and the local customer, adding local elements into the visual mix. The fitting room area in the Munich store pays homage to a typical alpine hut. The structure is made from reclaimed wood from Bavaria that was finished to increase its aged patina. Incorporated into the hut are PUMA-specific elements such the signature red of the door and shutters, and the Puma cutout on the door. The cat is also prominently displayed—with a handsome set of antlers—on a wall plaque. In Amsterdam the local love of bicycling is incorporated. On one wall a collection of old car mirrors is displayed. They refer to the Dutch custom of hanging car mirrors near doors in order to see who is ringing the doorbell.

PUMA Munich, Amsterdam

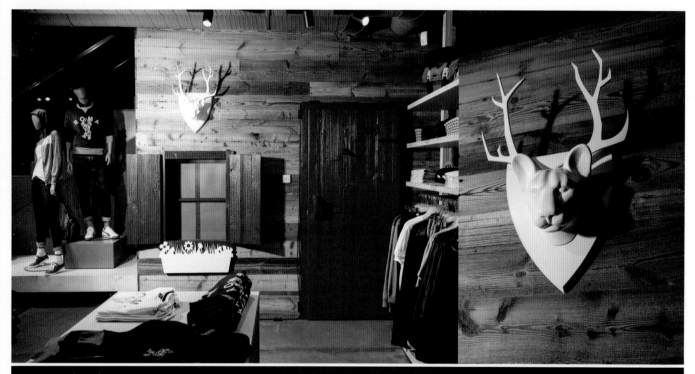

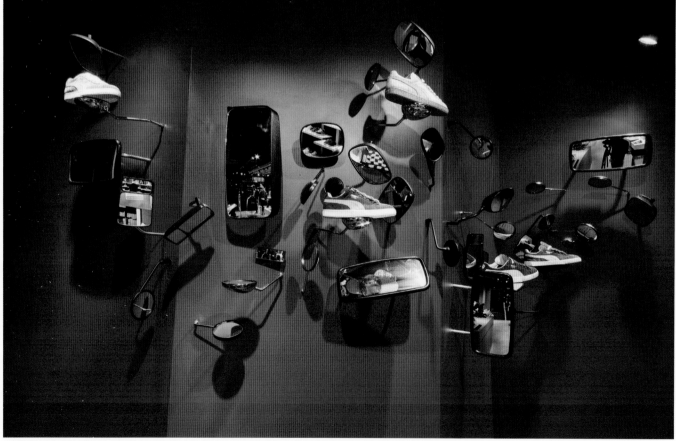

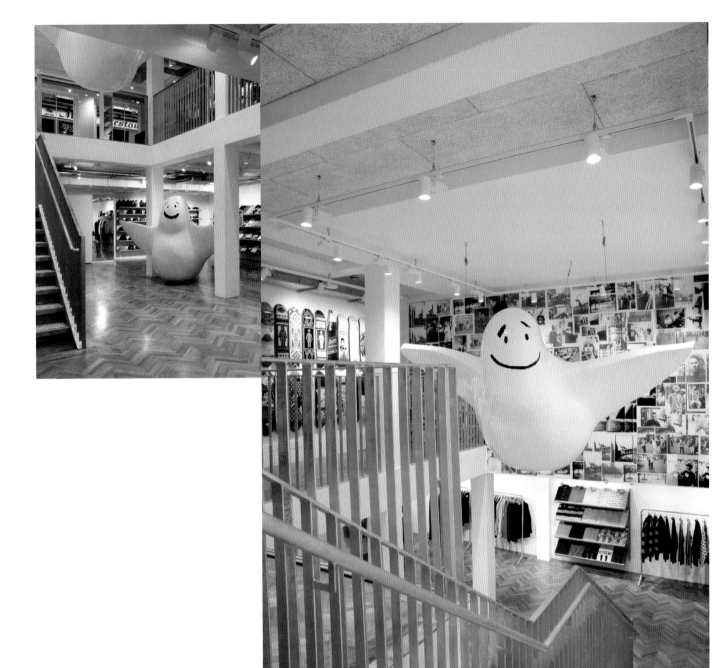

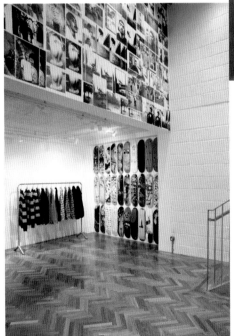

THIS PAGE: In Supreme, a store dedicated to all things skateboarding, a fanciful character takes wing, not unlike the customers who frequent the store. The two-floor shop has large expanses of lovely wooden floors and lots of air space, a temptation for sure, but no skateboarding is allowed.

Supreme London, UK

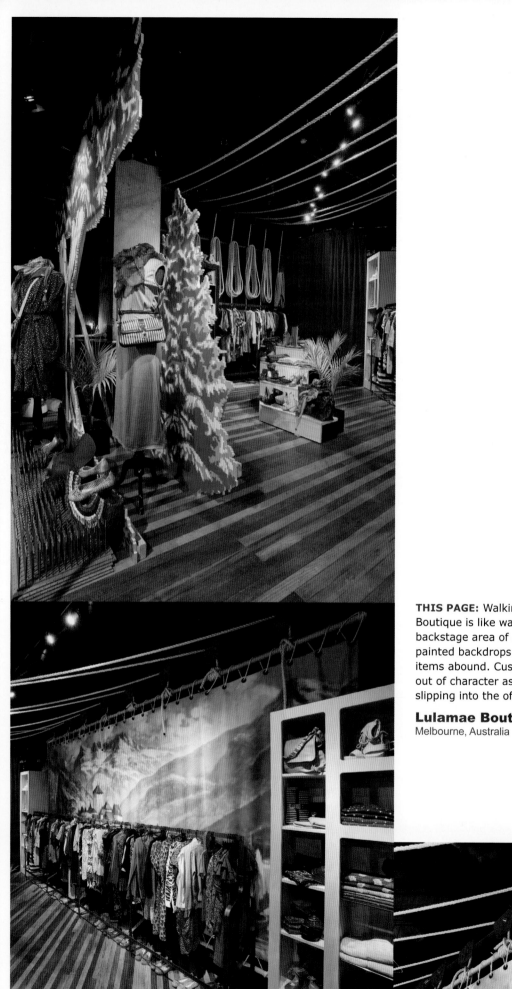

THIS PAGE: Walking into Lulamae Boutique is like walking into the backstage area of a theater—props, painted backdrops and all manner of fun items abound. Customers can slip in and out of character as they please, just like slipping into the offered outfits.

Lulamae Boutique
Melbourne, Australia

A sponsor of rodeos, it's only fitting that the Original Wrangler Store would include a life-size horse standing proudly on top of a display table. Made from chunks of wood, its stylized shape is spot lit to draw attention from across the room.

Merrell collects items related to its brand, and the brand's endeavors in the wide world, and offers them on a shelving unit near the entrance. Shoes are displayed on another shelf directly underneath. Together the displays promote product and brand.

Original Wrangler Store
Lone Tree, CO (right)

Merrell Rockford, MI (bottom)

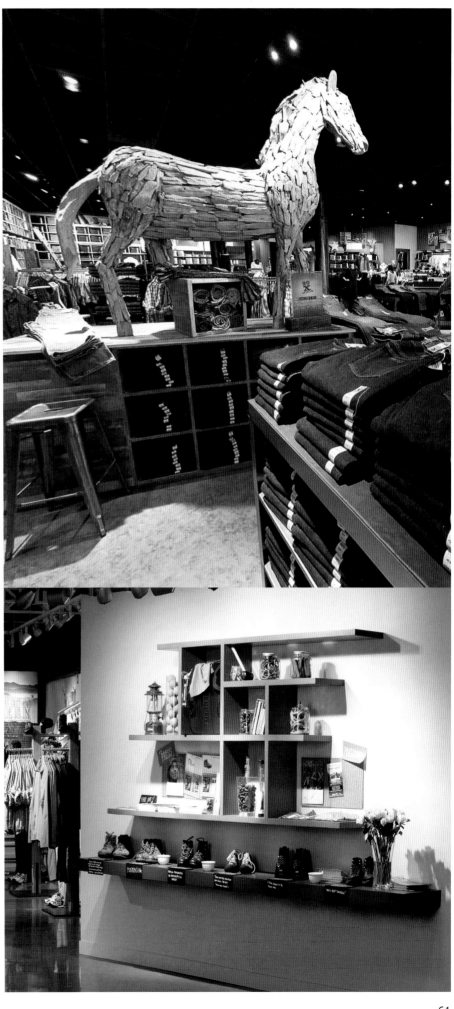

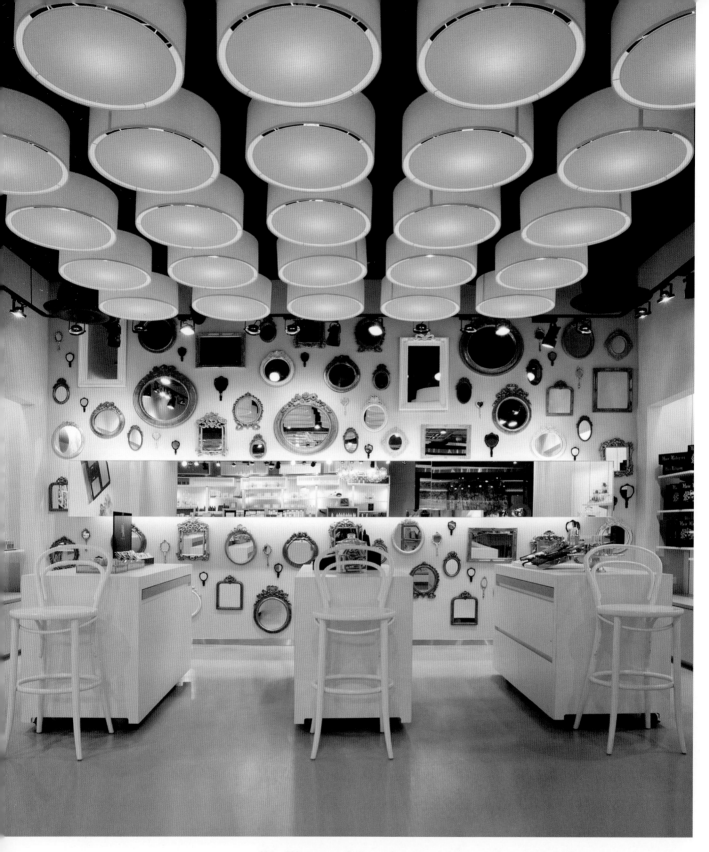

Skin 6|2 surrounds its make-over counters with round light fixtures on the ceiling above and (mostly) round mirrors on the wall behind. The message becomes evident, "You *will* look good in these mirrors when we are finished with you."

Skins 6|2 Cosmopolitan Hotel, Las Vegas, NV

THIS PAGE: At Spencer Hart a simple hang-rod of merchandise and a single row of books and CD covers evoke a long-gone era of cool jazz, an era referenced on the retailer's website and important to the brand.

Spencer Hart London UK

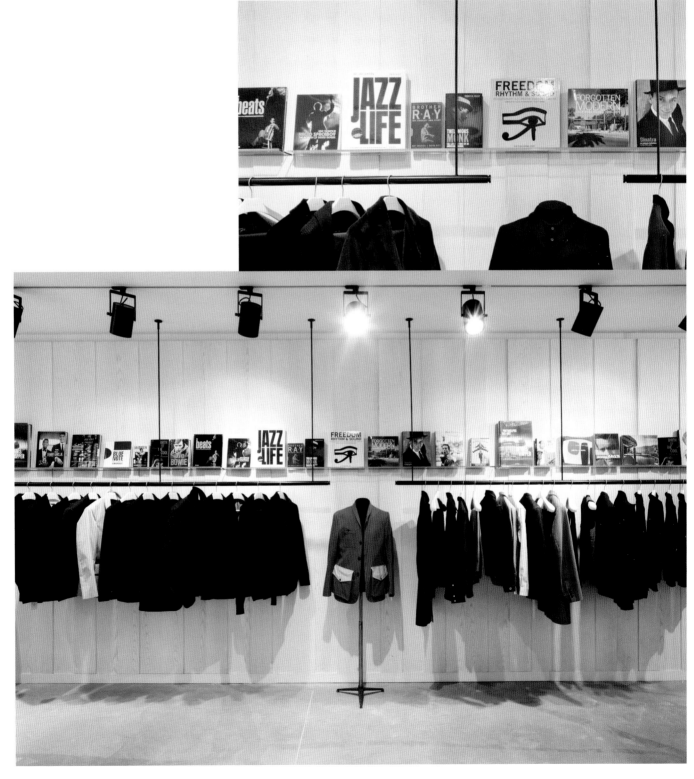

Merchandising Displays and Fixtures

The basic elements in a store, the display fixtures, tables, shelves, drawers and cabinets do much more than hold merchandise. They provide color and contrast; they add height and depth. They are focal points and branding tools and they guide the shopper through the space. Walls units are transformed into abstract paintings and floor displays into sculpture. The retailer's image is communicated and reinforced.

Yet, merchandising displays and fixtures *do* hold merchandise. And what could be more important in a retail setting than products that are well lit and easily accessible? In order for the merchandise to be appreciated, it must be well presented. The displays that follow do precisely that.

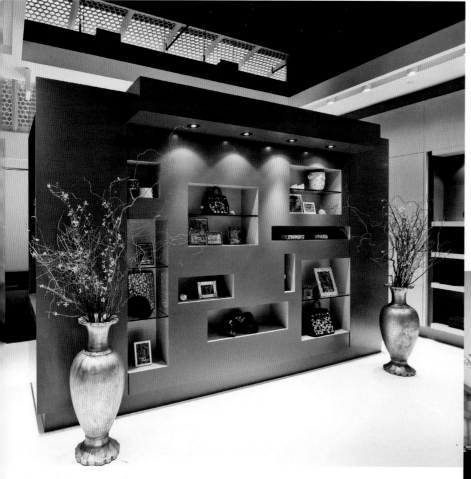

THIS PAGE: A shelving unit is the focal point near the back wall of Realm Boutique. Dramatically lit from above, it holds accessories and frames and is framed itself with a pair of handsome vases. The unit can also be seen behind the round checkout counter as customers enter the store. Together, the stately and elegant counter and shelves set the tone for the entire shop.

Realm Boutique New York, NY

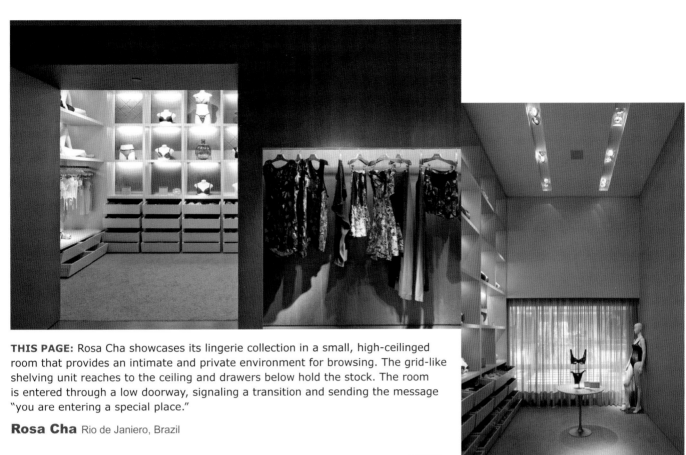

THIS PAGE: Rosa Cha showcases its lingerie collection in a small, high-ceilinged room that provides an intimate and private environment for browsing. The grid-like shelving unit reaches to the ceiling and drawers below hold the stock. The room is entered through a low doorway, signaling a transition and sending the message "you are entering a special place."

Rosa Cha Rio de Janiero, Brazil

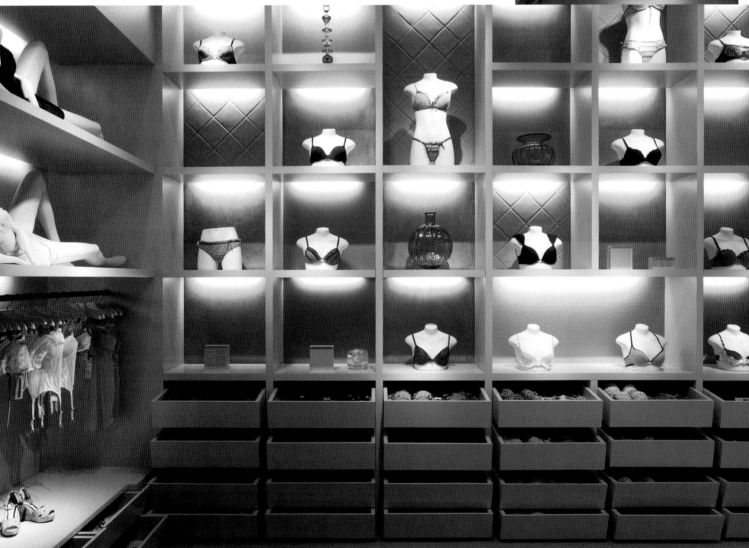

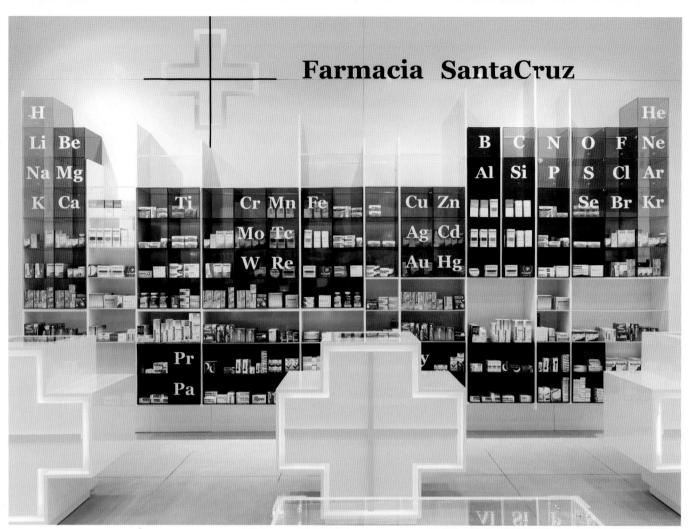

Farmacia SantaCruz

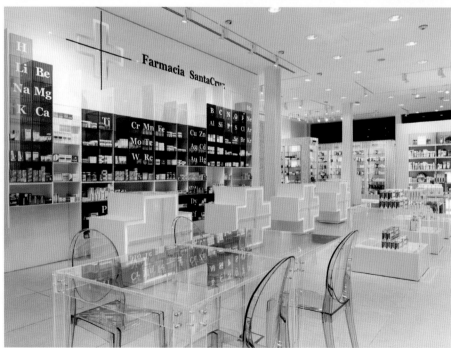

THIS PAGE: A display in case the shape of the Periodic Table of Elements plays with the relationship between pharmaceuticals and the basic elements of which they are made. Located in a pharmacy in Spain, the colors, partitions and letters organize the products while bringing a smile of school-time remembrance to the shoppers's face—and smiles are all too rare in the pharmaceutical world.

SantaCruz Pharmacy Santa Cruz de Tenerife, Spain

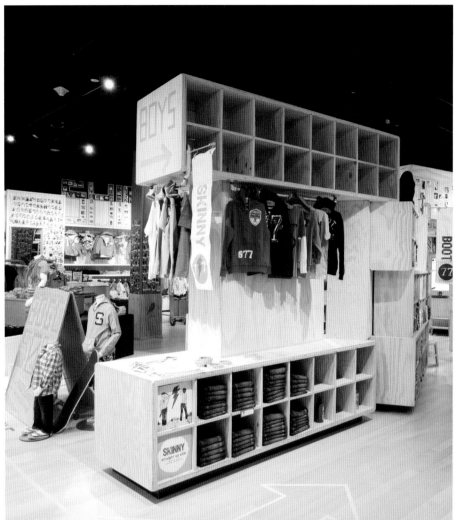

THIS PAGE: 77Kids imagines its store as a giant playroom and creates an environment of building blocks and cubbies, much like those found in schools. Kids and their parents are invited to browse in the fun and familiar space, perhaps even forgetting any displeasure they may have encountered in the past while clothes shopping.

77Kids Cherry Hill, NJ

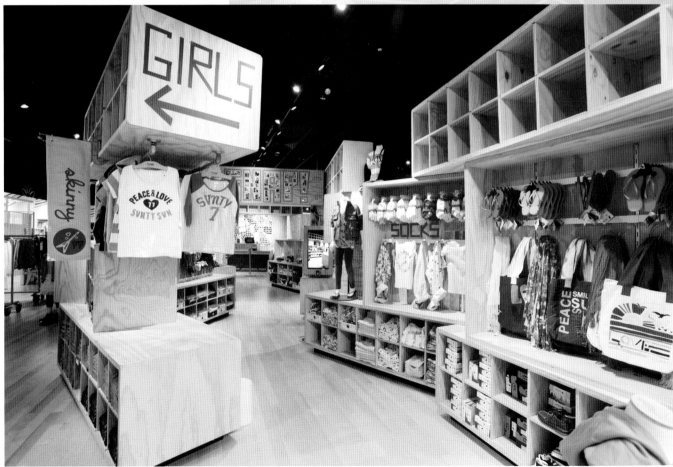

At Streetology and Sneakerology the displays *are* the design of the store, and the store design is the displays—they are inseparable. At Streetology t-shirts are stored in cylindrical tubes held in vertical dispensers, one color to a column. As shirts are removed the pattern of color changes, involving shoppers in the decoration of the shop. The shirts hang below for inspection.

At Sneakerology, Streetology's sister store, the walls of sneakers create a graphic and bold design. Each show is clearly numbered and that number enables customers to access more information from one of the monitors in front. The monitors are connected to the retailer's website, connecting offline and online brand presence.

Streetology Sydney, Australia (opposite page)

Sneakerology Sydney, Australia (this page)

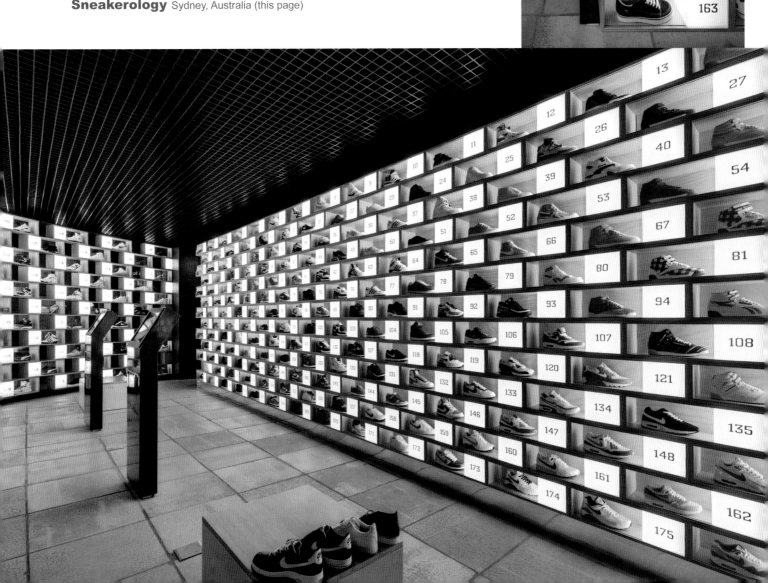

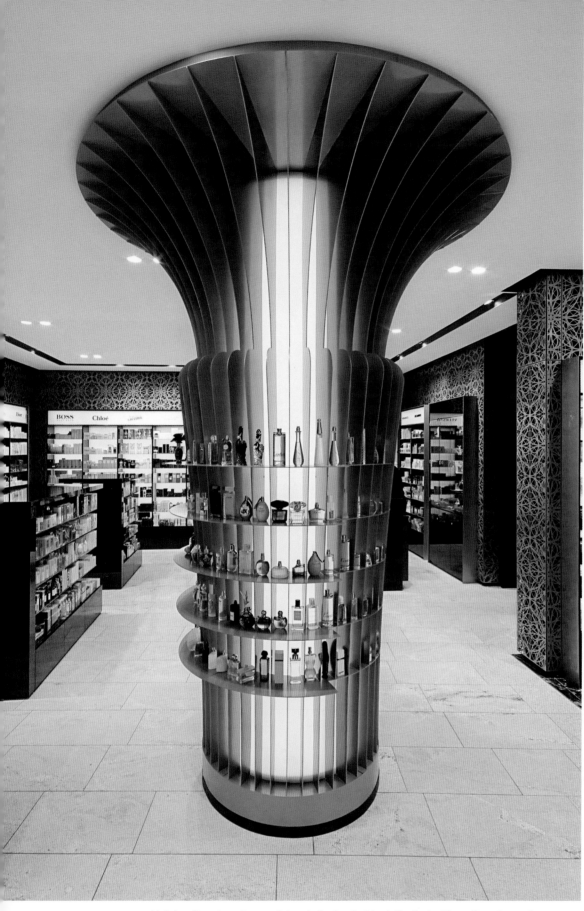

At Jelmoli a stunning sculptural display holds delicate bottles of perfume for sampling. The shopper is encouraged to linger and sample whatever they please from the one central location. When a decision is made, the boxed products are close at hand. Anchored from floor to ceiling and lit from within, the display is impossible to miss or resist.

Jelmoli Zurich, Switzerland

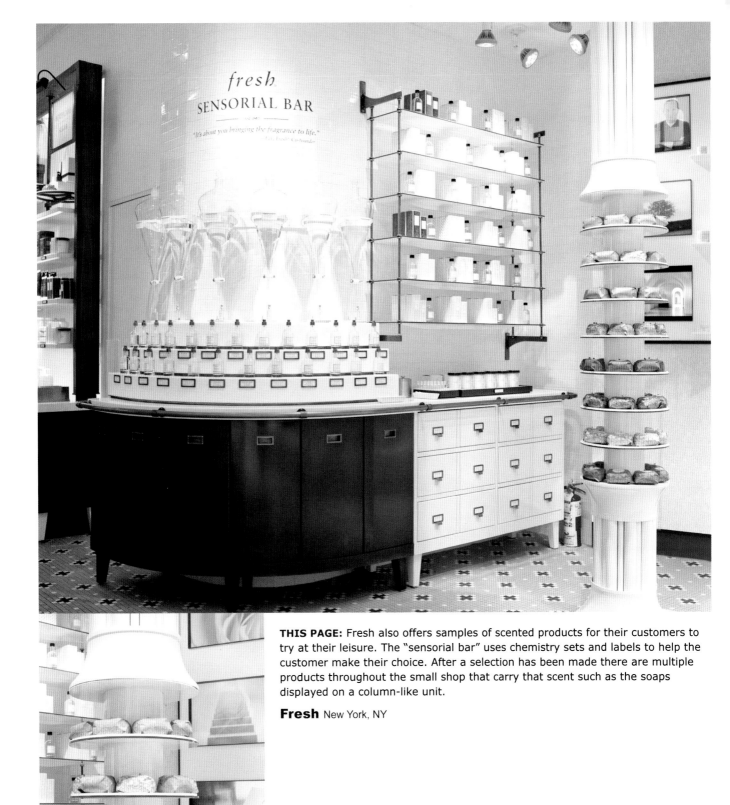

fresh
SENSORIAL BAR

"It's about you bringing the fragrance to life."

THIS PAGE: Fresh also offers samples of scented products for their customers to try at their leisure. The "sensorial bar" uses chemistry sets and labels to help the customer make their choice. After a selection has been made there are multiple products throughout the small shop that carry that scent such as the soaps displayed on a column-like unit.

Fresh New York, NY

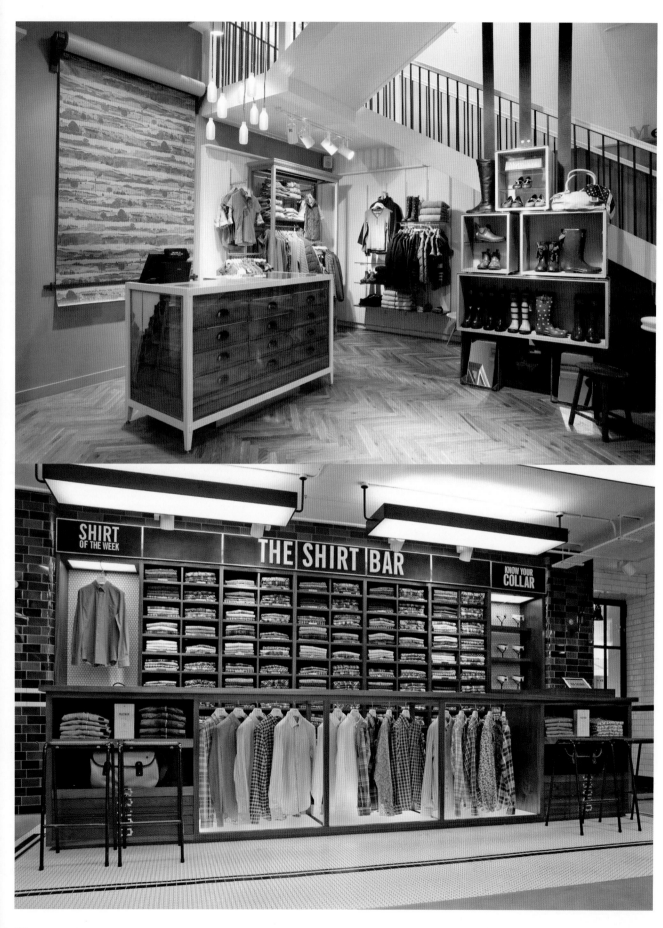

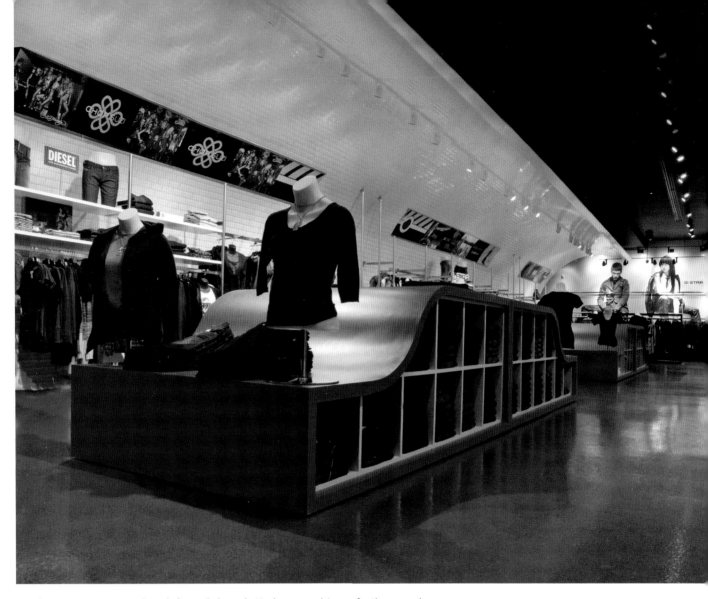

The long narrow space that defines Calgary's Underground is perfectly served by the curved display cases that occupy mid-floor. Their strong color and curving design pulls attention to the center of the store and complements the underground transportation theme—all while holding neatly folded stock.

Underground Calgary, AB, Canada (above)

In a niche under its stairs, Joules creates a quiet, well-lit corner. At first glance the checkout counter nearby appears to be an old-fashioned bureau. At second glance it can be seen that it's actually an illusion. The bureau is "printed" and enclosed under a clear casing.

Ben Sherman invites customers to step up to a "shirt bar" complete with samples conveniently hanging under the counter, collar displays, a shirt of the week and even bar stools. Find your perfect shirt without fuss or bother—personalized service is not out of fashion, only re-imagined

Joules London, UK (opposite page, top)

Ben Sherman London, UK (opposite page, bottom)

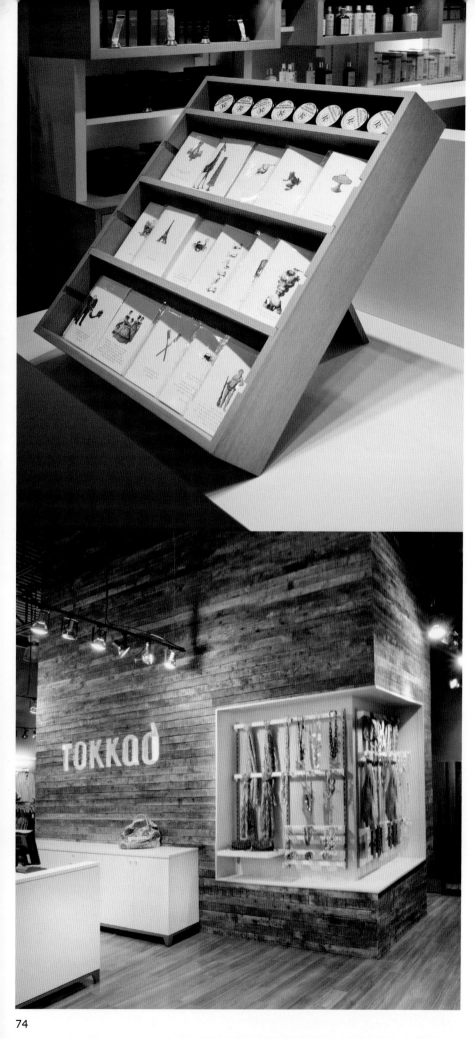

Focusing attention onto a limited number of products is what these displays—one at Skins 6|2 and the other at Tokkad—do well. Although the units are completely different in size and form, both display products to the fullest advantage. Natural wood adds warmth.

Skins 6|2 Las Vegas, NV (top)

Tokkad Quebec City, QC, Canada (bottom)

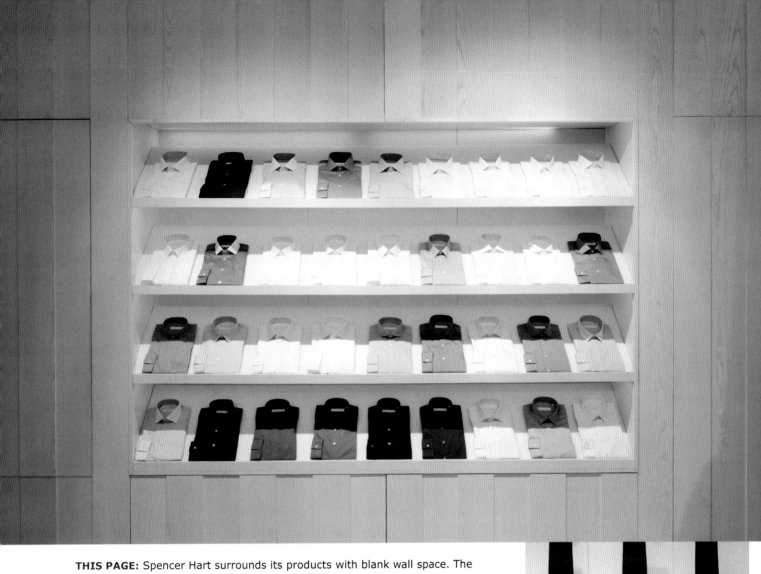

THIS PAGE: Spencer Hart surrounds its products with blank wall space. The sparseness causes the shape of a simple shirt, tie or scarf to transform into a modern graphic design. The display of select items in such a select manner increases the need-to-have response.

Spencer Hart London, UK

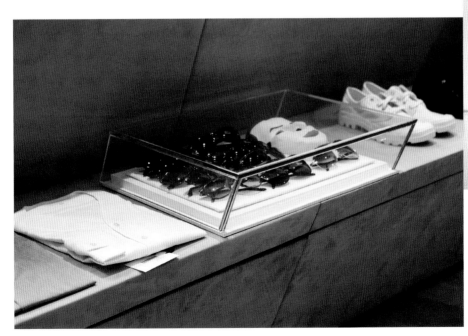

These two displays act as sculptural elements within the store, attracting attention and shoppers from near and far. At Bloomingdale's the dark, monolithic display has an internally lit inset for each pair of sunglasses, creating a wall of darkness and light.

At s.Oliver, a modern, red unit hangs from the ceiling, its elements curving into shelves as it descends. The mirrored ceiling doubles the height of the display and the amount of merchandise underneath.

Bloomingdale's Santa Monica, CA (below)

s.Oliver Munich, Germany (opposite page)

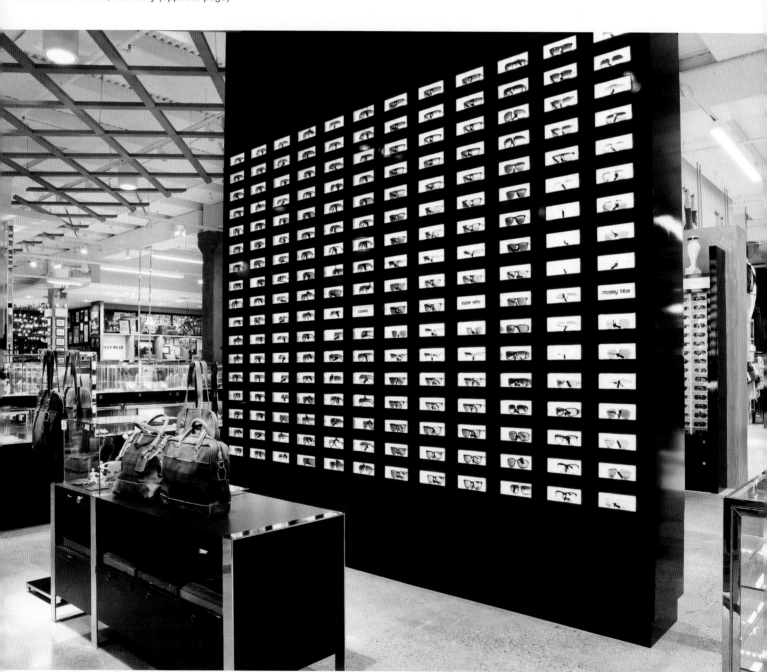

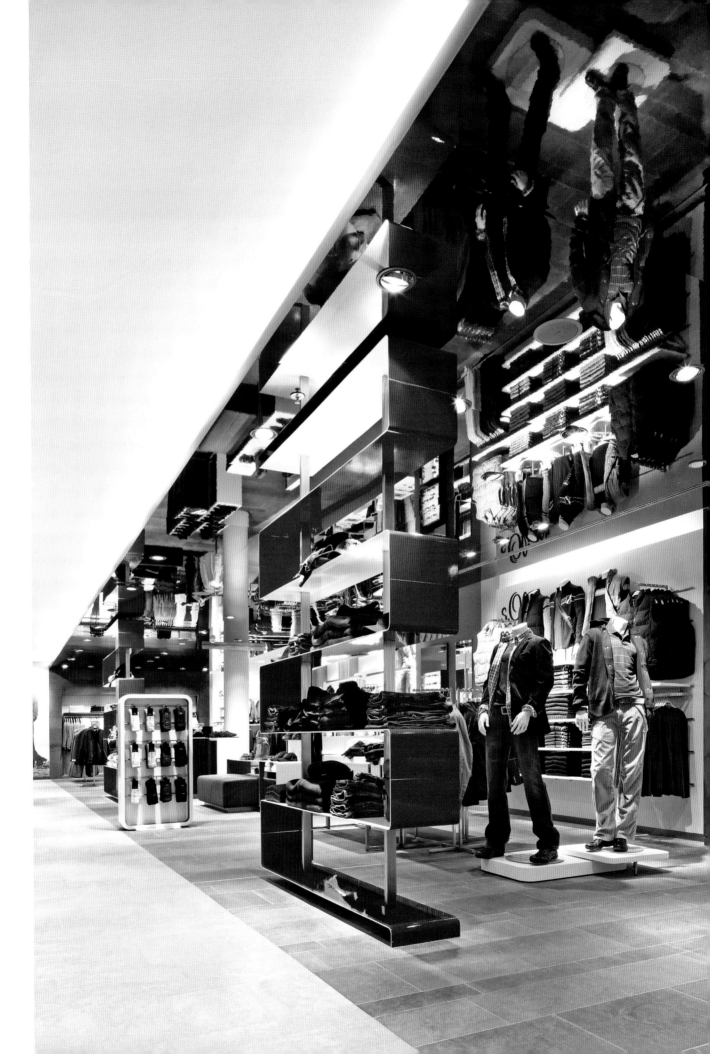

Harry Cunningham
Saks Fifth Avenue

Harry Cunningham is Senior Vice President of Store Planning, Design, and Visual Merchandising for Saks Fifth Avenue. In this role, he is responsible for Store Planning, Design and Visual Merchandising at Saks Fifth Avenue, and Store Planning and Design at Saks Fifth Avenue OFF 5TH. Harry was previously VP/Creative for Saks Fifth Avenue's OFF 5TH division, overseeing all store design, visual merchandising, and branding efforts for that division. In addition to a new prototype concept for OFF 5TH which debuted in 2007, Harry and his team recently launched a new design for the company's "WEAR NOW" business at Saks Fifth Avenue, and in fall 2012, opened the expanded 10022-SHOE floor in New York—a shoe floor so big it has its own zip code. Prior to rejoining Saks, Harry spent a year at Liz Claiborne Inc. as Director of Visual Merchandising – leading worldwide merchandising direction and showroom installation for several of the company's brands. Previously, Harry was VP/Visual Merchandising for the Proffitt's/McRae's division of Saks Incorporated until Saks' divestiture of the department store business in 2005. Harry's background also includes 10 years with Dillard's, Inc. where he held roles of increasing responsibility, with his most recent position Regional Director/Visual Merchandising, overseeing stores in the Southeast United States.

Harry sits on the Advisory Board of the High School of Fashion Industries in New York City and The FIDM Visual Communications Advisory Council. Harry is also a member of the Board of Directors for the Planning and Visual Education Partnership (PAVE). In the fall of 2012, Harry was recognized as a "Retail Design Luminary" by the readers of DDI magazine.

Richard Stolls, Chairman of Lifestyle-Trimco, has been one of the leaders of our industry for the past 30 years; also being selected by DDI as one of the most influential people in our Industry. Stolls was the long time President of NADI, co-founder of The Society of Visual Merchandising, and co-founder and President of PAVE, as well as serving on the ARE Board of Directors. He recently spoke with Harry Cunningham.

Tell us about your background & how you got started in the field of visual merchandising/display.

I began my career in visual merchandising while selling newspaper ads in high school. I worked freelance for limited hours fluffing holiday trim, and thought it was the greatest experience ever... fast forward 25 years, and that experience still enters my mind when I walk a store and look at how they've prepared and installed their holiday décor.

What are your current responsibilities at your current position?

In my current role as SVP/Store Planning, Design, and Visual Merchandising, I oversee a team that designs and develops new stores and store renovations and a visual merchandising team that creates and implements merchandise presentation and window design concepts in Saks Fifth Avenue stores nationwide.

Tell us about your company, the image, the brand and how it relates to everything you do.

With 45 locations across the United States, Saks Fifth Avenue is

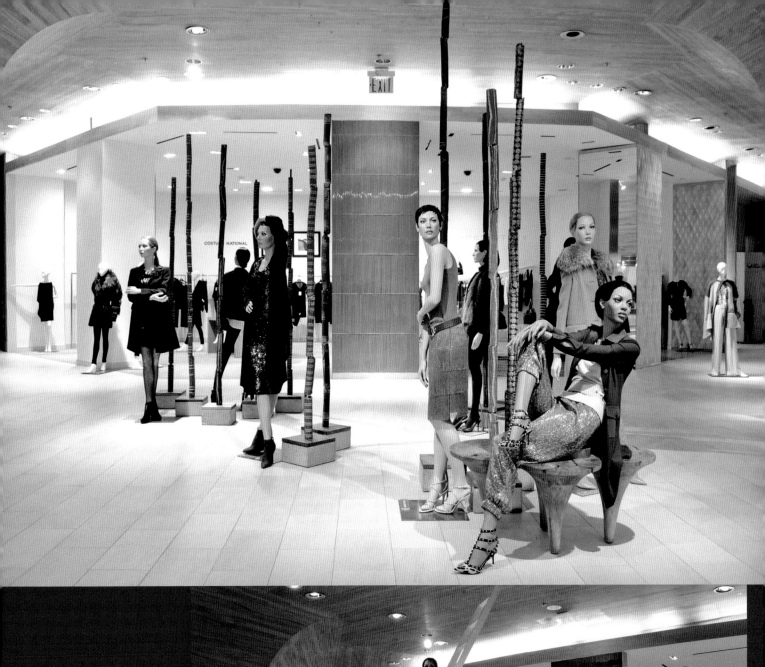

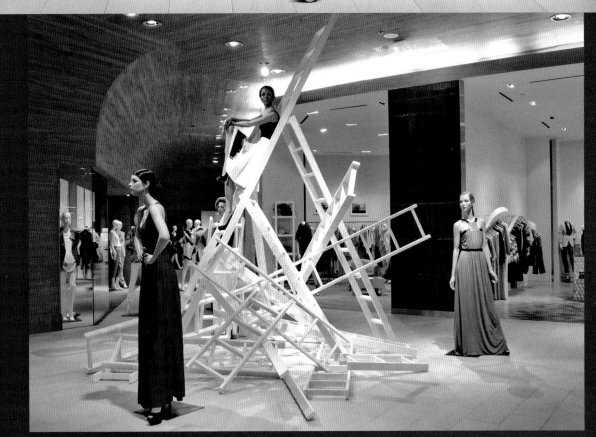

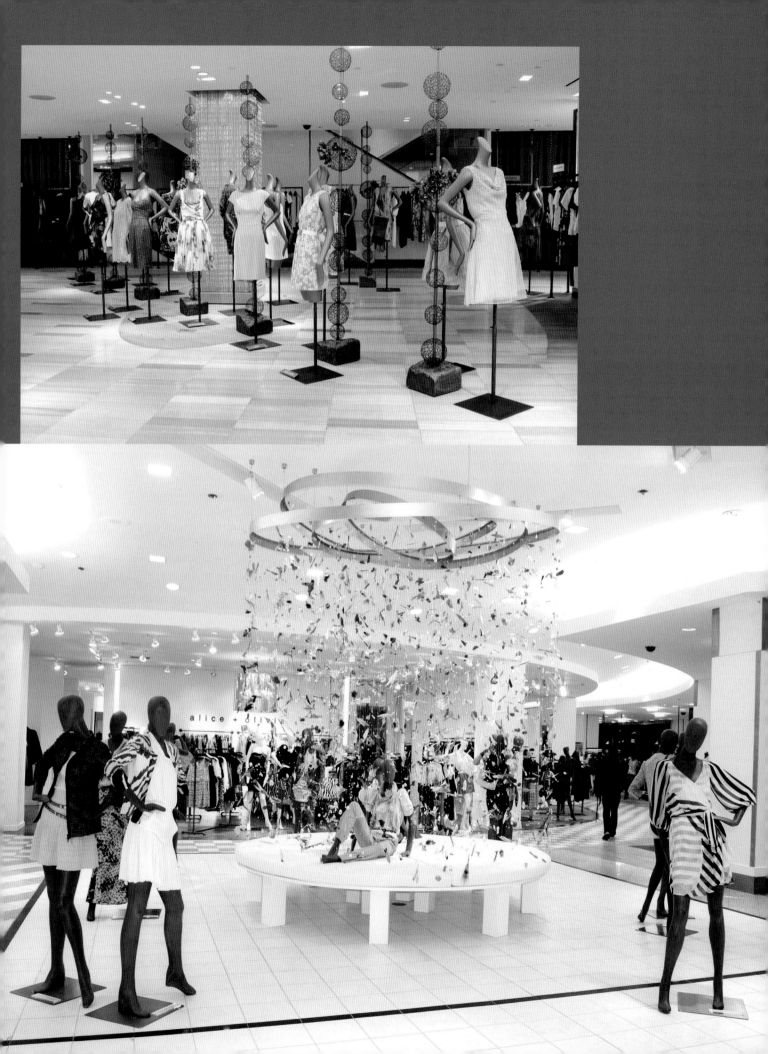

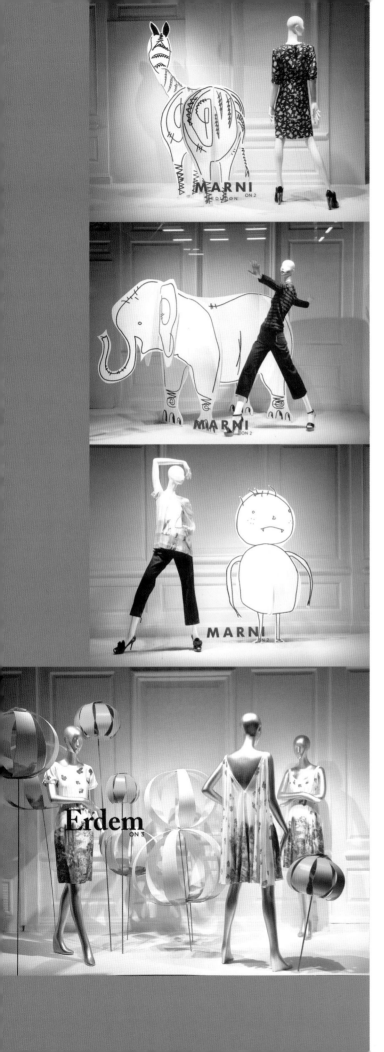

renowned as an arbiter of modern style. From the day its doors opened in 1924, the purpose of this retail legend has always been the same: to be the first and only choice for the most discerning consumers, the ones with the highest expectations. With modern energy and great fashion authority, Saks Fifth Avenue pays tribute to—and continues to enhance—a rich legacy of exceptional style and service.

Tell us about your team. What are the different rolls each member plays?

My team is made up of a group of architects, interior designers and visual merchandisers, all with a passion for design and a keen sense of style.

Do you have a single design philosophy?

Our design direction is "modern heritage," ensuring that everything we do reflects a modern edge with intense for respect the rich heritage of the brand.

What projects are you working on now or just finishing up?

In the last twelve months, we launched a new "WEAR NOW" department for ladies in New York. In August 2012, we opened our newly expanded 10022-SHOE floor in New York. Additionally, there are various new projects throughout the country currently underway.

What is more important: the idea or the execution, and why?

Neither the idea nor the execution, are more important; they both have equal value. Without a great idea, nothing can be executed. Without great execution, a great idea has no value.

What is the most rewarding aspect of your job?

Watching the reaction of customers to our environments, and perhaps more so, watching the eyes of children when we unveil our holiday windows.

What is the most challenging or frustrating part of your job?

Not having enough time in the day to do everything I'd like to do!

Who has most influenced your career?

My career has been influenced by various family members—each for their own qualities and reasons.

Looking back at your career, what are the things you are most proud of?

I'm most proud of my current position... as a "keeper of the brand," I'm very honored and humbled to get to do the work I do, working with a world-class team for one of the world's preeminent retailers.

What sets an ordinary visual display apart from an extraordinary one?

Without fail, attention to every last little detail.

How is today's display and visual merchandising most different from a few years ago?

Visual Merchandising is back... people are starting to care about display again... not assuming that technology is the "end all." There's an entire generation of shoppers out there now that haven't experienced situational window displays and realistic mannequins!

How does window display and in-store visual merchandising relate to each other?

Window displays and in-store visual merchandising are directly related... the window gets you in the store, and the presentation inside should both get you excited and keep you there.

What advice would you give someone entering the field?

Be willing to start at the bottom... get your hands dirty, burn your fingers on a glue gun; ruin that favorite shirt with paint. It's all in a day's work, and you'll appreciate it that much more as you move up the proverbial ladder.

What advice would you give a fellow visual professional and how to keep their work fresh?

Continue to be open to inspiration from everywhere, and always ask that second question... Did I add too much? Did I add enough? What was the story I was telling and did it interest me too once it was complete?

Are you very involved with the industry?

I'm very involved with educational organizations for a myriad of reasons. The two most notable ones are: I come from a family of educators. My grandmother, with whom I was very close, was an elementary school principal when she retired after 50 years in education. I always admired her passion and the enjoyment she got at seeing children learn. I hope I can inspire just one or two students the way I know she inspired so many. Additionally, I believe that we are responsible for educating the future of the industry... they need to know who Andy Markopoulos was. They need to know what display was and what it can become. As far as I'm concerned, being involved is not an option when you get to a certain point in your career. Give back.

What is your outlook for Visual Merchandising in the future?

There will always be visual merchandising. There's just something special about picking up a shoe, trying on a garment, smelling a fragrance... that mystery and allure will never go away.

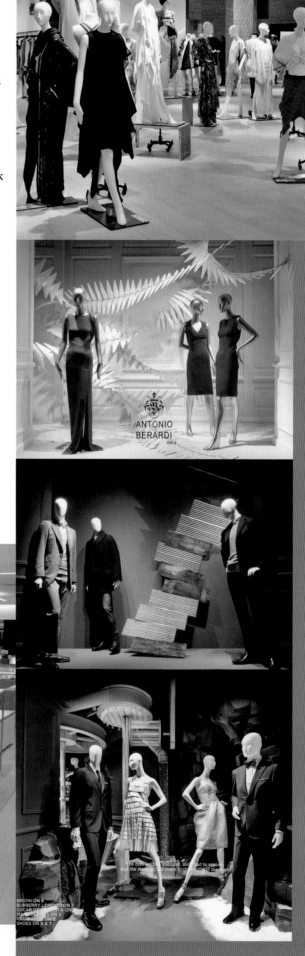

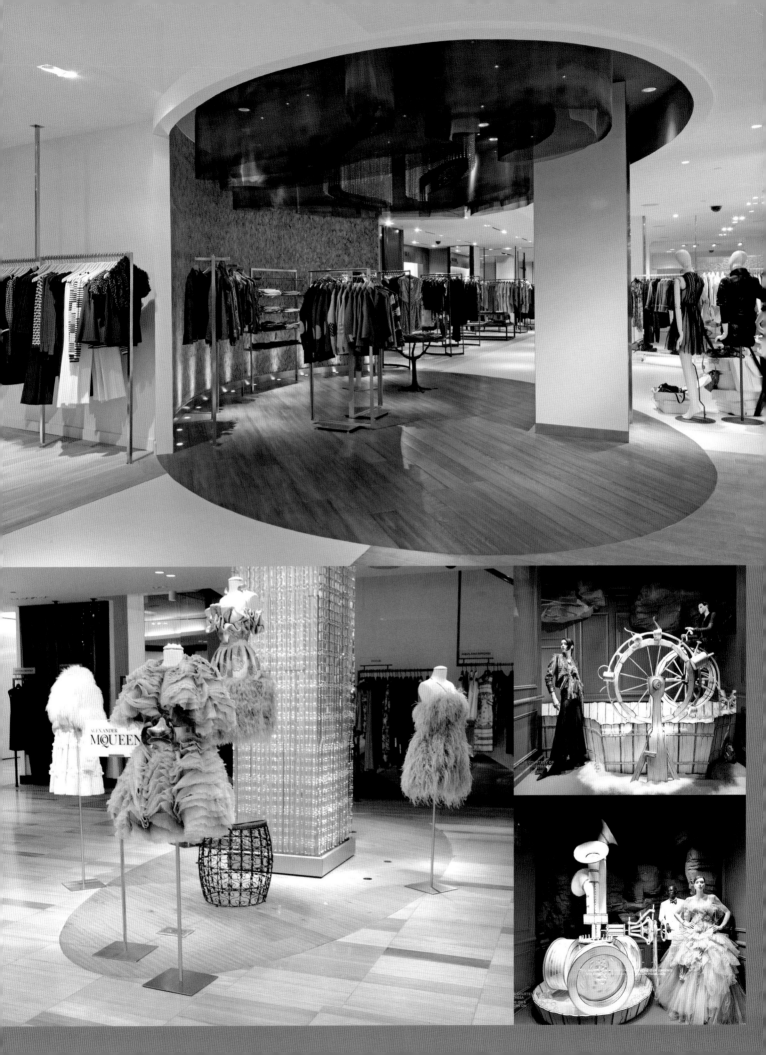

ALEXANDER MCQUEEN

In-store Mannequins

Mannequins have long been vital to window displays, luring passersby into the store. In today's retail landscape they are now equally important inside the store. Just like their sisters in the windows, the in-store mannequins entice shoppers with fashion's possibilities—what's new and what's hot, and what should at least be tried on.

However, mannequins take on additional responsibilities in-store. They act as guides, enticing shoppers through the store, gently luring from wall to wall. They may appear as friends, brimming with helpful advice, or as slightly out-of-reach beings, an aspiration for all. On the following pages you'll see how far they've come.

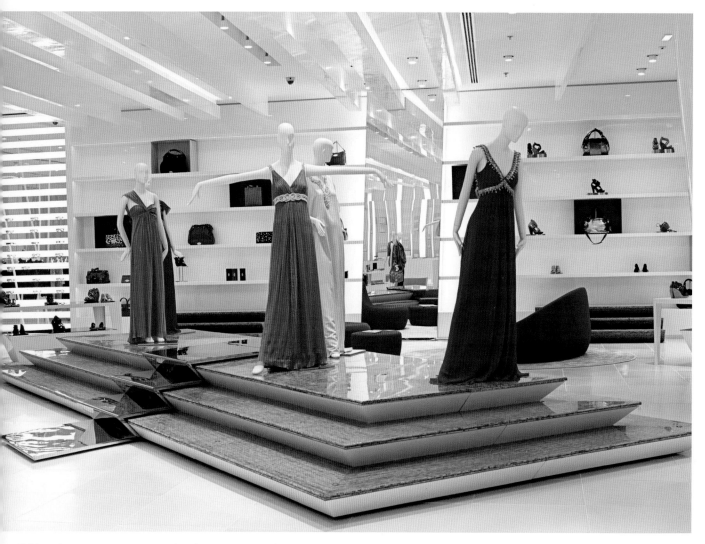

White abstract mannequins take the stage near the entrance of Boutique 1 in Dubai. The serene simplicity and subtle variety of their poses and angles gain attention without having to shout. This display could, of course, take many forms and even the platform can be separated and repositioned as two units.

Boutique 1 Dubai, UAR

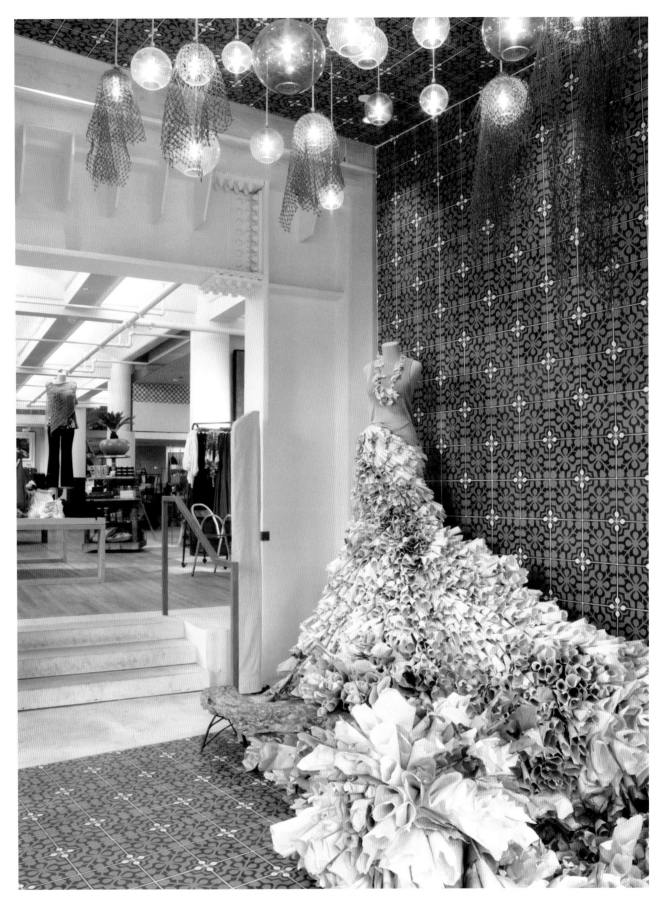

A corner of a store, by a few stairs, could all too easily become a dead zone. Not at Anthropologie. Nor does the retailer stuff the corner with merchandise. Instead, a form is adorned with a simple top and ornate necklace—and then so much more. A billowing floral "skirt" spills over the floor, its texture and color working wonderfully with the patterned wallpaper behind and the illuminated globes overhead. Could anyone walk by without stopping?

Anthropologie Chelsea Market, New York, NY

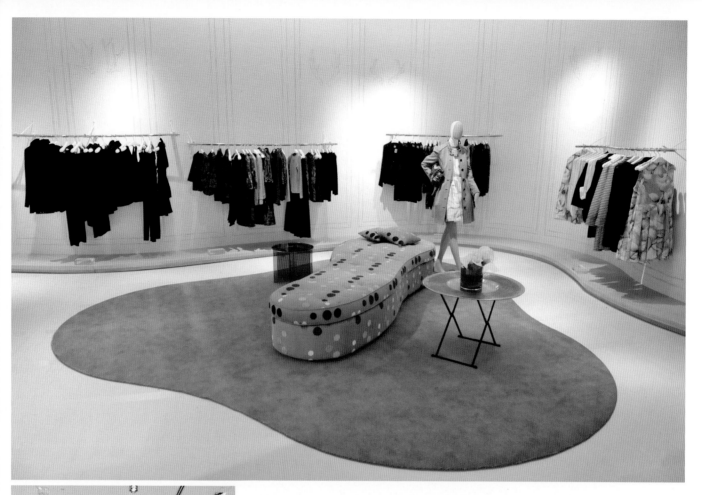

THIS PAGE: Mannequins placed around The Room, a shop-within-a-store concept at The Bay, provide points of color in an elegant yet largely monochromic environment. Some of the mannequins are positioned as if to interact with the shopper—behind a seating arrangement or seated on a display table.

The Room The Hudson Bay Co., Toronto, ON, Canada

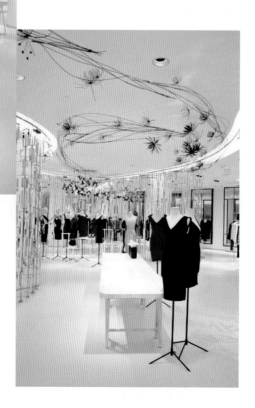

THIS PAGE: The designer floor at Saks Fifth Avenue houses almost 50 designer collections showcased in their own individual boutiques. Placed throughout the floor are mannequins, individually and in groups, that inhabit the floor and, except for their abstract design, could be shoppers themselves. They represent the ideal shopper, no doubt, and are out to entice actual customers into and through the many boutiques. Saks knows its target market well. The mannequins amplify the attitude of the Saks shopper and reflect it back with heightened style.

Saks Fifth Avenue, Designer Floor New York, NY

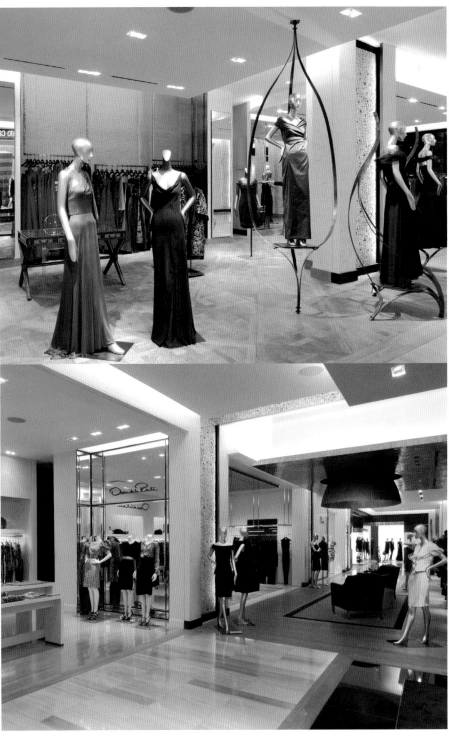

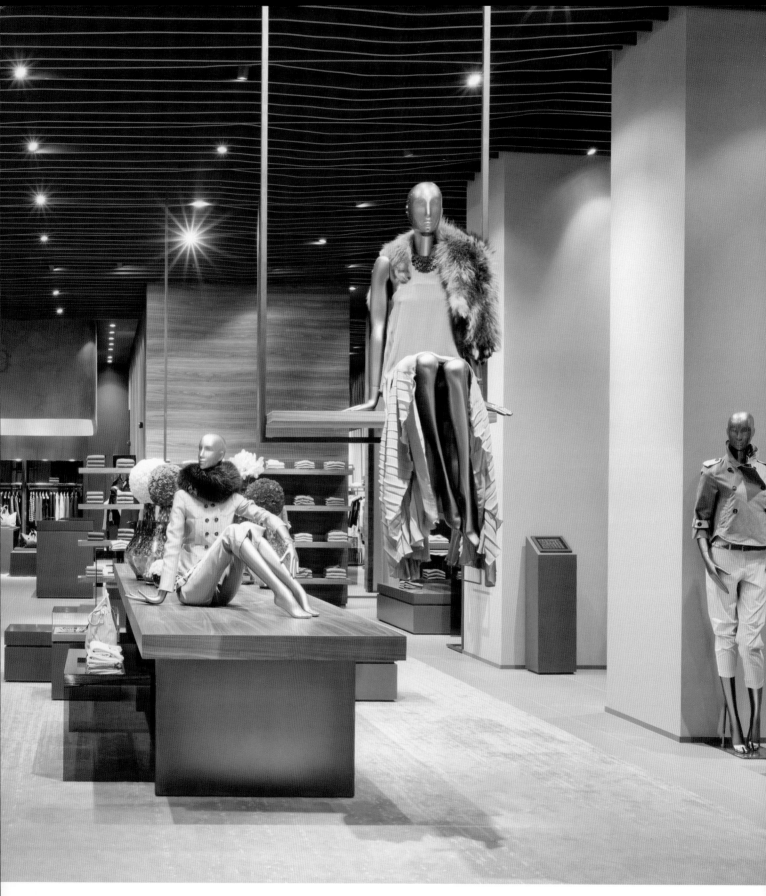

At this German retailer, a trio of abstract mannequins is dynamically positioned to draw the customer's attention through the space, right and left and up toward the ceiling—filling the vertical space. The attractive wooden table is, perhaps surprisingly, free of stacked or piled merchandise. The mannequin's siren song is deemed more valuable.

Michael Meyer Liza & Yves Bochum, Germany

In this narrow area of Mexico's Liverpool department store, three half forms hang near the ceiling while undulating rods cause the walls to appear to move. Bench seating invites the shopper to sit and contemplate the scene, enjoying a respite before plunging toward the well-stocked room beyond.

Liverpool Polanco, Mexico City, Mexico

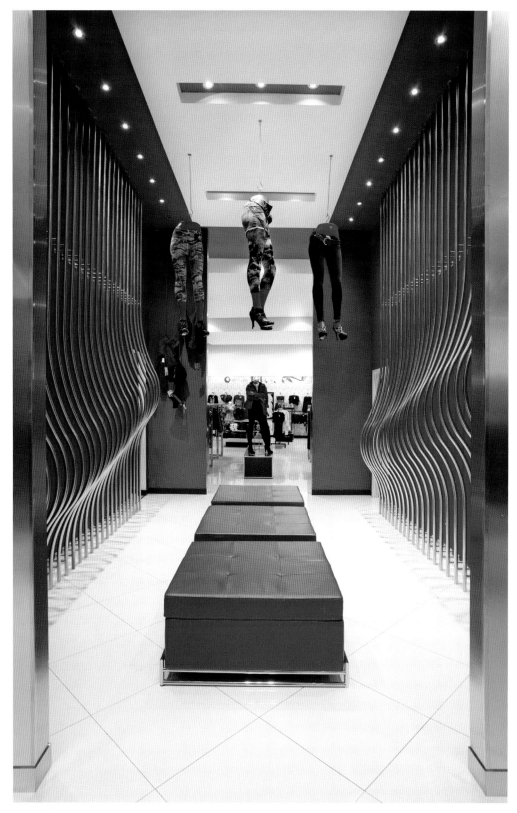

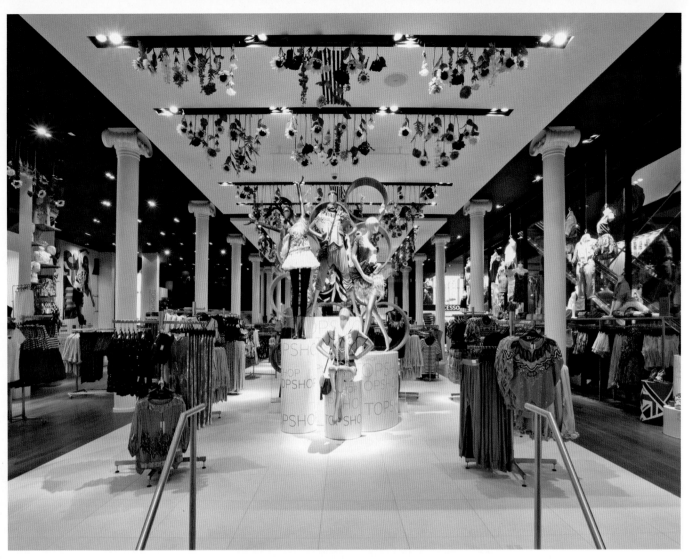

THIS PAGE: Topshop creates a special area within the larger store. White columns, flooring and a dropped ceiling define a space within the larger room without enclosing it. The center of this area is further highlighted with four dynamically posed mannequins, colorful loops and an array of flowers. The resulting focal point draws attention from near and far. Elsewhere in Topshop a mannequin with a casual pose and matching attitude is found, unexpectedly, on top of hang rails.

Topshop/Topman Lower Broadway, New York, NY

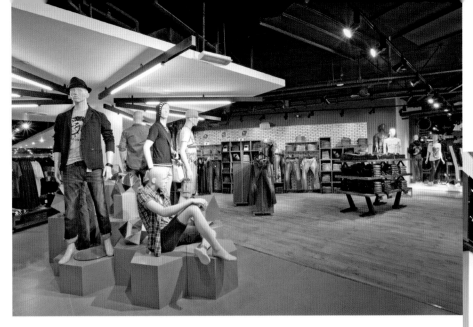

THIS PAGE: The huge spaces in Iconic might be overwhelming if not for the displays that humanize and entice. The blue abstract mannequins on their matching blue ramp offer youth and excitement, transforming the huge space to a shopable scale. Throughout the store they turn large spaces into backdrops—exciting backdrops to be sure—but still backdrops for the products.

Iconic Dubai, UAE

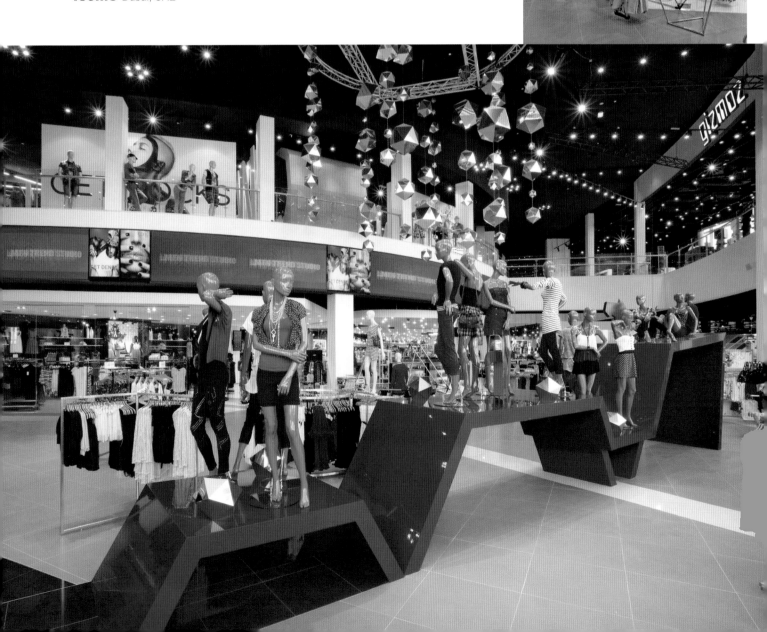

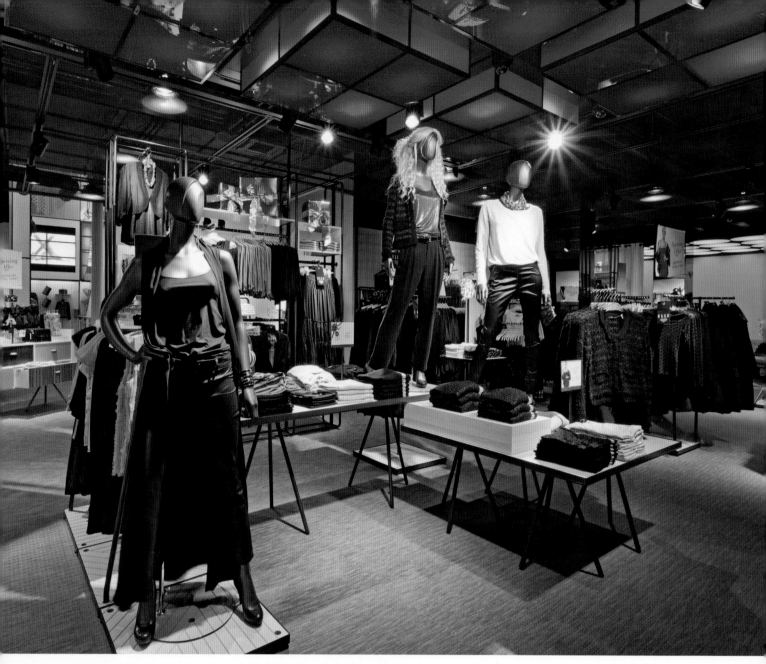

Groupings of mannequins have become so important to delivering in-store messages that it's hard to image some retail spaces without them. It's certainly impossible to imagine Lindex and Oasis without the bold attention-getters. Both groupings of mannequins lead the eye to what's behind them, at Lindex a floor-to-ceiling display fixture and at Oasis a large branding graphic. Both of these stores were designed by Dalziel and Pow Design Consultants whose principal David Dalziel recently stated: "Every successful consumer-facing brand employs design as part of its strategy and that has not always been the case. In recent years we have been stressing the importance of the store as an inspirational showroom, not simply an open stockroom."

Lindex Oslo, Norway (above)

Oasis London UK (opposite page)

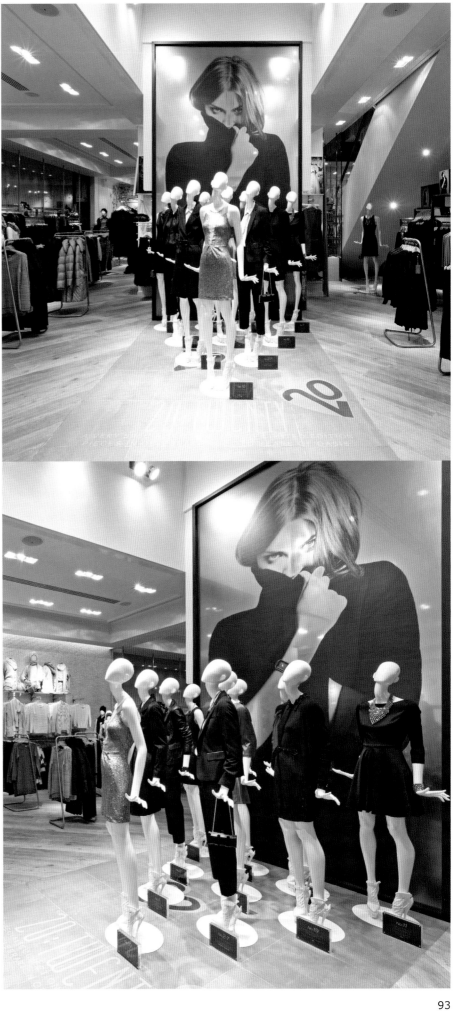

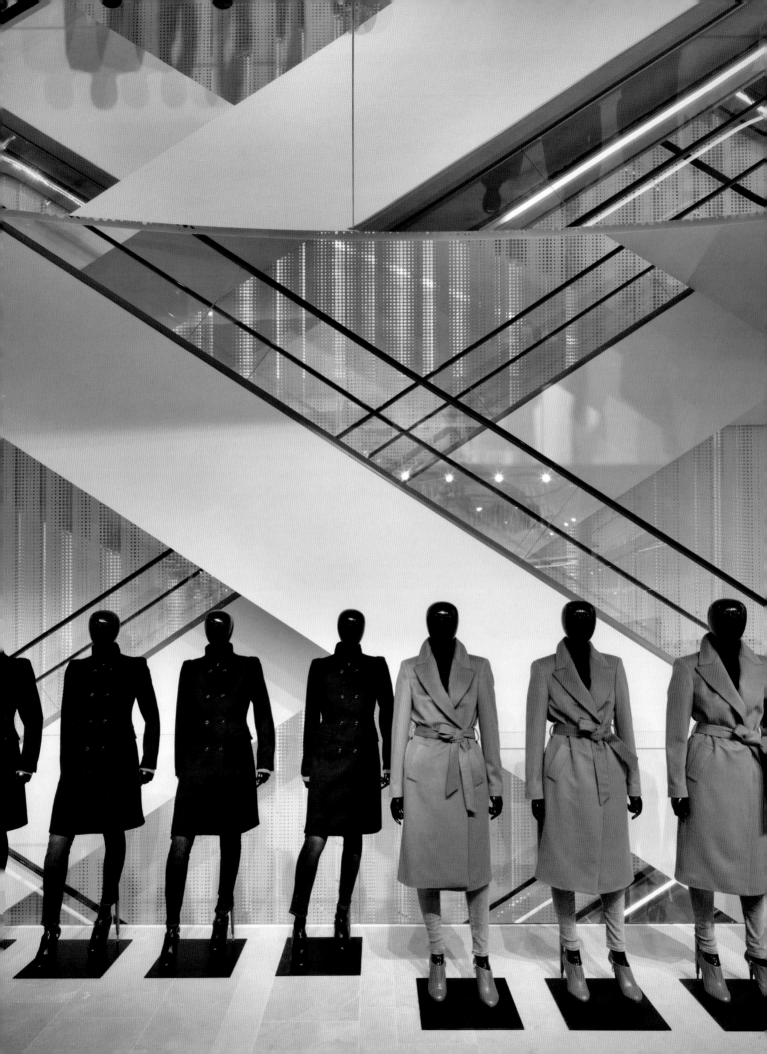

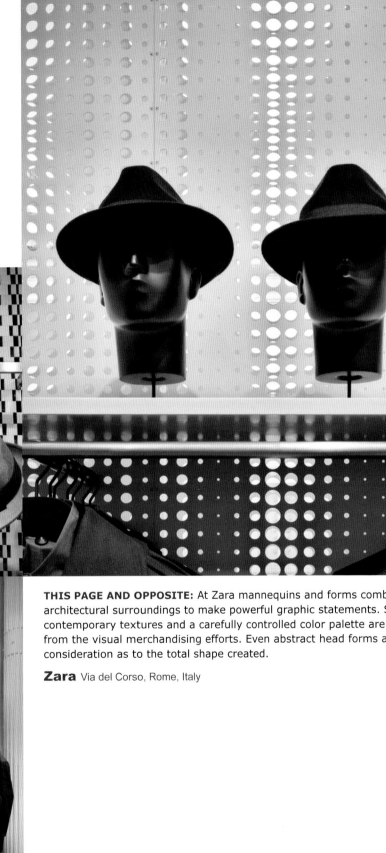

THIS PAGE AND OPPOSITE: At Zara mannequins and forms combine with their architectural surroundings to make powerful graphic statements. Strong lines, contemporary textures and a carefully controlled color palette are inseparable from the visual merchandising efforts. Even abstract head forms are placed with consideration as to the total shape created.

Zara Via del Corso, Rome, Italy

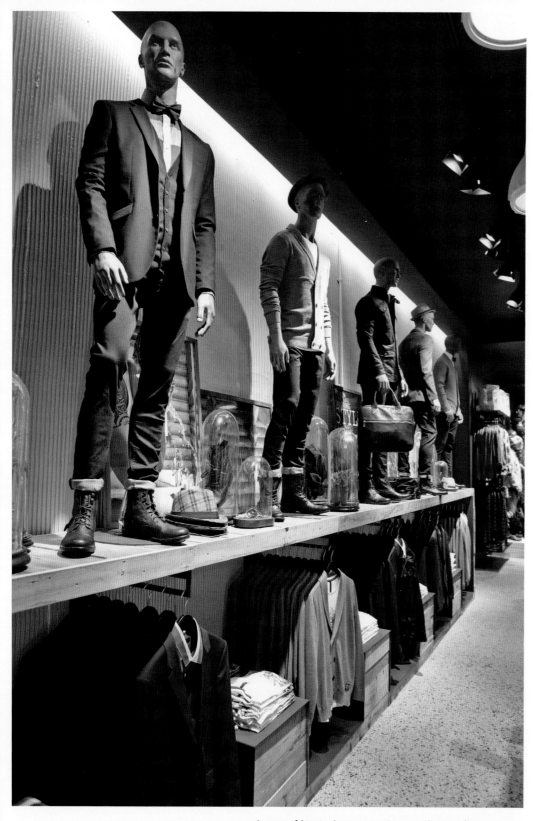

A row of booted mannequins, each standing directly above the front-facing hanging item that they are wearing, dramatically beckons customers to the wall at Jack & Jones. Shoppers across the room can see exactly where that great jacket or cardigan can be found. Accessories displayed under glass are interspersed on the platform and a few plants add some green color.

Jack & Jones Oxford St., London, UK

The height of these two displays attracts attention. In Levi's Women the mannequin itself is elevated, drawing the eye to the upper level of the store. The display also artfully hides a structural pole. In Lola a decorative spiral stair fills the vertical space while an artfully placed mannequin blocks the inattentive shopper from trying to ascend. The stairs also make an excellent place to display accessories and folded items.

Levi's Women Paris, France (left)

Lola Mall of America, Bloomington, MN (below)

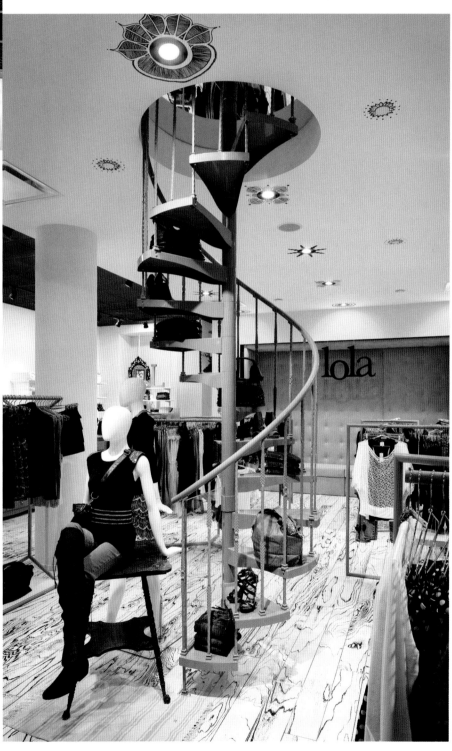

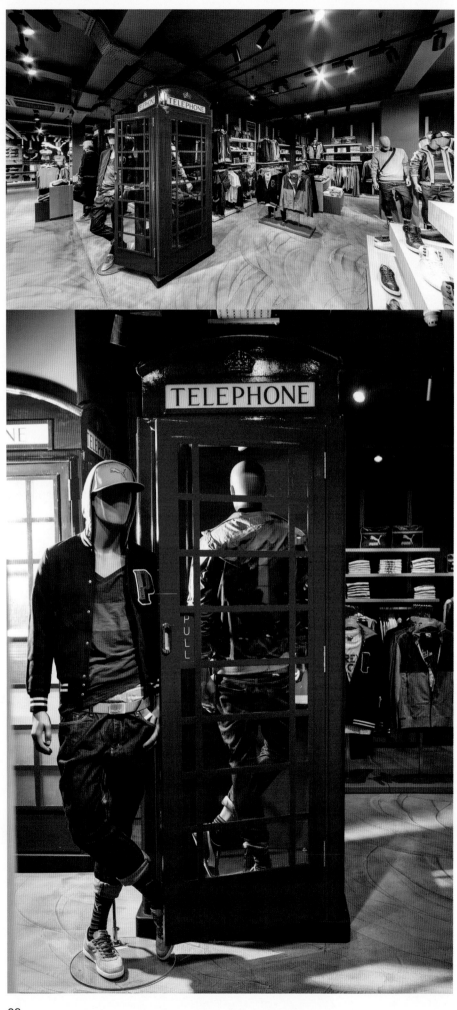

THIS PAGE: The PUMA store in London localizes its brand and ensures attention for its mannequins by placing them in and around the iconic red phone booths for which the city is famous. By happy coincidence, or not, PUMA's signature color is the same bright red.

PUMA London, UK

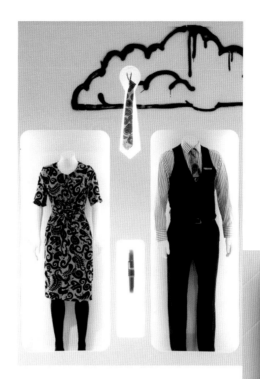

THIS PAGE: Within its minimal décor, Clothes Hanger places its mannequins in wall insets and surrounds them with a glow of light. Accessories are similarly placed and lit, including a tie in a tie-shaped inset. The whimsical cloud above, with its just-drawn-at-this-moment look relates to the store's mission: selling uniforms to employees of Air New Zealand.

Clothes Hanger Aukland, New Zealand

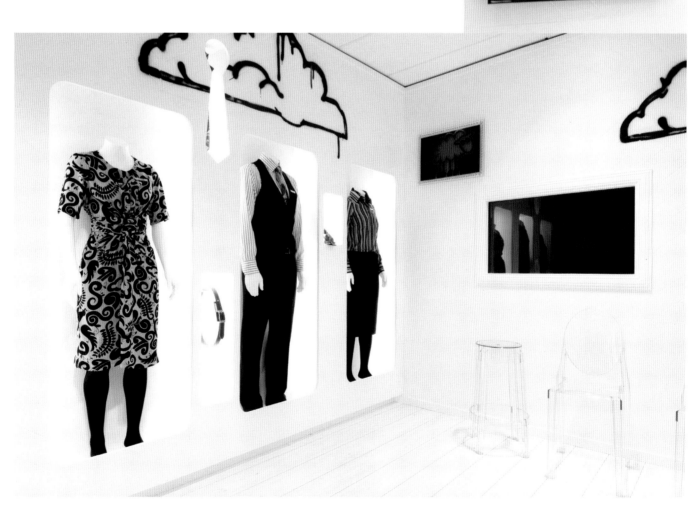

Mannequins help Jenny Lee achieve two levels of realism. The mannequins, placed around the store as if they are just shoppers casually waiting for a friend's opinion, surely generate a few double takes from real shoppers. Meanwhile, propped against the wall are large, silver-framed photos of elegant brides and their parties. The resulting space is surprising and alluring.

Jenny Lee Bridal Shop Newport Beach, CA

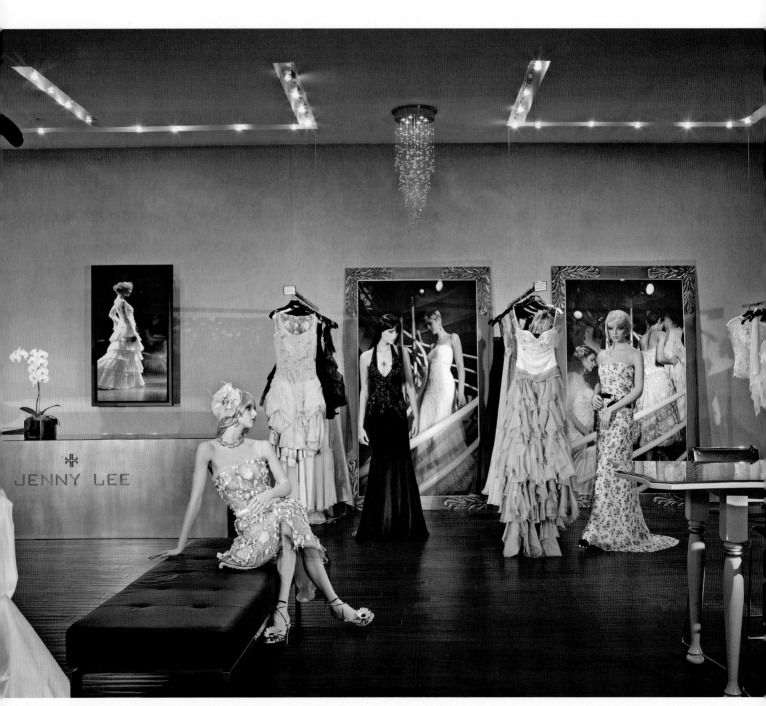

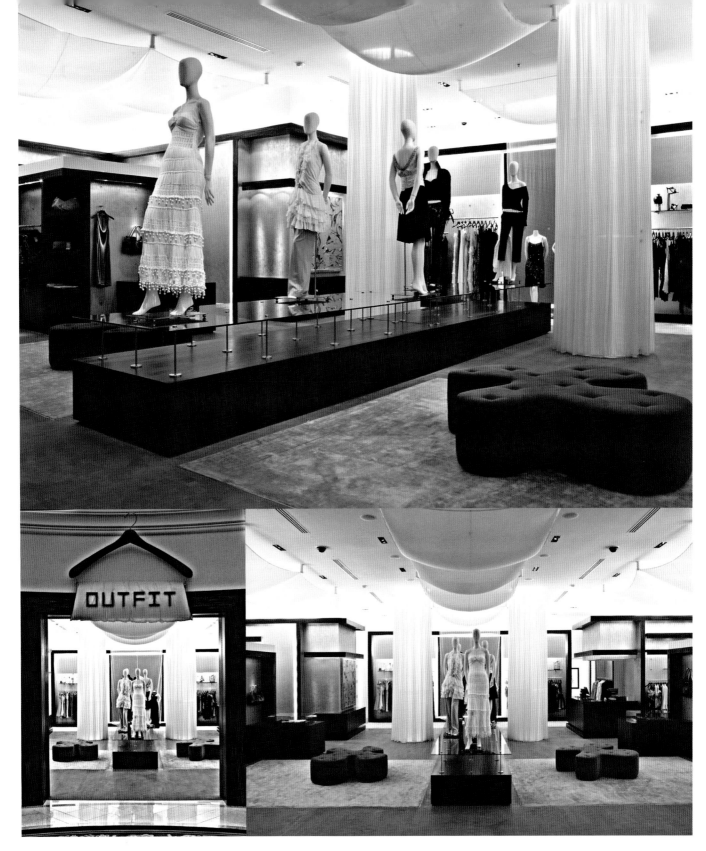

THIS PAGE: Outfit in Las Vegas sends its mannequins down a runway that directly faces the entrance. Runway and mannequins are framed from above and from the sides with swatches of sheer fabric. The display effectively highlights a few select items and beckons to passersby in the Wynn Hotel and Casino.

Outfit Las Vegas, NV

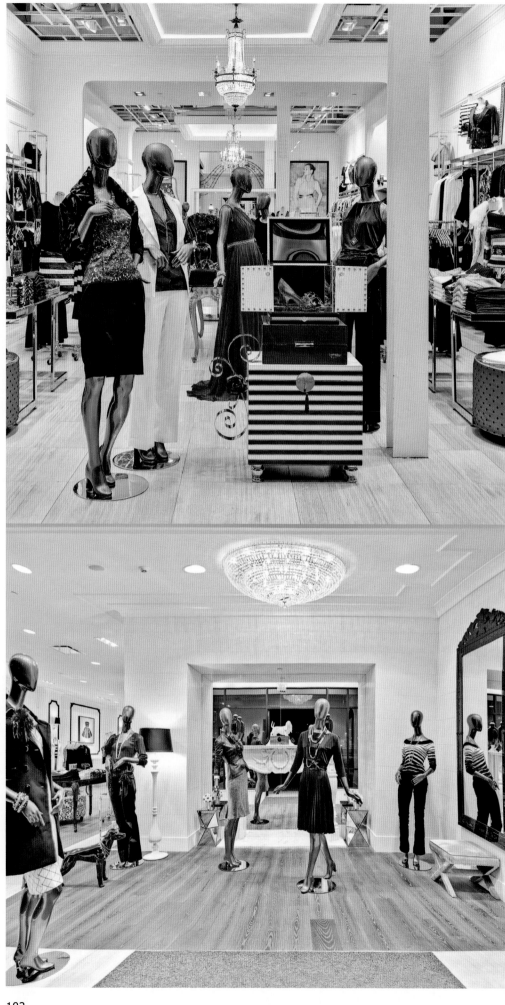

THIS PAGE AND OPPOSITE: Travel bags and trucks and a sparkling Eiffel Tower suggest that the mannequins at White House | Black Market are about to embark on a wonderful adventure. In turn they suggest that the shopper—after being properly attired—can too. Elsewhere an elegant room is evoked. The message is similar; envision yourself in these elegant outfits and in these oh-so-lovely locales.

White House | Black Market

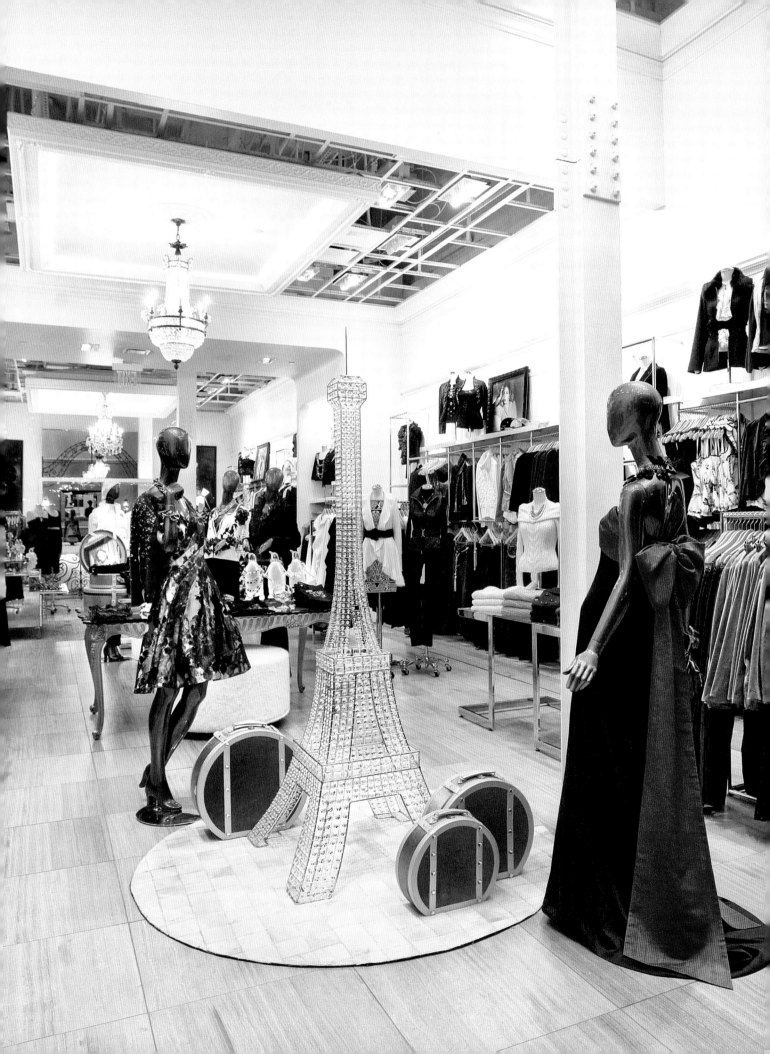

Branding the Fitting Room

Fitting rooms may not be the first place one thinks of at the mention of visual merchandising, however, smart retailers don't overlook the opportunity the fitting room presents to entice shoppers to buy, and buy more. The basics are important: the fitting rooms must be clean, maintained and well staffed. Doors that won't shut properly, lack of hooks, littered floors and disappearing sales associates will drive shoppers promptly from the store.

However, retailers that put time and thought into making the fitting room a pleasant and self-esteem building experience for the customer will certainly be rewarded. Comfortable chairs, an ambience that reflects that of the store, decorations and additional product offerings will ensure that any hard-won brand loyalty will not be nullified at the fitting room door.

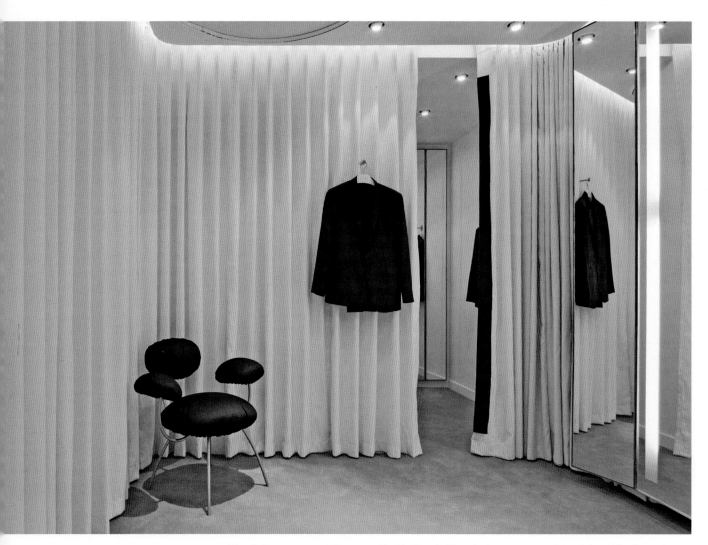

The fitting rooms at Spencer Hart's Brook Street store are consistent in attitude and style with the retailer's dedication to "edgy elegance" and "understated cool"—a dedication declared on the Spencer Hart website and evident throughout the store. The curtains, the chair and the ample floor space all speak to an upscale customer not looking for their grandfather's suit, unless grandpa was Steve McQueen.

Spencer Hart London UK

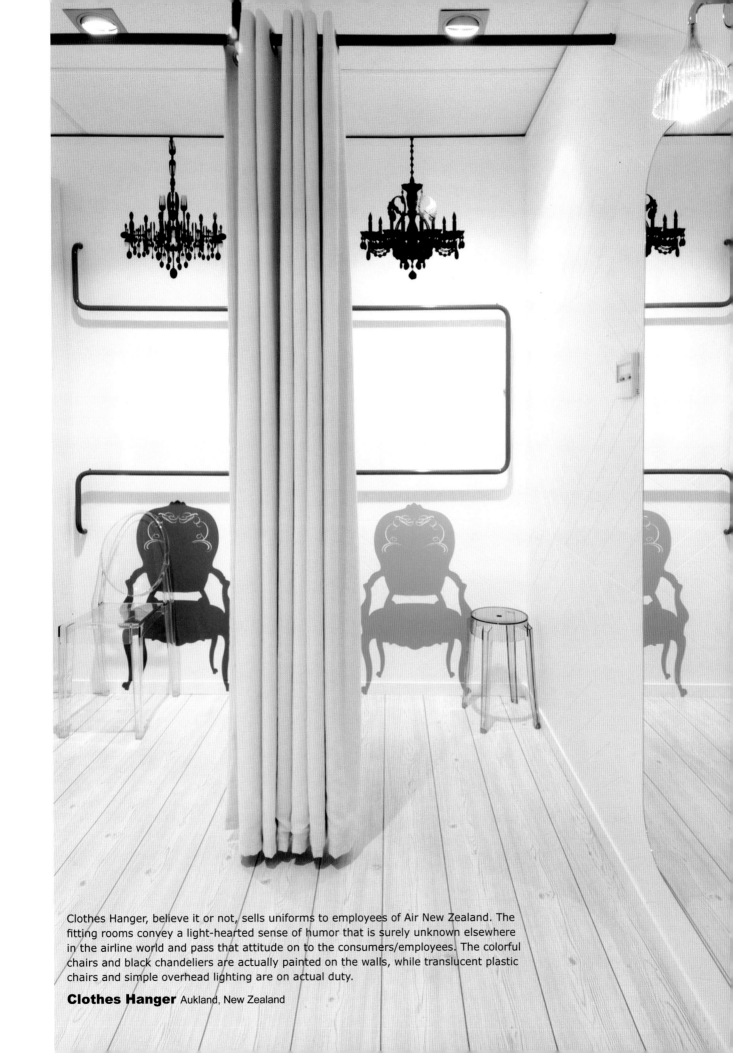

Clothes Hanger, believe it or not, sells uniforms to employees of Air New Zealand. The fitting rooms convey a light-hearted sense of humor that is surely unknown elsewhere in the airline world and pass that attitude on to the consumers/employees. The colorful chairs and black chandeliers are actually painted on the walls, while translucent plastic chairs and simple overhead lighting are on actual duty.

Clothes Hanger Aukland, New Zealand

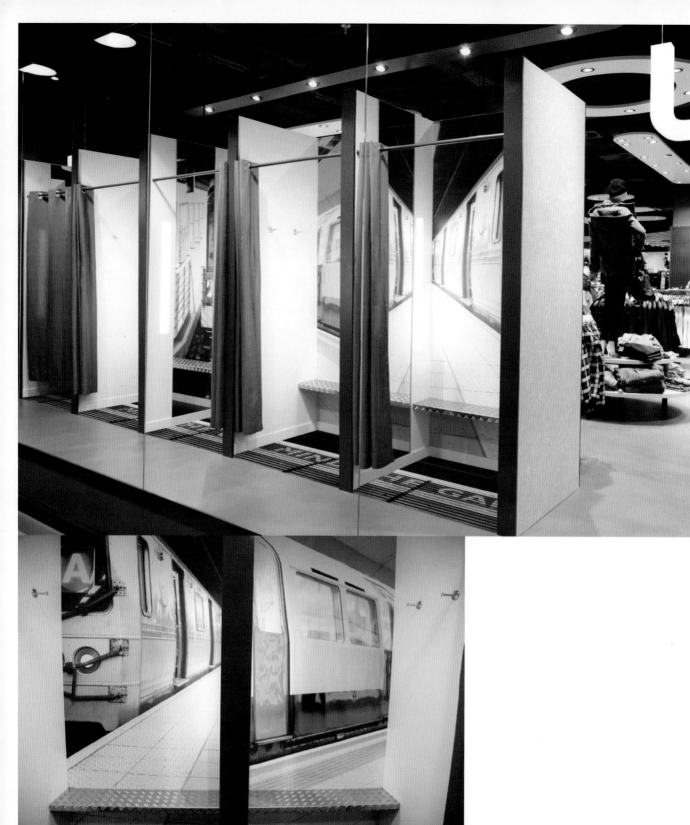

THIS PAGE: Mister*lady, a store in Germany, takes its fitting room customers for a ride on the A train, a line—the longest—in the New York City subway system. The images on the back walls must make a wonderful backdrop for customers trying on the wares. "Just how cool would I look in this outfit in the Big Apple ridin' the A train?" It's pure fantasy, those subway platforms will dampen any look, but fantasy and shopping go together very well.

Mister*lady Nuremberg, Germany

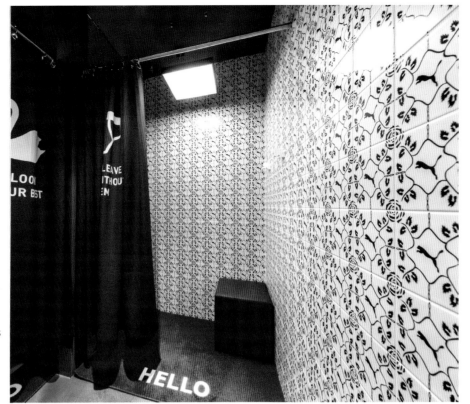

THIS PAGE: The famous personification of the PUMA brand makes its purring self present in the fitting rooms at both the London and Munich stores, below. The London store throws in a local reference to the London Underground (underground transportation systems are in vogue), and in Munich the Bavarian Alps are evoked. Meanwhile in the Amsterdam store, right, the fitting rooms are lined with that region's famous Delft tiles. References in all three stores are both local and brand-wide.

PUMA Munich, Amsterdam and London

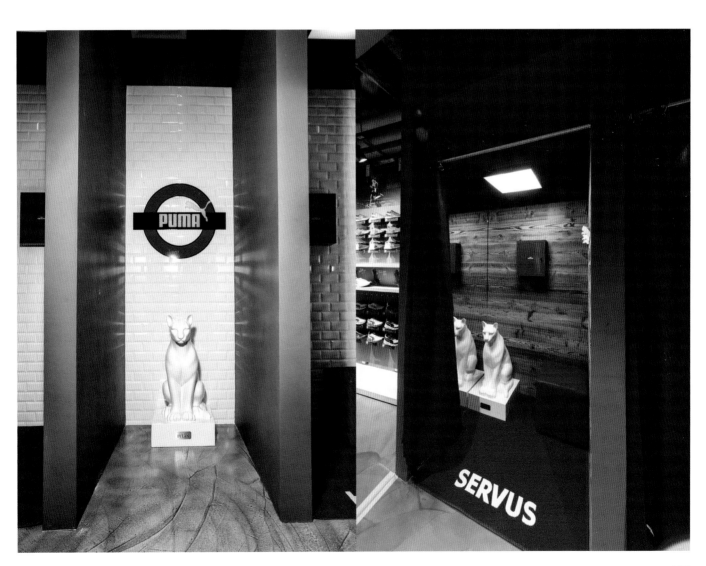

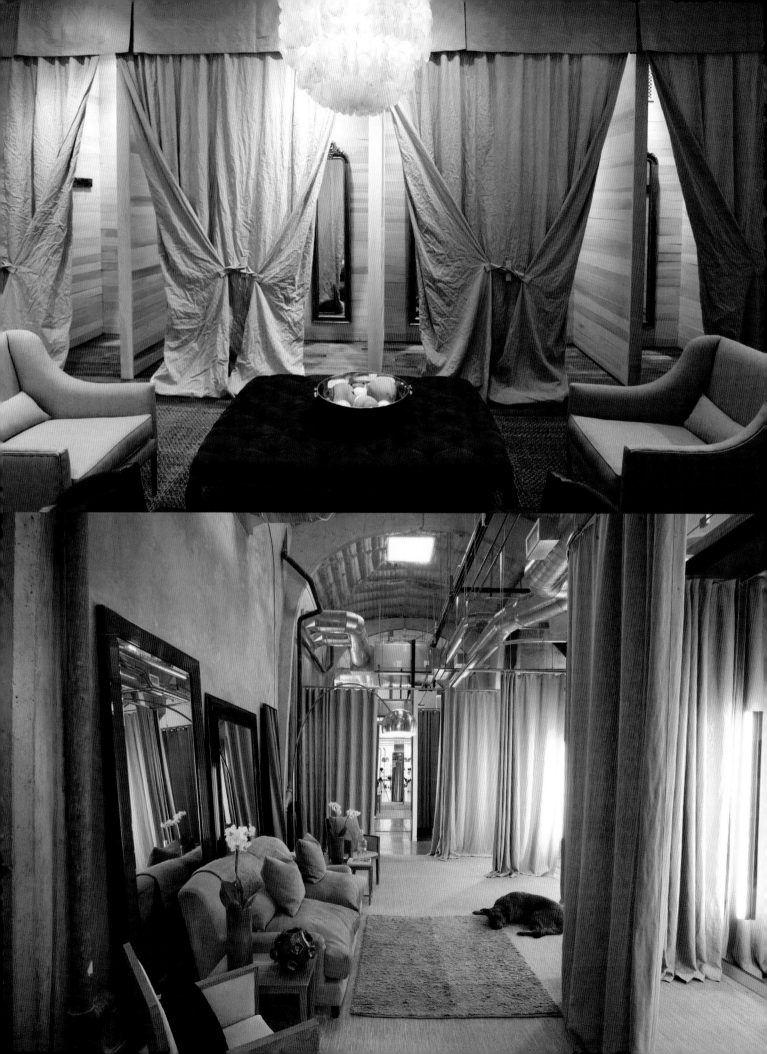

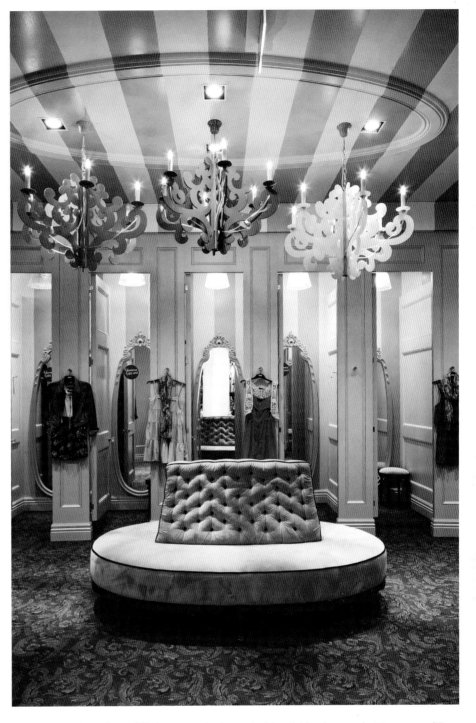

Glassons' high-ceilinged fitting room is decorated in vivid colors and stripes, resulting in a plush, fun-filled setting. Comfy seating and outfit suggestions encourage the retailer's young audience to relax, hang out and interact with each other.

Glassons Broadway Newmarket, New Zealand (above)

The fitting rooms in Calypso St. Barths and A'maree's both surround the shopper in rich, draped fabrics, soft seating, muted colors and even a dog—sumptuousness of a casual chic sort. The retailers—located on beaches on opposite US coasts—are providing pampered privacy in what is surely a close approximation to the targeted customer's dream home.

Calypso St. Barths East Hampton, NY (opposite page, top)

A'maree's Newport, CA (opposite page, bottom)

THIS PAGE: Princesse Tam Tam, a lingerie retailer, provides its customers with a contemporary cubicle for the all-important undies try-on. Inside are an ample number of wooded pegs for hanging merchandise, and shelving units offer additional product suggestions. Lighting is subtle, not the bright, unflattering light that might jar the sensibilities. Never underestimate the value of providing the little niceties.

Princesse Tam Tam Paris, France

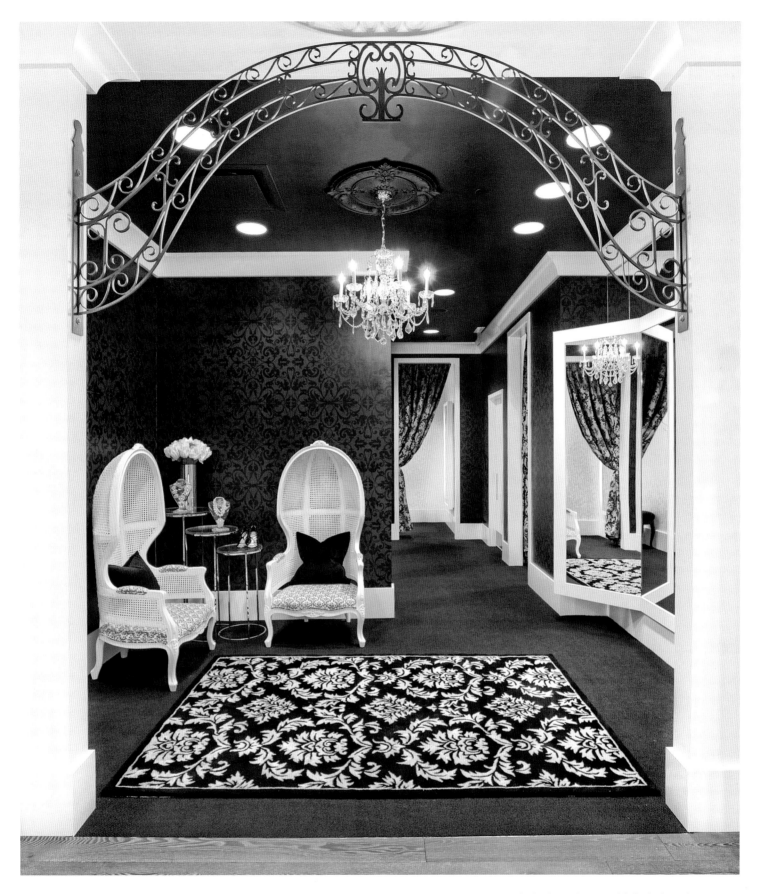

While it's not surprising that White House | Black Market would deck their fitting room out in black and white, they've done that and so much more. The ornate entrance arch, playful patterns, wicker chairs and large space invite the shopper inside with graciousness and wit—words that could describe the brand as accurately as the color references in its name.

White House | Black Market

INTERVIEW:
Kenneth Lee
Tommy Hilfiger Europe

Kenneth Lee is the Director of Store Windows and Visual Merchandising for Tommy Hilfiger Europe, located in Amsterdam. He began his career at the Gap where, over the course of ten years, he went from sales associate in Vancouver to overseeing 100 locations from the retailer's European headquarters in London. Before joining Hilfiger in 2008 he worked in VM projects for store design and marketing at Marks & Spencer, and then at Esprit—both in London. From 2006 to 2008, Ken was the Global Manager of Visual Merchandising for MEXX in Amsterdam. A role in which he first actively set the creative direction for a brand. The editors of Retail Design International recently set down with Ken at their offices.

What are your responsibilities at Tommy Hilfiger Europe?
Amsterdam is Global Headquarters for Tommy Hilfiger. All the merchandise design, marketing concepts and creative for Europe, Middle East and Asia comes out of the Amsterdam office. The head office in NYC oversees North America, South America and our international market as well.

My department branches into three main areas: One is what we call creative R&D (research & development) and it includes art installations, graphics, posters, taxidermy, special and hand-painted items, fitting rooms, fabrics (cushions, curtains, wallpaper)—all of these things I like to call 'icing on the cake' for our stores. The second area is store windows. We, along with the New York team and the marketing department people, look at the seasonal ad campaign and concept the seasonal windows, first for our international flagships and anchors, then down to our other stores and franchise locations

The third area that we are responsible for is visual merchandising. We set the guidelines each season for the stores—how the merchandising should look from the walls, to the tables, and the in-store displays. I have teams looking after each of the three areas. We work very closely with the New York global team to make sure that our global direction for windows and visual are consistent and we create one global vision for the brand.

Do the ad campaigns determine what you are doing?
What we like to have is a global 360 approach for the customer to see—from campaign to billboards, through to windows and in-store. We take the ad campaign as our inspiration, or our starting point, for our in-store and windows each season. So there is that link.

Do you do the creative work yourself?
Our procedure is as follows: first we will sit with the seasonal brief that marketing gives us. We'll find out a few months before they shoot the campaign what the theme is going to be—for instance, this past season it was "prep camp." We have everything in front of us, even the location where they are going to shoot, but we don't have the actual ad campaign.

A select group from our Amsterdam and New York teams will sit in our conference room in Amsterdam for two days and thrash out ideas. Everyone is asked to bring their best-of-the-best ideas for in-store and windows to the meeting. Whatever they think prep camp means to Tommy's image of American Classic Cool. They'll do the same in New York. We then pow-wow over a video call with Trent Wisehart, our Global EVP of Creative Services, and everyone presents their ideas. The group then picks out the two or three best ideas.

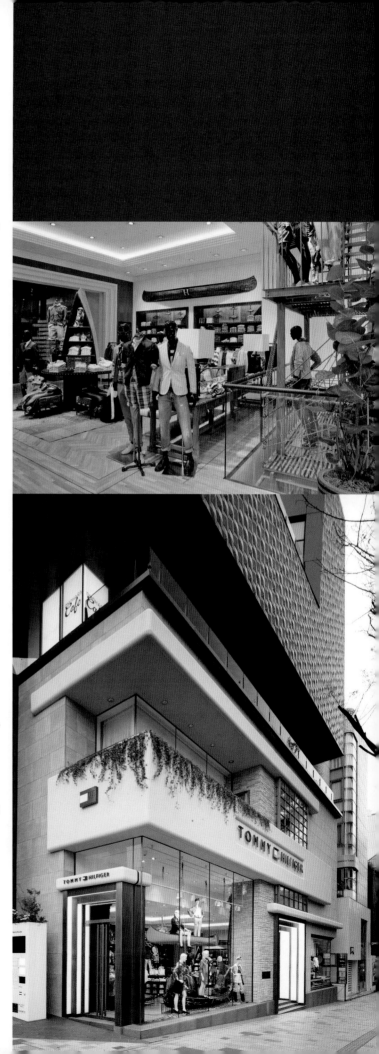

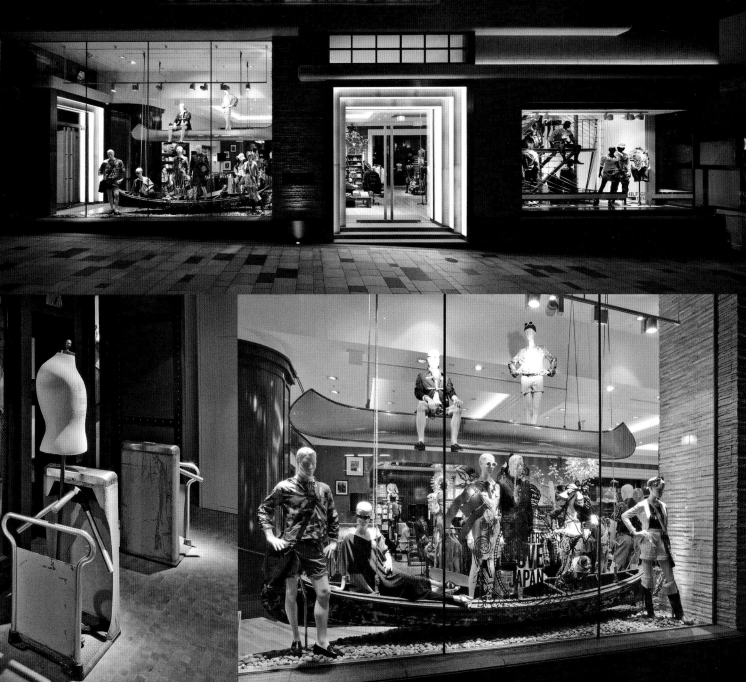

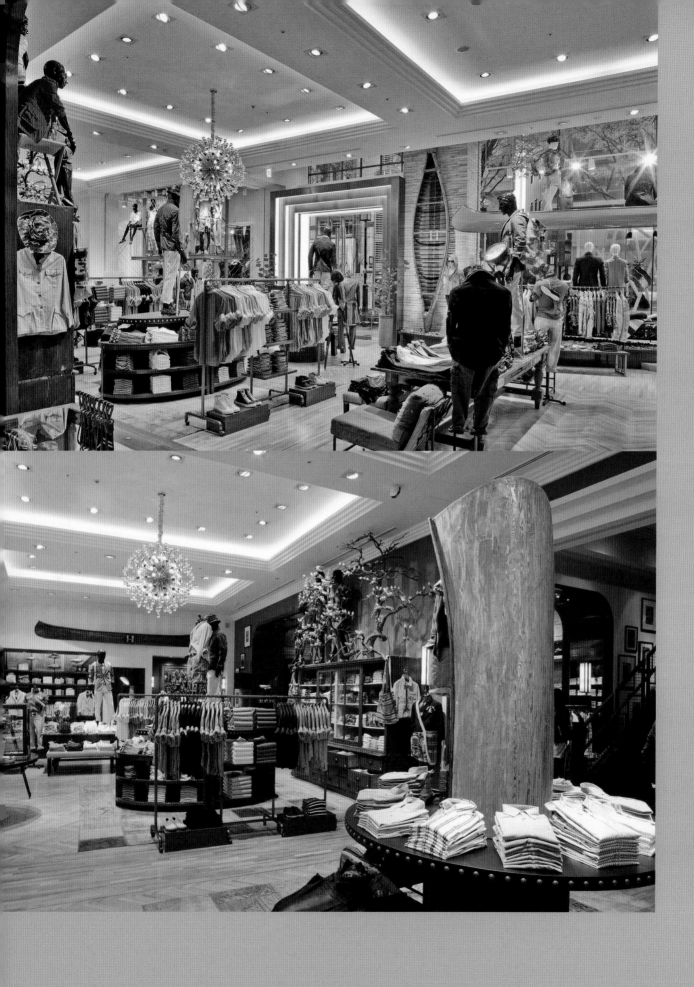

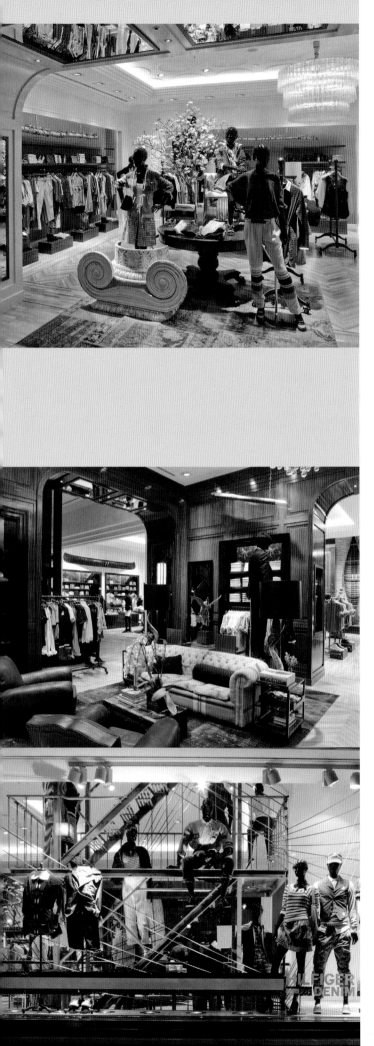

Do you modify elements for Europe and Asia?
Yes we do. Certain propping or colors, or certain themes perhaps, don't resonate with certain markets in Europe. We also have some limitations for what we can show in the Middle East. There are, for each market and each continent and sometimes for each country, some limitations.

Does each store have a visual merchandising person?
Depending on the size of the store and the sales volume, they do. They might have a full-time in-store visual merchandiser and he or she would report to an area coordinator in charge of 10 to 25 locations. Then this coordinator, depending on the size of the country there might be several of them, would report into one VM Manager or Head of Visual for one region or country. So the individual stores "dot line" into us, they don't report directly to us.

Do you make a book for them?
Yes, every season we have a set of visual merchandising guidelines. This gives all of the in-store information—Menswear, Tailored, Womenswear, Denim Men, Denim Women, Kidswear. We shoot the images in our global sales showroom in Amsterdam after having looked at the retail buy for the season and picking the best of the best. Then we create, from a VM point of view, the best wall set up, the best table set up. We also select the top eight mannequins for the season and we rank them from one to eight, "must, must, must, must and these are the extras." All of this turns into a 60-plus page book that gets sent to owner operated stores, franchise stores, outlets, and what we call shop-in-shops. Galeries LaFayette department store in Paris, for instance, would receive men's guidelines for the Menswear areas. This goes out twice a year, spring/summer and fall/holiday and it's for VM in-store.

The windows are a separate story. We create them separately with our windows team and provide a step-by-step document with very detailed instructions. We try to make it as user-friendly as possible.

How do windows and in-store relate to each other?
If a customer sees a billboard and then comes in and looks at the window there should be a link. This past season for example, our Hilfiger family went camping. So, in a large number of our stores we had a canoe. We had oversized fish lures hanging in menswear walls and bird-watching binoculars on the womenswear walls. Each prop has their own unexpected Tommy twist to it

What is the difference between in-store and window display?
What we're trying to do in the windows—certainly in the larger stores—is give the customer that stop/pause moment, that mini wow. Perhaps it's an art installation or something oversized, something that enhances the look on the mannequin.

When you're in-store you have a lot more area to cover so those big installations may not be as effective. In-store should speak more about the product. The customer shouldn't necessarily be walking into only wow visual moments, because the front table should be commercial—next to your 14 colors of chinos or your eight blue shirts. There is more of that balance, in-store is perhaps 70 percent commercial and 30 creative. Whereas the windows, at least in these top stores, should really 80 creative and 20 commercial or in some cases even 90/10. When you walk in store there should be that balance. You look at that canoe, the fish, the binoculars and you get that it relates to that beautiful family in front of the camper van. But what really should speak to you is that beautiful wall of runway dresses, or the trench statement, or 20 colors of polo shirts.

What were your responsibilities for the new Tokyo flagship?
For new stores part of my role is to sit with our store design team and look at fixturing and the store build. We work very closely with Trent Wisehart who oversees global store design and global store windows and visual merchandising. We recently opened Asian flagships in Hong Kong, Tokyo and Osaka, and for Tokyo specifically, we were responsible for helping to concept the windows, taking what we had already executed in Europe and cranking it up a few notches.

My team also develops the layout of the in-store, the merchandising

and the special propping. There are also what we call found pieces. There are lamp sets from Antwerp, door handles from London. A lot of items are bought in the US and then shipped to the Netherlands where it gets labeled, tagged, photographed and measured before it goes to our warehouse. Then, when we are working on a store design, we have walls of cabinets, walls of tables and lamps to pick from and place on the floor plan. They eventually get shipped from the Netherlands to the stores.

Do you buy for all the stores at one time?
We do. We purchase the mannequins either in bulk or one-off orders for special production. For example, the new Tokyo store has the newest of everything, in terms of mixing the darker and lighter mannequins, hard vs. soft forms, heads vs. no heads. Those we can order from our warehouse were we have bulk quantities. For special productions we just call IDW, our good friends there, and say, "Doris, I need this." We've been working with them for years and I worked with them at Esprit and also at MEXX, so our working relationship goes way back.

For the seasonal propping—all the fish, binoculars, those special half canoes—we order our bulk for Europe and then what happens is, Macy's for instance, will tag on to our order. Going forward the new Asian Flagships will also tag on to our order.

Tell us about your background and how you started?
I was born in Hong Kong and my family moved to Vancouver when I was eight months old. I went to university there and received a degree in finance and marketing. As an only Chinese son you're supposed to be good and become a doctor, lawyer or banker. Retail wasn't really in my blood.

During my third year at university I worked a few hours here and there at the Gap, just selling. I really liked the philosophy of the company, it was a great retailer and such a great place for training. After graduating, while I was working at an insurance company, I went back to the Gap three days a week. I had a full-time suit and tie job during the day, then took off at 6:30, ran to change into my pocket-T and chinos. There I was selling shirts off of that front table.

Some nights I would do what they called "flip outs," changing mannequins or a window or doing the new collections in front. I started dressing a mannequin here and there and the store manager said, "Wow, where did you learn to do that?" And I said, "Well, I just looked at the picture on page 8 of what they sent you."

We were in the main store on Robson Street in downtown Vancouver and people would fly up from the San Francisco office and visit us. The VP of visual started noticing our windows and asking who was doing it. I was introduced and one store turned into two stores; 10 hours a week on top of my full time job turned into 15 and 20, and six months down the road I got a full-time job offer to window dress and do in-store visual for three locations. This meant less pay and it didn't have anything to do with my schooling, so I told them I wanted to take the job for one year. They gave me a year, and the year turned into 15 stores in western Canada and in another year down the line I was given the chance to go to Germany when the Gap opened their first store in Düsseldorf.

I stayed there for six months as a VM trainer before moving back to Vancouver and picking up 30 locations in western Canada. Then it was back to Germany when they decided to expand and I was head of visual for about 10 to 12 stores. For two and a half or three years I lived between Dusseldorf, Cologne and Munich. I was then asked to move to London, which was the European headquarters for the Gap, and look after about 100 locations. I said "London, are you kidding me?" Of course, I went there and did another year and a half. I had spent about 10 years at the Gap when the London office moved to a place called Rugby, an hour and a half from London. I hadn't moved to London not to live in London, so I went to Marks & Spencer for about three years and then on to Esprit and then to MEXX.

I joined Hilfiger Europe in September 2008 as Director of Visual Merchandising. At the time they also had a Director of Windows. For me this was the very first company in which the roles were split and I had questioned that during the interviews. Three months after I joined, the two departments were merged and I inherited windows.

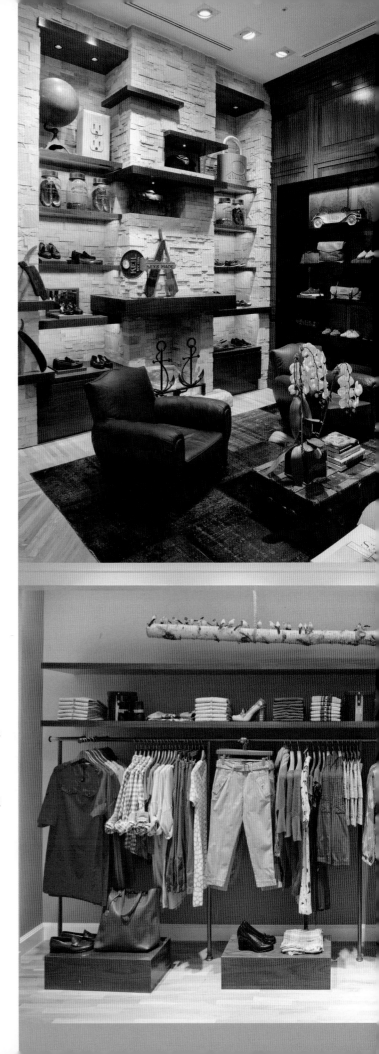

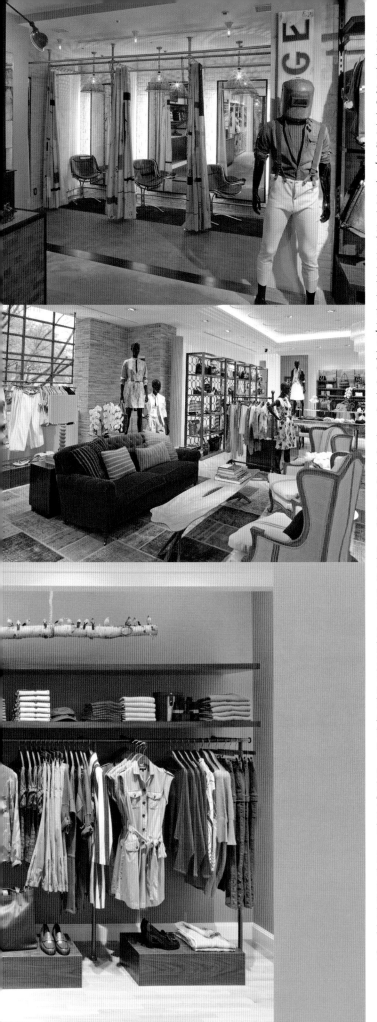

Do you think they should be merged?

I definitely think they should be merged. It should be one vision for the brand. You can have different departments doing their specific roles, but I think, from a brand perspective, it comes across so much stronger if there is one group of a limited number of people who oversee everything. At that time we were four or five people, now we're 18. In the meantime we have been working strongly in partnership with Marketing and PR on projects throughout the year - special events, pop-up shops, showroom set-ups, Tommy Hilfiger appearances. We're not just stores, it's now many other projects seasonally.

What are the different talents needed to do your job?

My ideal VM manager would be creative and by that I mean they would understand the brand. That may take six months to a year, but for the right individual I'm willing to give them that time frame to develop. You have to have the creativity and you also have to have commerciality and understand that we are not just "dolly dressers"—as some people call it to this day. We make things look pretty, yes we do, but pretty takes time, it costs money, it takes talent, and it takes the right people to execute. We make the stores look amazing, but we also have to make that product look appealing to whoever comes into the store. It's not just about stacking things. It's also, how many size runs to you have? How do you replenish? Are you doubling up on your best sizes? If you're hanging six shirts why are you doubling the small when properly you're selling more of the mediums and larges? A visual merchandiser must understand all of these things. I say these things because that's where I started, I had great trainer, who trained me at the Gap on those basics.

For my specific role, I have to be creative, yes, but I also manage a team of people, understand the brand, think about the costs and the quality, and ensure that everything we execute represents the brand the best way we can. At times it's difficult, but I really don't like to show the team any unnecessary stress. I'm a firm believer in telling someone right away if I think something looks great and is well executed. If I see something going awry, or I have a question, I'll also say something right away.

For me work never really stops. When I'm in down time cycling around Amsterdam looking at vintage antiques—because I personally love to do that—I am thinking, "Wow, this would look amazing as part of the next campaign." Part of being successful in our business is to always have that ticker going in your head, of what could be the next idea.

Do you have any advice for someone wanting to come into the business? Where do you suggest they start?

I would say get some experience in retail. Work in a store to understand how a store operates including the back of house. Spend time with the stock guys. How do you receive shipment? How do you crack open a box? How do you tag a shirt? How much time do these things take you? Also spend time in a store selling—work in the fitting room, understand the customer. All of that helps you as a visual merchandiser. In my opinion getting some retail experience is about a third of it.

Another third is to really have an active interest in what's going on in retail. Look at your competitors; know your clothing; know your look; know the brand that you're working for and what it stands for. The final third is to just hone your craft. If you are hired as a visual merchandiser, work hard—keep cuffing that cuff, keep pinning that blazer. Keep doing it until you do it right and it looks 'perfect'.

When I interview these days—I want to say young kids 21 or 22— I ask "What's your dream job?" And I get frustrated when they say, "I want to be creative." I'm 40 and I still vacuum to get a store ready. I don't mind doing that because I love it. You have to understand what the job entails and it entails everything. You must be willing to work hard, get ready for long hours—work hard and have a love for what you do.

Thank you, Ken, for taking the time to talk to us.

Shoes and Leather Goods

Shoes, glorious shoes—and other leather goods—have long been consumer favorites. And yet, these items so prized by shoppers get a boost with an exciting and careful display. The retailers on the following pages create complete environments to showcase their offerings. The large number of relatively small items that must be displayed may present a challenge, but it's also an opportunity to experiment with shelves, display cases and tables. A shoe department can have many arrangements, color schemes and moods.

As important as the displays are to a shoe store or department, the consumer is just as vital. The environment is as much for the shopper as for the shoes, and his or her comfort and wellbeing must be carefully considered when choosing the seating and planning the layout. A successful space pleases both shopper and shoe.

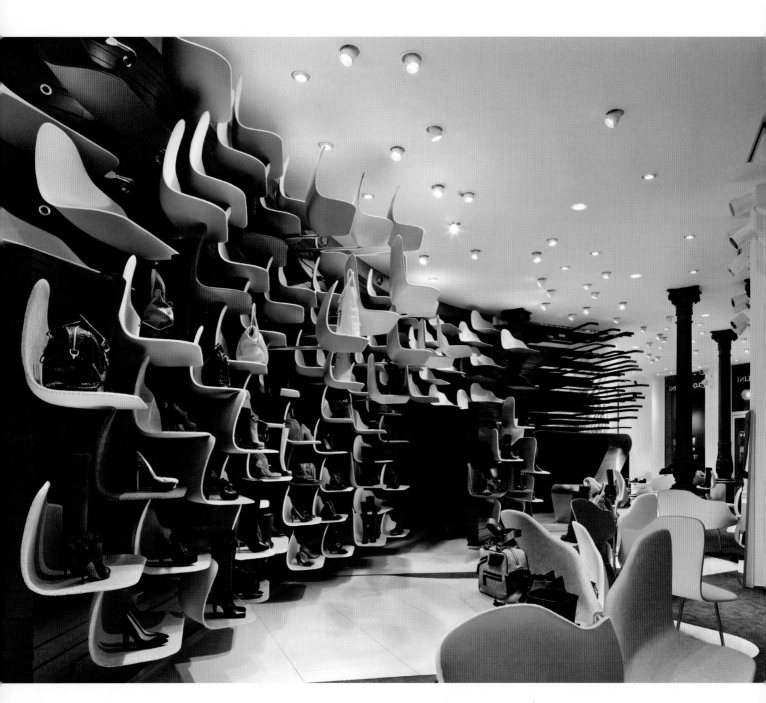

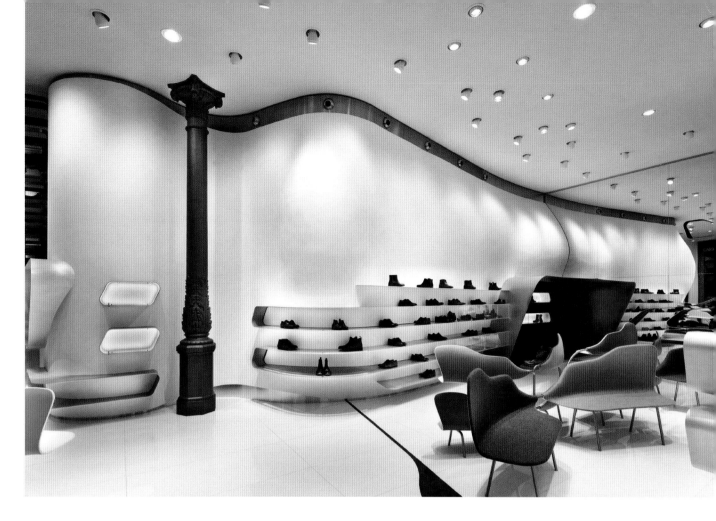

THIS PAGE AND OPPOSITE: The "wow" factor may be an overused term, but it certainly applies to the Carlo Pazolini store in Milan. Shoes and other leather goods sit on their own brightly colored bench-like shelves. The result, when seen close up, is something like an abstract painting, or sculpture. The orange and green, and occasional yellow, pop from the otherwise white and dark brown interior. Elsewhere in the store a futuristically curved structure is doubled in size by the careful placement of a mirror. Contrasting the modernism are flourishes on the columns.

Carlo Pazolini Milan, Italy

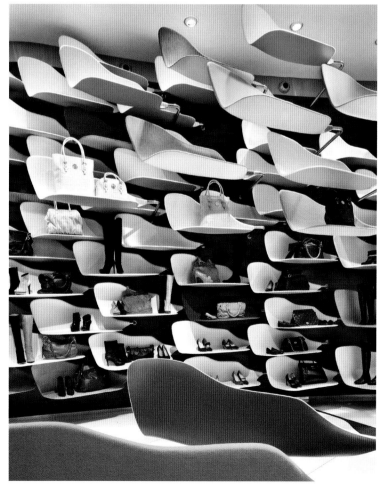

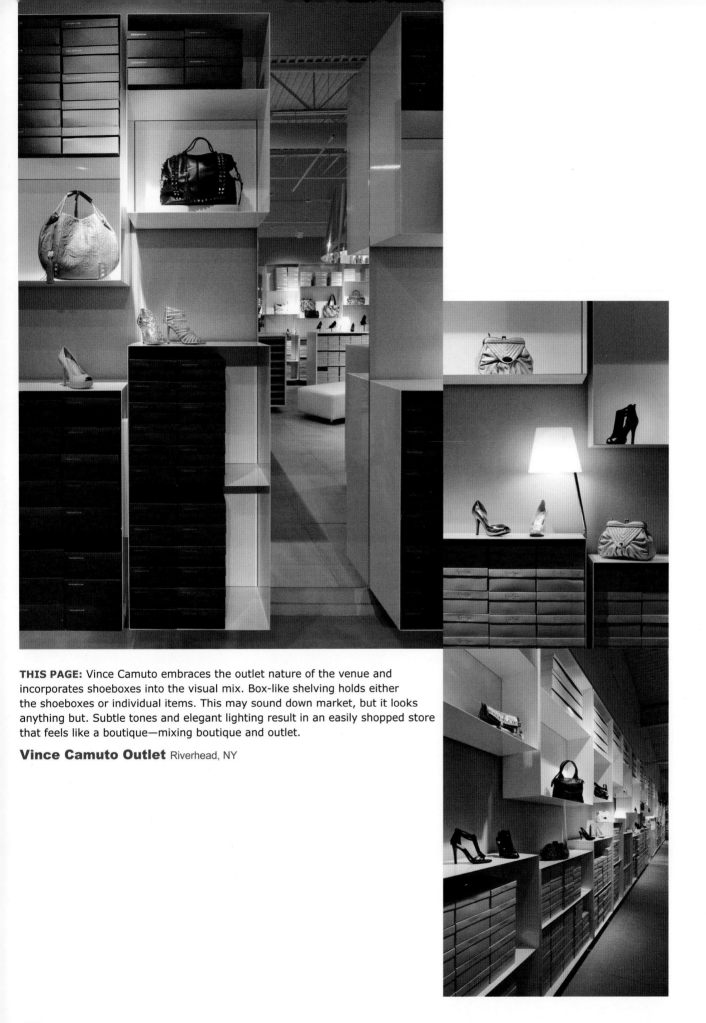

THIS PAGE: Vince Camuto embraces the outlet nature of the venue and incorporates shoeboxes into the visual mix. Box-like shelving holds either the shoeboxes or individual items. This may sound down market, but it looks anything but. Subtle tones and elegant lighting result in an easily shopped store that feels like a boutique—mixing boutique and outlet.

Vince Camuto Outlet Riverhead, NY

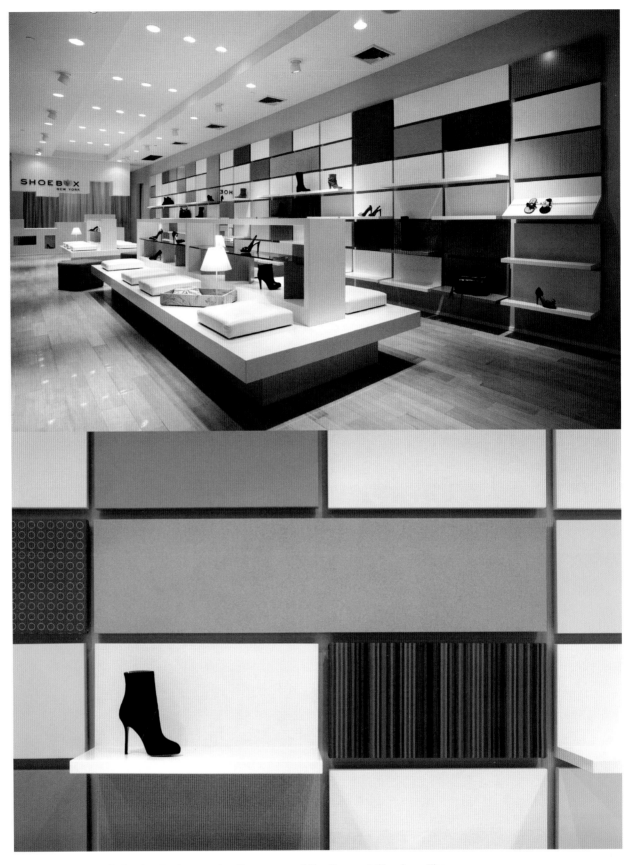

THIS PAGE: A grid of color, texture and pattern support the items at Shoebox. The display system allows for each panel to be repositioned so that the look of the design may be periodically altered. The bench in front continues the grid theme, this time in white-on-white with square seating cushions positioned on the low table.

Shoebox Greenvale, NY

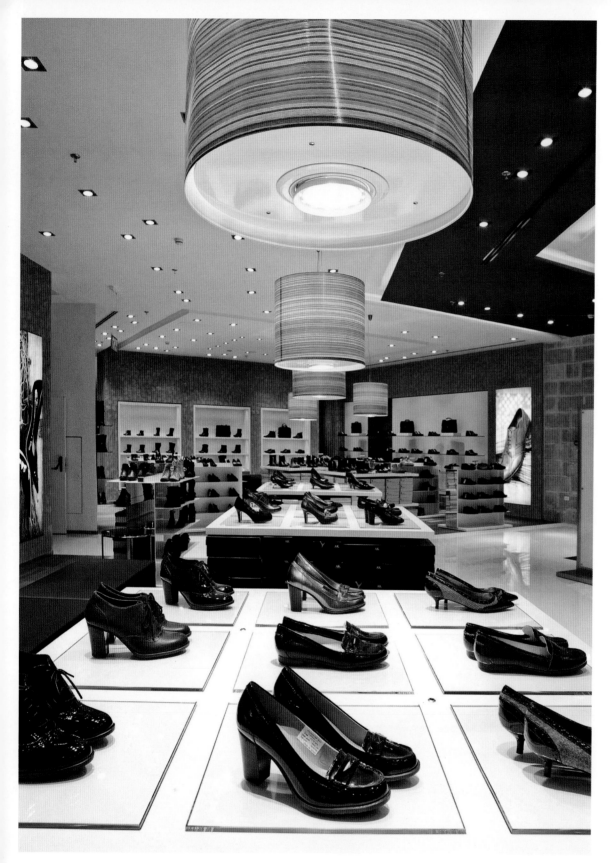

Each pair of shoes sits neatly in the middle of its own square of glass in the shoe department of Hamashbir Department Store. Light from directly overhead makes the shoes shine irresistibly. It reminds one of the clicking together of magical toes.

Hamashbir Department Store Jerusalem, Israel

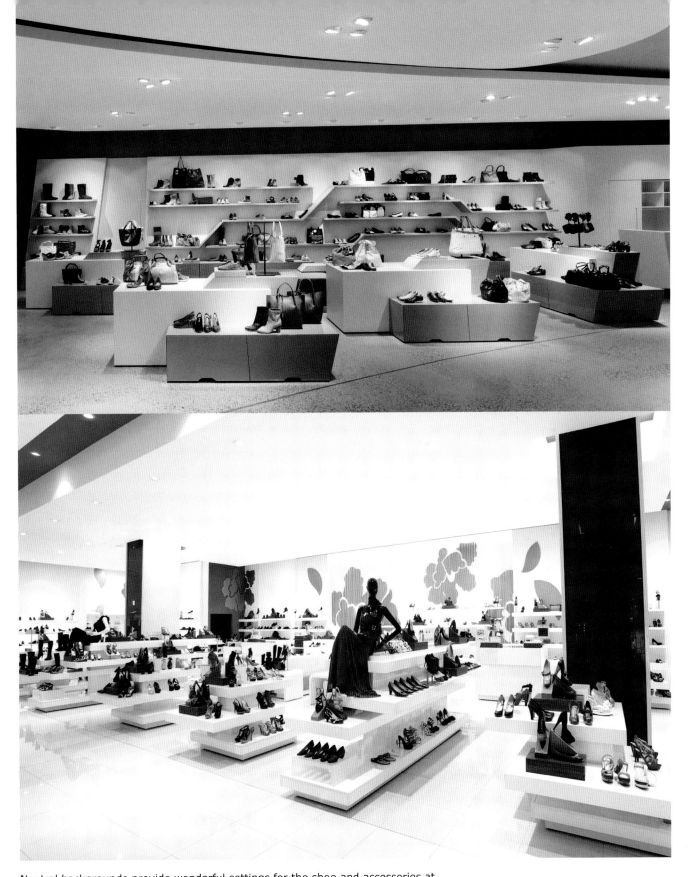

Neutral backgrounds provide wonderful settings for the shoe and accessories at Blijdesteijn and Liverpool. Visual interest is added in Blijdesteijn with shelving and display tables that are not quite square. The leans and tilts are subtle but capture the eye. In Liverpool the white display units, constructed of slab-like elements, are tiered and terraced and hold the items at various heights and orientations. The wall decorations draw customers to the rear of the space as the bright pink gown adds a point of strong color and gives context to the high heels.

Blijdesteijn Tiel, The Netherlands (top)

Liverpool Mexico City, Mexico (bottom)

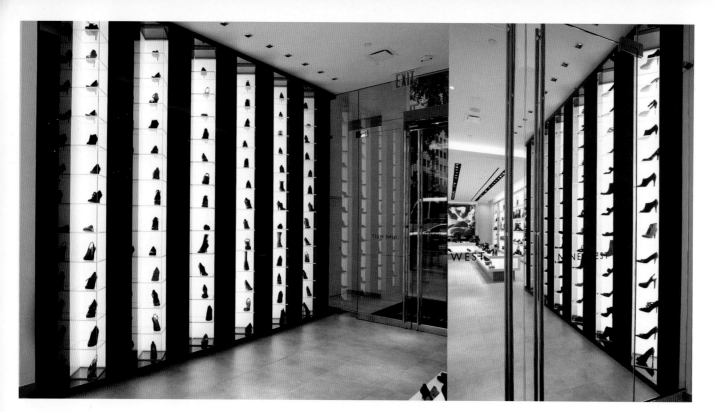

THIS PAGE: Customers entering Nine West walk beside a floor-to-ceiling showcase of shoes. Ensuring they find their way into the rest of the store is a large, colorful graphic on the rear wall. In between is the store's main merchandise collection. Shoppers are very effectively moved through and around the store.

Nine West New York, NY

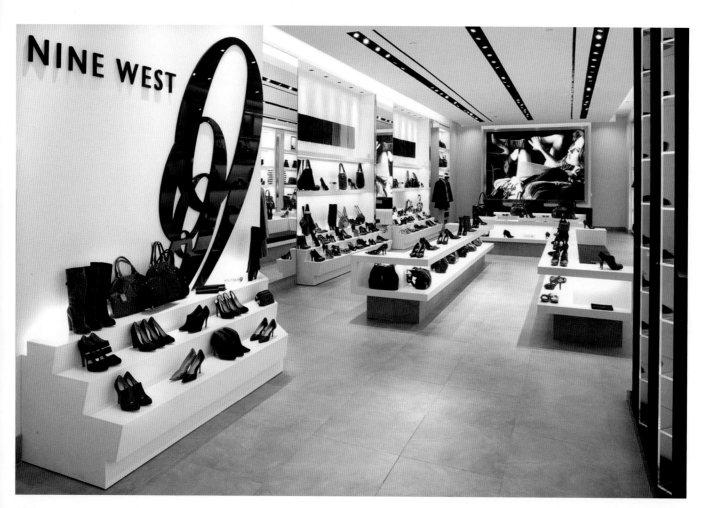

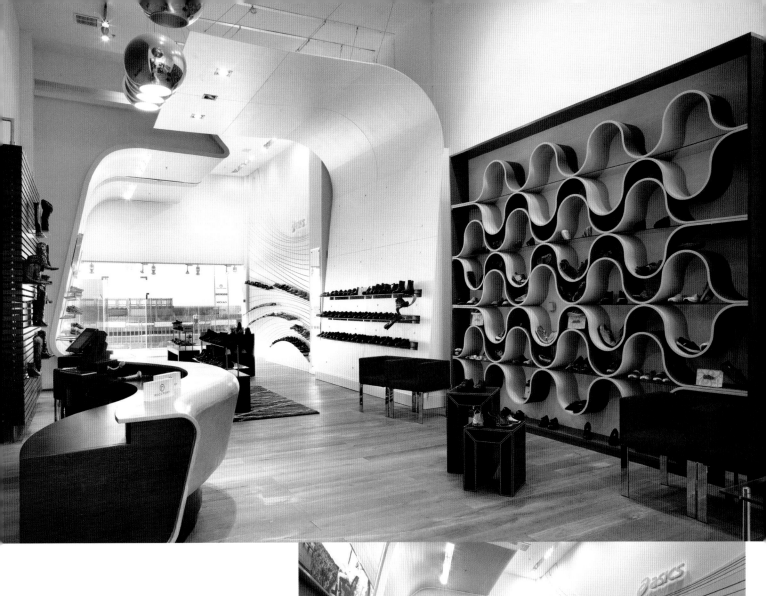

THIS PAGE: There are straight shelves in Originals, but they are contrasted with two wall-filling display units of bends, swirls and twists. Items are tucked in the crevices and curls, inviting shoppers to play search and find. The ceiling and checkout counter add bends of their own to the space.

Originals Ramat-Aviv, Israel

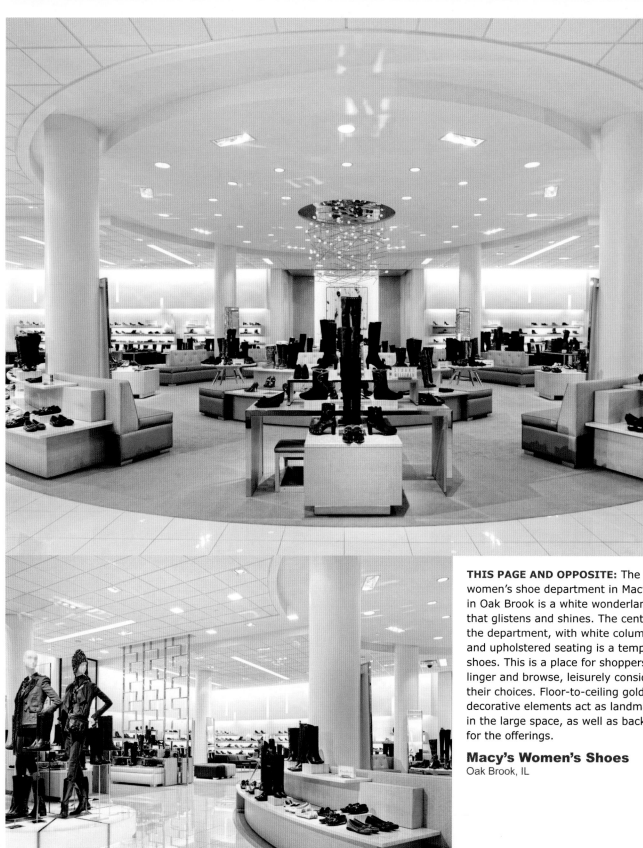

THIS PAGE AND OPPOSITE: The women's shoe department in Macy's in Oak Brook is a white wonderland that glistens and shines. The center of the department, with white columns and upholstered seating is a temple to shoes. This is a place for shoppers to linger and browse, leisurely considering their choices. Floor-to-ceiling gold decorative elements act as landmarks in the large space, as well as backdrops for the offerings.

Macy's Women's Shoes
Oak Brook, IL

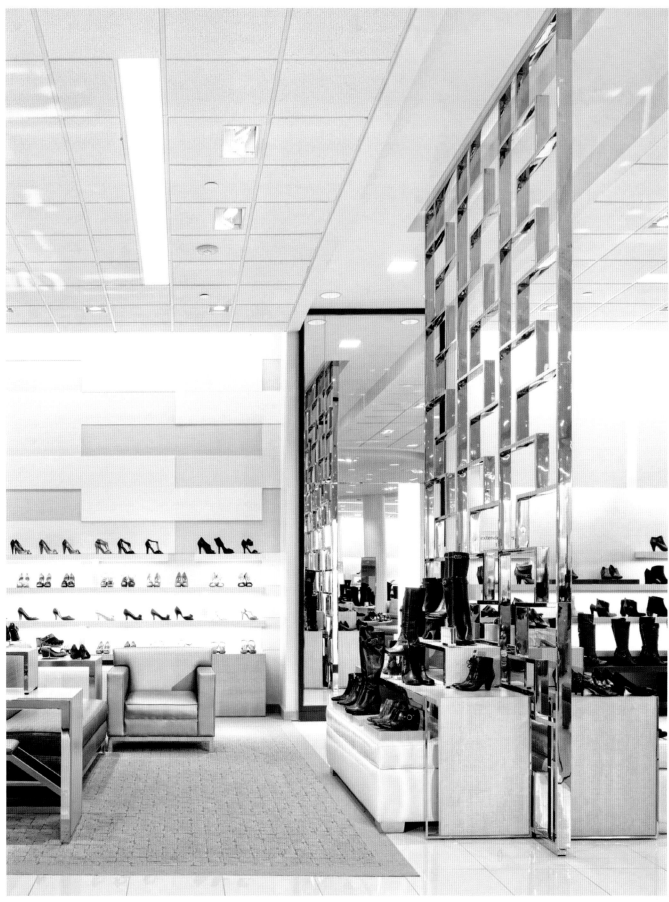

THIS PAGE AND OPPOSITE: Hirshleifer Shoes creates a cohesive environment for its fine footwear. Yet within the controlled design there is much variation. Wall units of red or white are contrasted with curtains and mirrors. A twisting overhead neon light is echoed in a textural design etched into a wall.

Hirshleifer Shoes Manhasset, NY

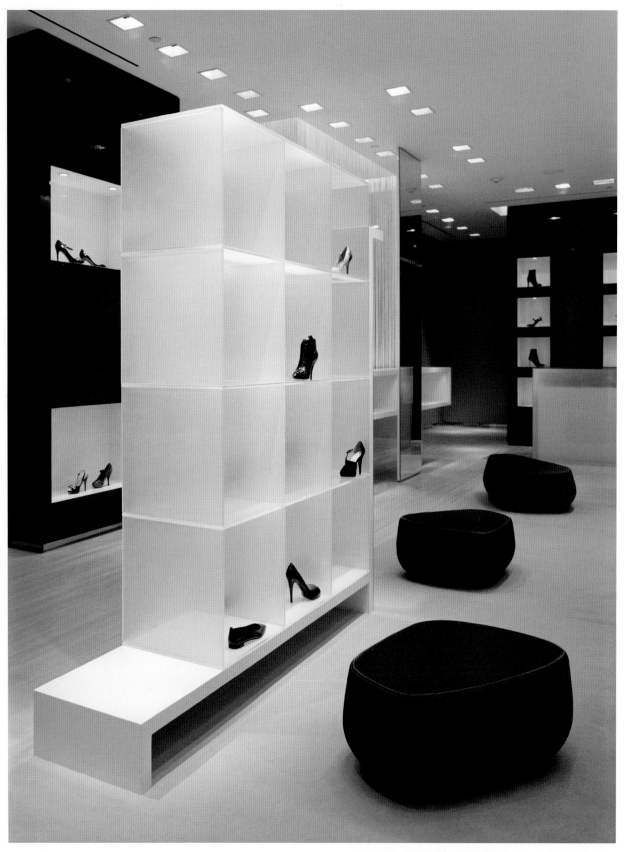

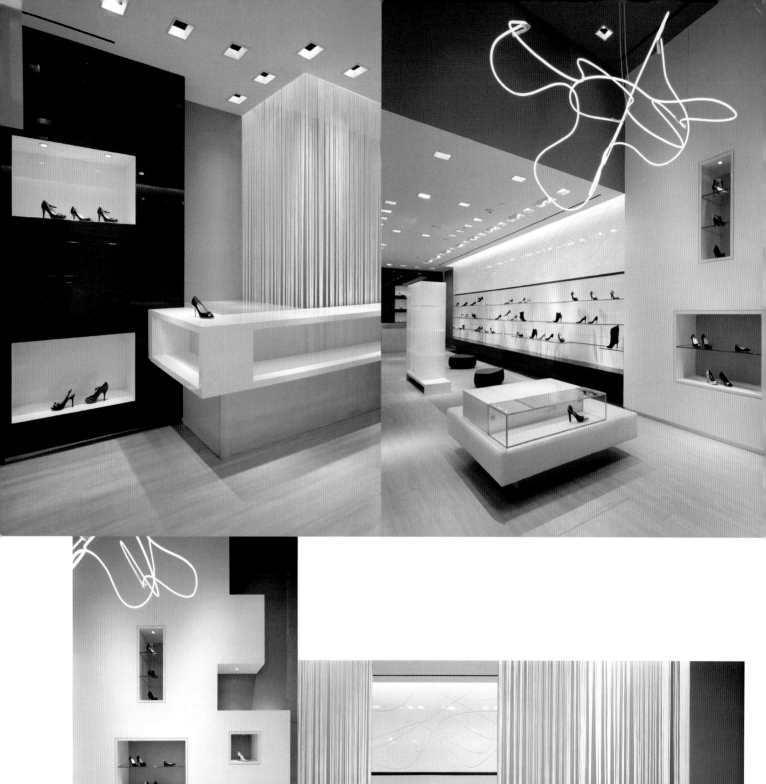

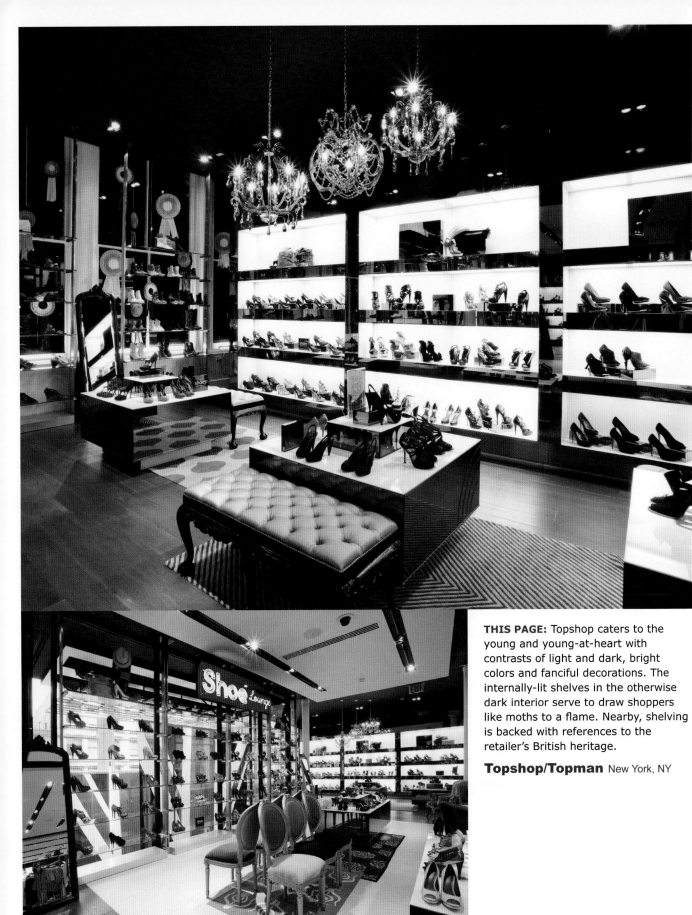

THIS PAGE: Topshop caters to the young and young-at-heart with contrasts of light and dark, bright colors and fanciful decorations. The internally-lit shelves in the otherwise dark interior serve to draw shoppers like moths to a flame. Nearby, shelving is backed with references to the retailer's British heritage.

Topshop/Topman New York, NY

There is something oddly outdoorsy about the Shoe Gallery in Selfridges. A table, constructed from a tangle of shoe forms is part sculpture, part display table, part conversation piece, and somewhat organic. On the floor nearby, a grouping of shoes have laces that are "growing" straight up, transforming into a field of long grass.

Selfridges Shoe Gallery London, UK

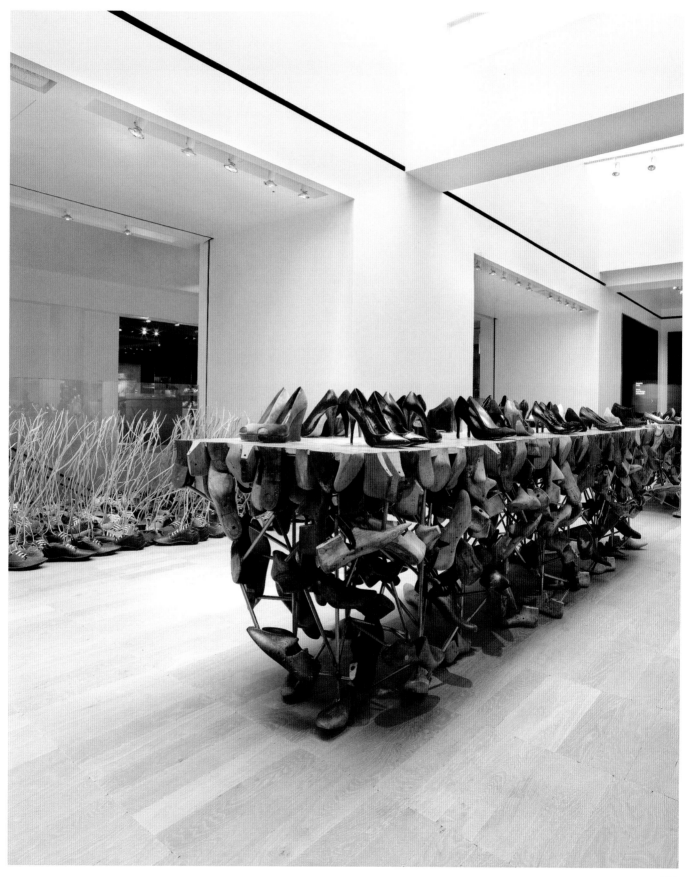

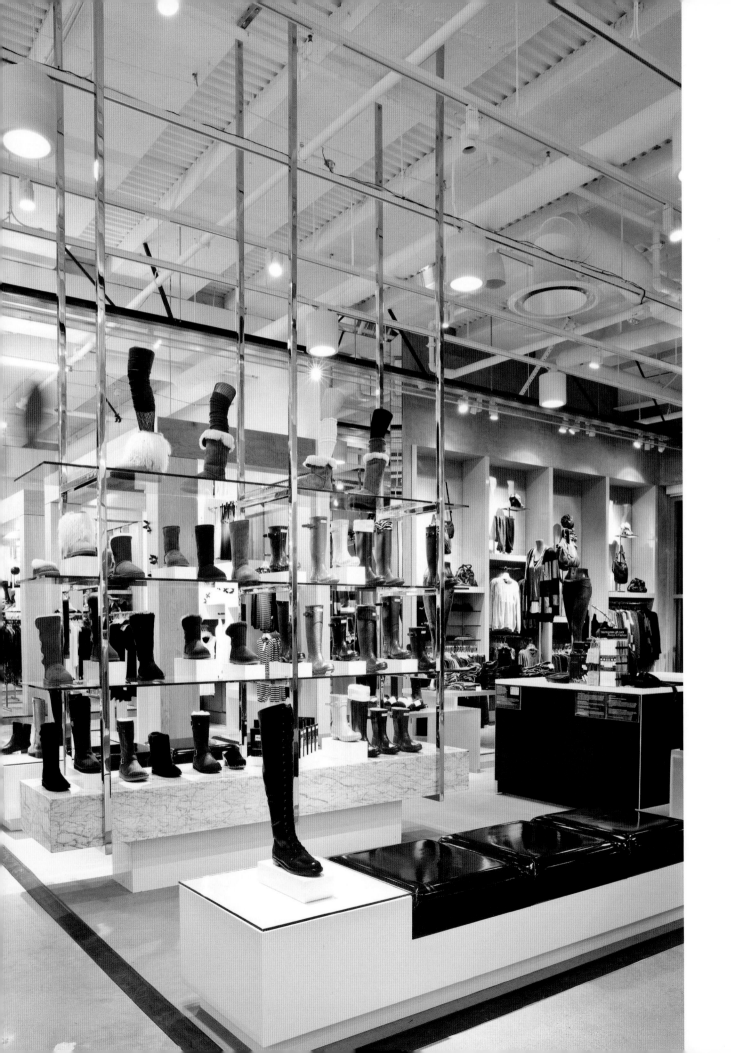

Strong verticals in the displays at both Bloomingdale's and Canali pull attention directly onto the footwear. Both retailers treat the product as art, in Santa Monica it's a hip gallery and in London an important museum piece—same idea, different tone.

Bloomingdale's Santa Monica, CA (opposite page)

Canali London, UK (right)

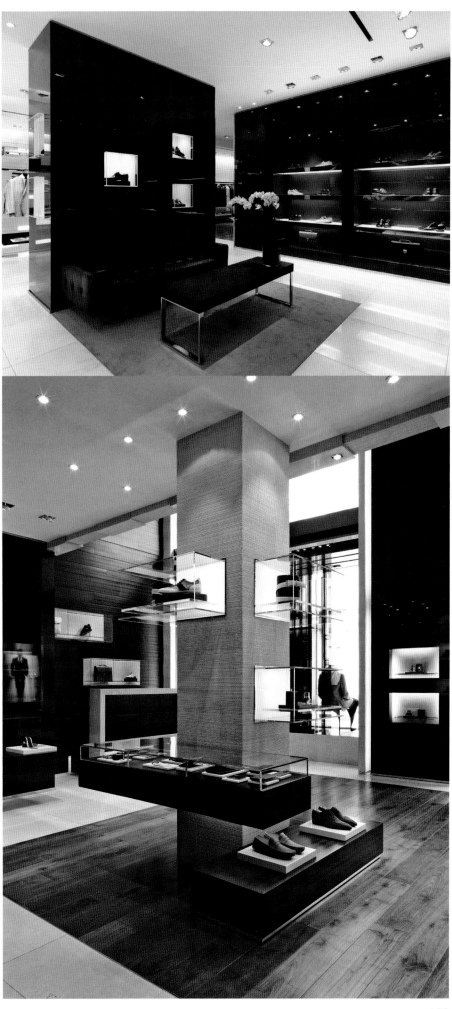

Fine Jewelry

The product is the shining star in this category as in no other. The consumer must get close, real close, in wide-eyed wonder. Sales associates are also of vital importance and the space must facilitate effective interaction between shopper and associate while protecting the small pricey items in this very real world.

The word "elegant" appears often on the next few pages. Fine jewelry is elegant, and expensive, and when retailers sell expensive items they are selling something more than the product. And that "something more" has to transcend fad and fleeting fashion. A customer paying tens of thousands of dollars for a necklace or brooch intends to wear it for more than one season. The most effective visual presentations will reflect that fact. So, yes, elegant, sophisticated, perhaps grand, sometimes intimate—always special.

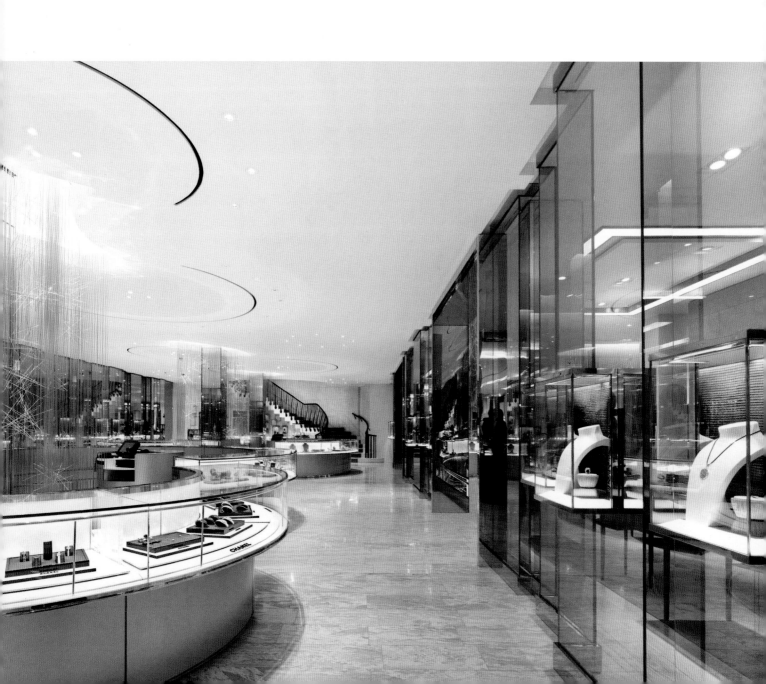

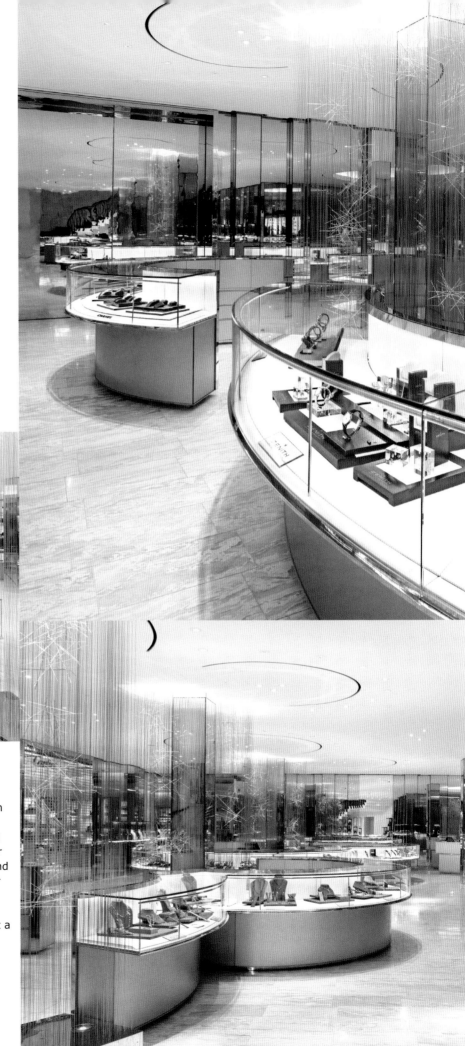

THIS PAGE AND OPPOSITE: Luxury Hall, the fine jewelry department in Dublin's Brown Thomas, sparkles with transparency. Rods shimmer down from the ceiling, the floors and walls shine and everything seems to be a glittering mirage—except the display cases. Their rounded elegance anchors the space and invites shoppers to wander and wonder at will. Large glass cases enclose the jewels without hampering the view, resulting in no fussing or angling to get a good look.

Luxury Hall
Brown Thomas, Dublin, Ireland

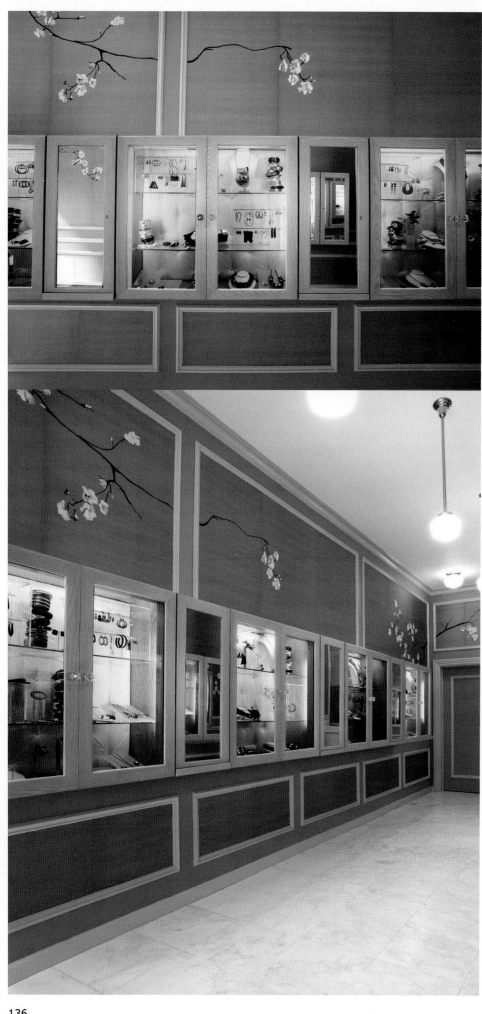

THIS PAGE: The wall of the small Alexis Bitter shop showcases the products in a row of rustic, wood-framed cabinets, interspersed with similarly framed mirrors. This row of cabinets is itself showcased in a neutral-toned wall with delicate Japanese-style print wallpaper. Taken as a whole, the wall focuses all attention onto the warmly lit merchandise.

Alexis Bittar New York, NY

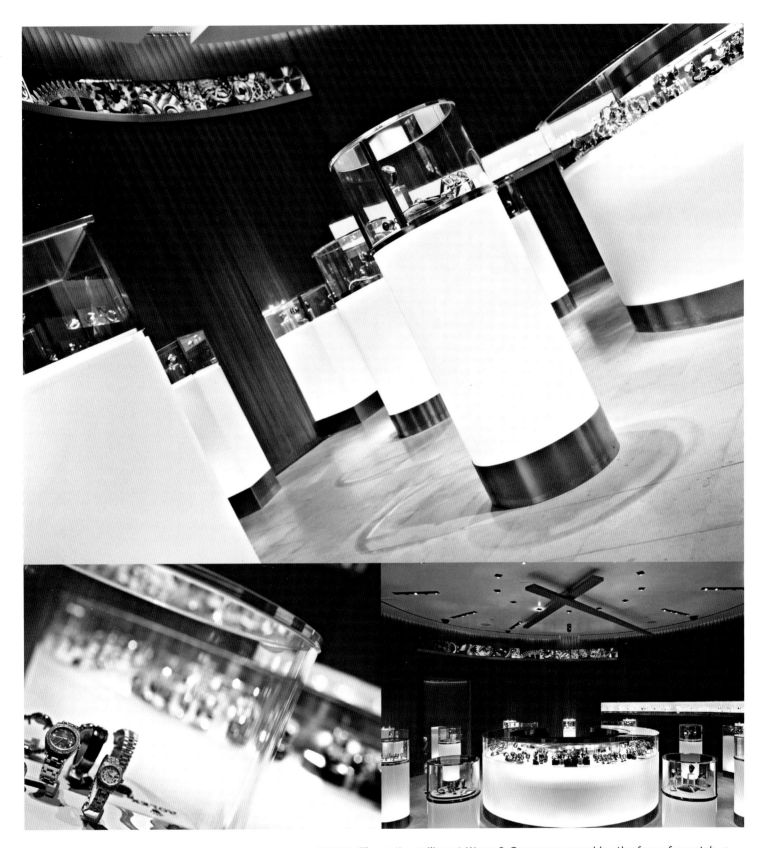

ABOVE: The entire ceiling at Wynn & Company resembles the face of a watch, a very expensive and elegant watch. Below this, the watches for sale are displayed in milk-white illuminated cases with minimalist design. The result might be too glitzy were the store in another location, but amidst the glitter of Las Vegas and the high-end wonder that is the Wynn hotel, it's exactly what the customer expects and wants.

Wynn & Company Las Vegas, NV

THIS PAGE: Anna Marek has created a home-like setting—a very elegant and stately home—to display their fine jewels. Merchandise is displayed in wall in-sets and floor cases that resemble antique furniture. But the true story here is the importance given to the sales associates. Large desks and chairs, again resembling antiques, are set prominently on the floor, sending the message that personalized service is what this store is about. "Come in and we will make you feel special while choosing just the right piece."

Anna Marek Fine Jewelry
Oak Brook, IL

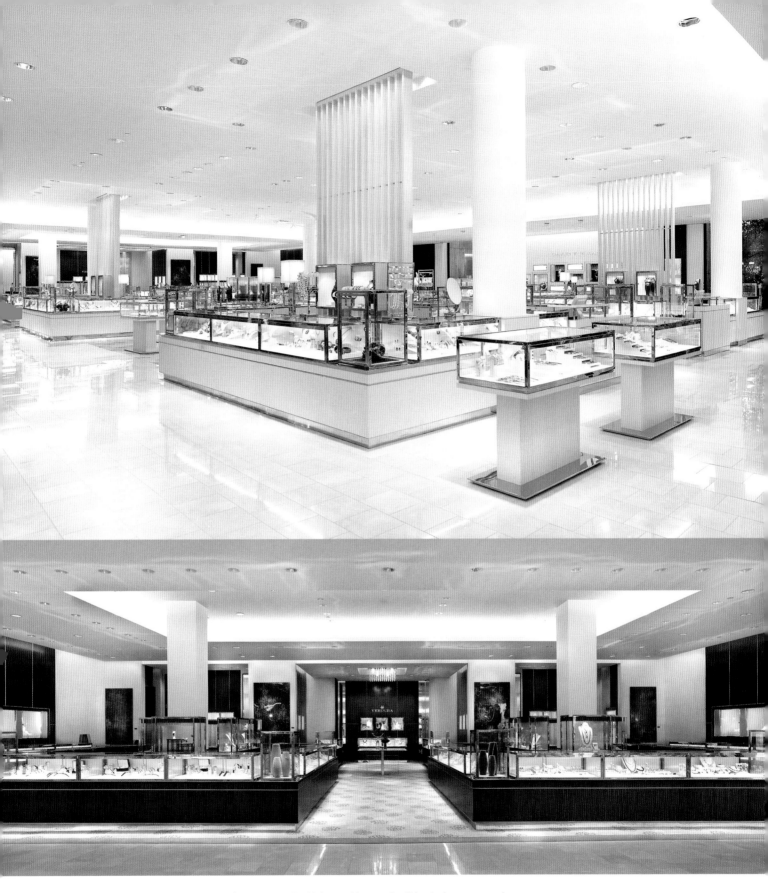

THIS PAGE: The fine jewelry department in Neiman Marcus in Atlanta has a grandeur that elevates both product and shopper far above the everyday. High ceilings, stately columns and elegant display cases create a setting ideal for the hushed contemplation of the merchandise and the understated exchanges with sales associates. The pops of blues and reds add just the right finishing touches.

Neiman Marcus Atlanta, GA

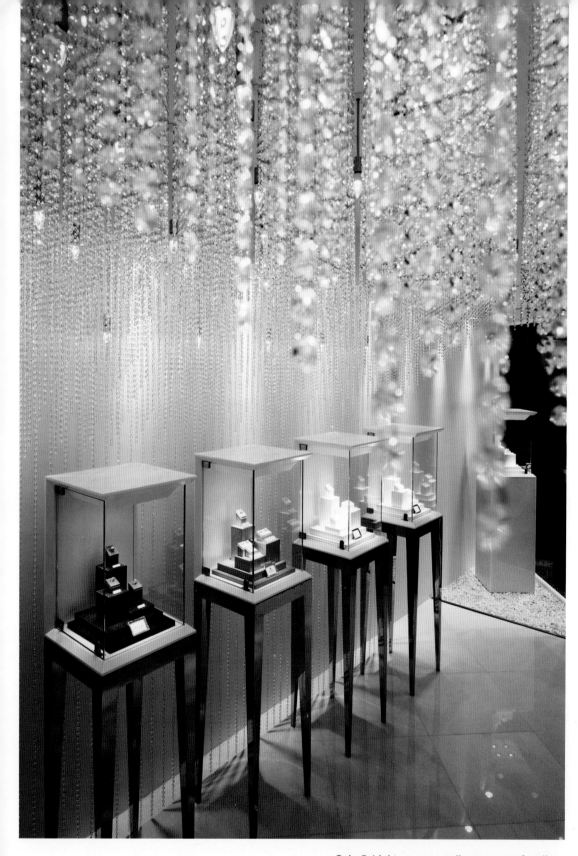

Gala Bridal turns a small segment of wall—
in a narrow hallway, next to the stairs—into
a showplace for a few select items. Glitzy
baubles hang from the ceiling, framing the
scene from above, while the contemporary
stands hold the offerings aloft.

Gala Bridal Tokyo, Japan

Display cases need not recede into the background to effective display fine jewelry. No Name Boutique displays its jewelry items on ornate pedestals. The architectural decoratives curve upward, appearing to hand the products to the shopper for inspection. At Highland Department Store the jewelry is displayed in bright red, lacquered cases while matching red design elements hang overhead. At both No Name Boutique and Highland, the jewelry is protected with simple clear cases that do not visually interfere.

Highland Department Store Doha, Qatar (above)

No Name Boutique Montreal, QC, Canada (left)

Sports Equipment and Sporting Goods

Sporting goods retailers face the initial challenge of convincing potential customers to get off the couch. Once convinced, however, the sports enthusiast's fervor is boundless. That's where the fun can begin. Most sports require, or seem to require, many accessories and special outfits—and the shoes are never all purpose. Equipment is often colorful and oddly shaped, allowing the visual merchandiser to create unusual arrangements and attention-getting displays.

Action and movement are explicit and the mood is upbeat and contemporary. After all, the point of sports is to have fun. Sports enthusiasts also crave information. Signage and product-rich displays alert consumers to what they may be missing. Merchandise, signage and decoration combine to form exciting, and fast-paced environments.

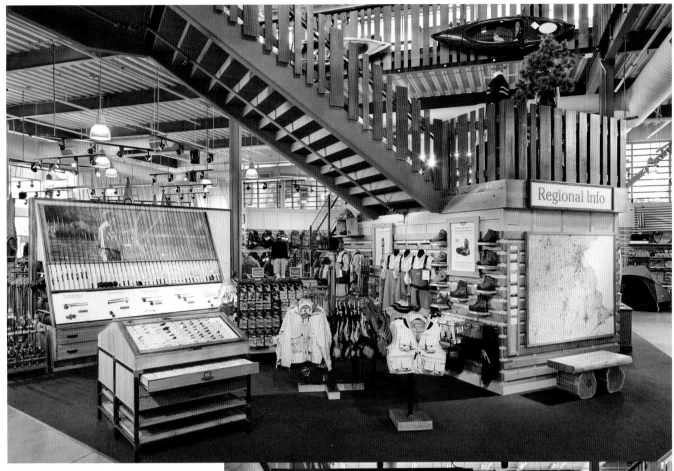

THIS PAGE AND OPPOSITE: In its Dedham, MA store L.L.Bean uses its central staircase, a focal point in itself, to maximum advantage. In addition to the kayaks ringing the upper level railing, a niche under the stair displays a dream camping site, complete with tent and all the accessories. On the other side of the stair are displays devoted to all things fishing. The selection of products is huge and must, to the camping or fishing enthusiast, be impossible to resist.

L.L.Bean Dedham, MA

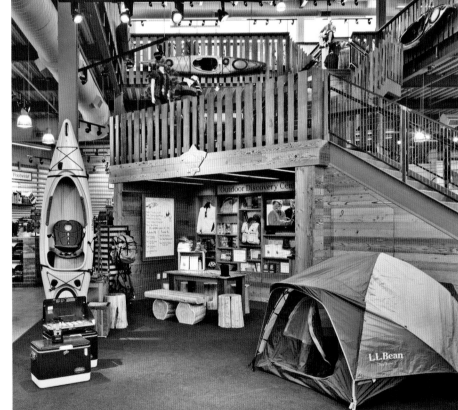

These displays at New Balance in New York City and El Palacio de Hierro Interlomas in Mexico City are both full of dynamic movement. The running mannequin at New Balance makes perfect sense, however the display is given increased energy by a 60-foot long, overhead "ribbon" that curves its way through the store and documents the brand's past, present and future.

El Palacio turns its entire sports department into a gymnasium complete with high ceilings, boundary markings on the floor and mannequin athletes. The centrally placed line of action mannequins is startling in their poses and impossible to resist. Adding to the adrenalin rush are large digital monitors and a young, contemporary vibe.

New Balance New York, NY (opposite page)

El Palacio de Hierro Interlomas Mexico City, Mexico (above)

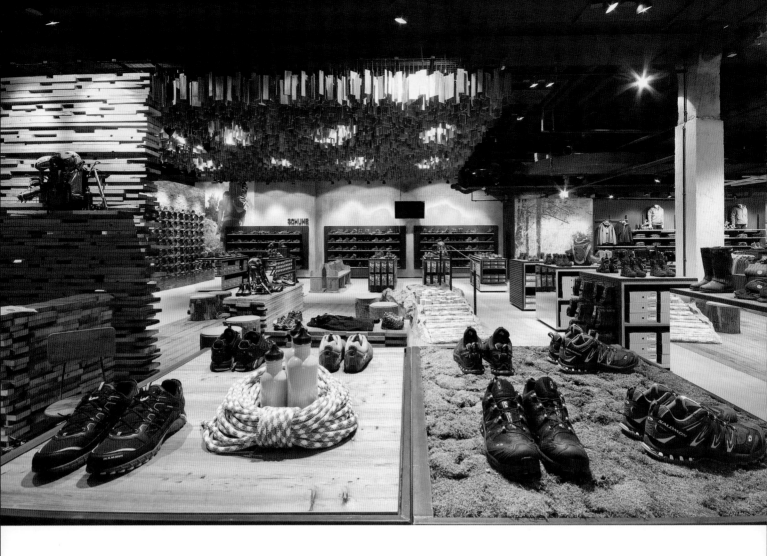

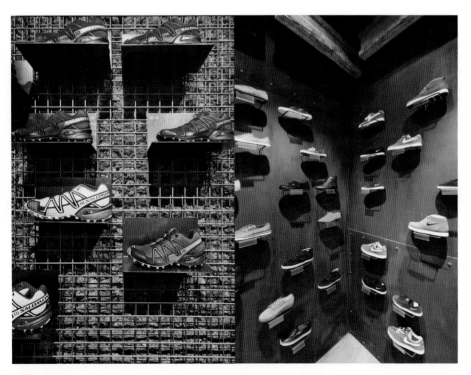

THIS PAGE AND OPPOSITE: Natural wood is everywhere in Reischmann. It hangs from the ceiling, covers the floors and is used in shelving and tables. Backpacks, shoes and rock climbing supplies rest on the woods' warm unadorned beauty, while in other displays grass and sod lend an earthy foundation. Reischmann is huge, about 55,000 square feet, and the product vignettes and displays focus attention, preventing shoppers from being overwhelmed.

Reischmann Kempten, Germany

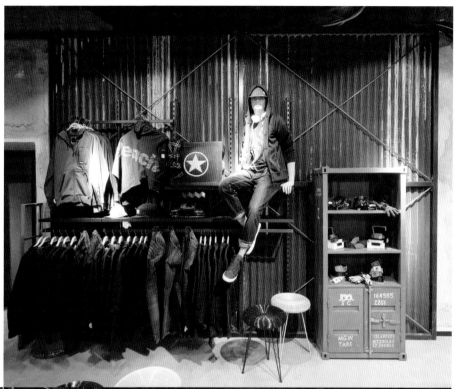

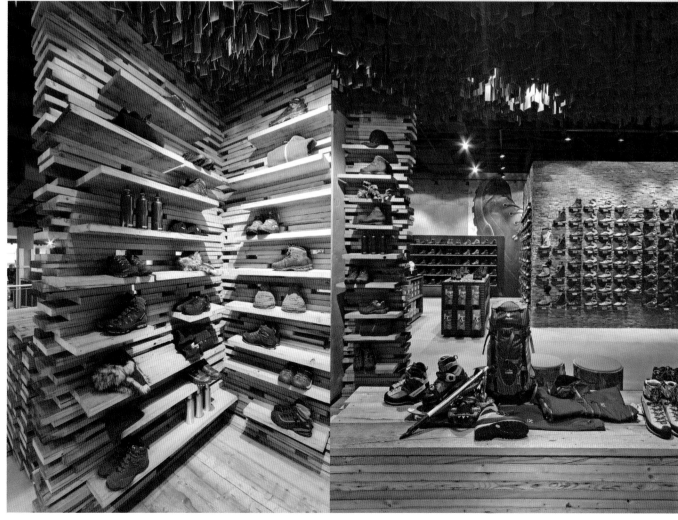

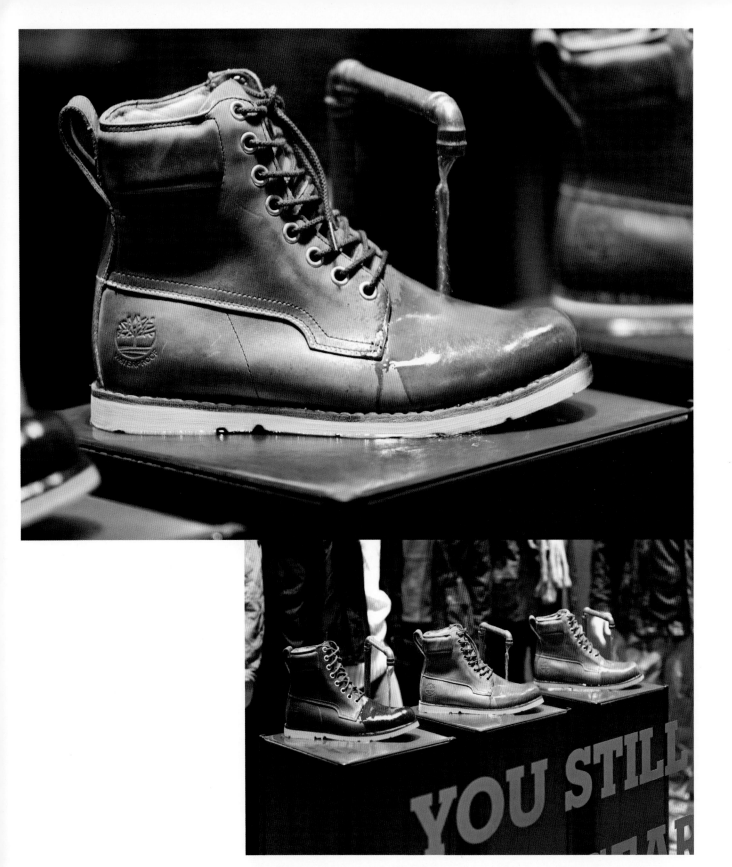

THIS PAGE: There is nothing as effective as a straightforward demonstration. In its London window Timberland continually pours water over its boots to prove the products are waterproof. There it is, the evidence is in front of your eyes. Walk through any creek or puddle you like and these boots will keep your feet dry. The straightforward message is sure to get the attention of passersby—and sell boots.

Timberland London, UK

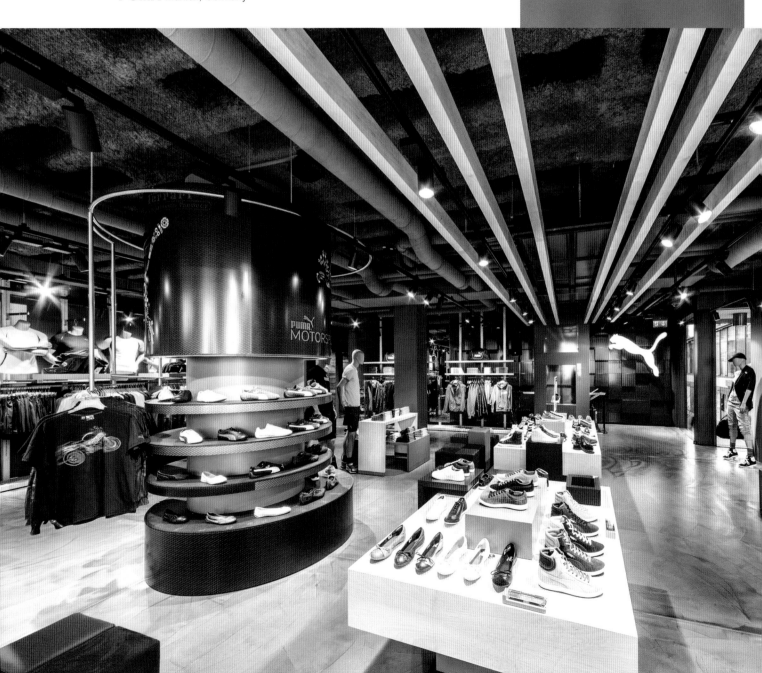

TEAM SCHUH DES MONATS

PUMA SOCIAL
OFFICIAL EQUIPMENT

FÜR FEIERABENDATHLETEN

THIS PAGE: In the center of its Munich store Puma focuses attention on sport shoes, its core product, with both horizontal and vertical displays. The round vertical display is dedicated to the brand's Motorsport line and invites shoppers to walk in a leisurely circle. Nearby, table signage holds aloft the "team shoe of the month."

PUMA Munich, Germany

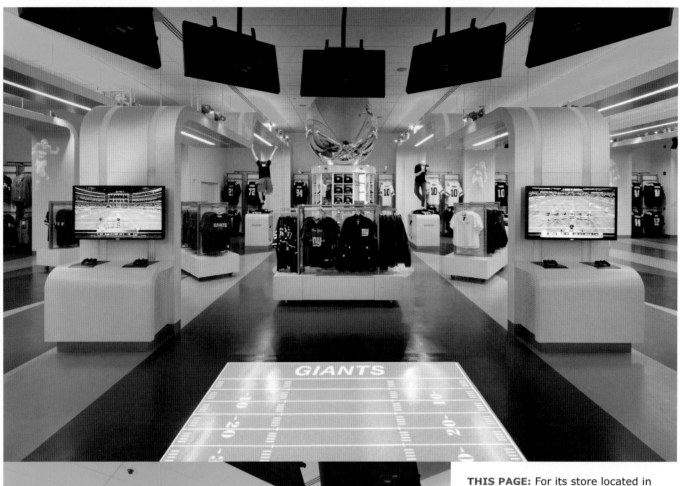

THIS PAGE: For its store located in the stadium where both the Giants and Jets play football, Reebok illustrates the power of a quick visual transformation. Walls, floors and fixtures are neutral in color and design, allowing lighting to change from Giants blue to Jets green and team franchised merchandise to be easily swapped. The entire store is then dedicated to whichever team happens to be playing.

**The Flagship Store
Powered by Reebok**
East Rutherford, NJ

THIS PAGE: This two-story structure was built within the larger Niketown store in London. The first floor of the transparent glass and steel cube houses the Nike iD Studio where customers can design their own Nike shoes on the software provided. On the second level shoppers are invited to meet with a professional designer to get that perfect pair of sneaks. The entire structure rises in the store like a glittering temptation.

Nike iD Studio @ Niketown
London, UK

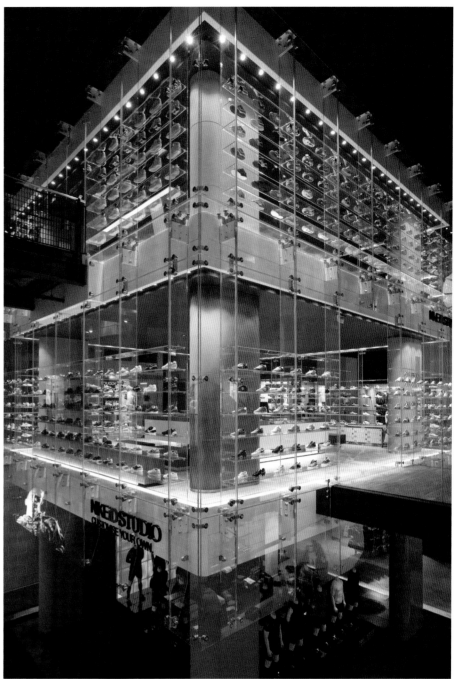

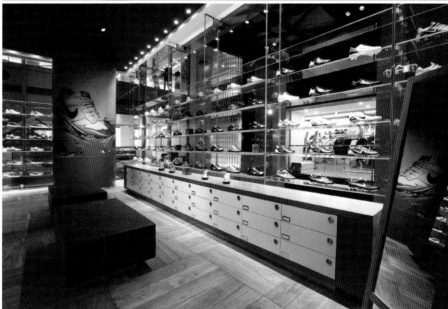

Demonstrating the opposite ends of the sports display spectrum are Chicago Sports Depot and K-Swiss. Although a direct comparison is a bit like comparing apples to oranges, it's interesting to see the extremes. In a Parisian pop-up shop K-Swiss keeps things simple while effectively promoting tennis and the K-Swiss brand. The tennis-racket dividers instantly represent the sport and the relevant shoes are placed just below. Photos and articles are attached to one wall, encouraging people to linger and learn more.

Meanwhile, the Chicago Sports Depot writes it large, promoting, in the displays shown here, all things relating to the city's White Sox baseball team. As surely as the K-Swiss display is about tennis, these displays are about baseball. Huge, colorful photo collages cover the wall, depicting the sport to its fullest advantage and luring casual and diehard fan alike to those team hats and jerseys.

K-Swiss Paris, France (below)

Chicago Sports Depot Chicago, IL (opposite page)

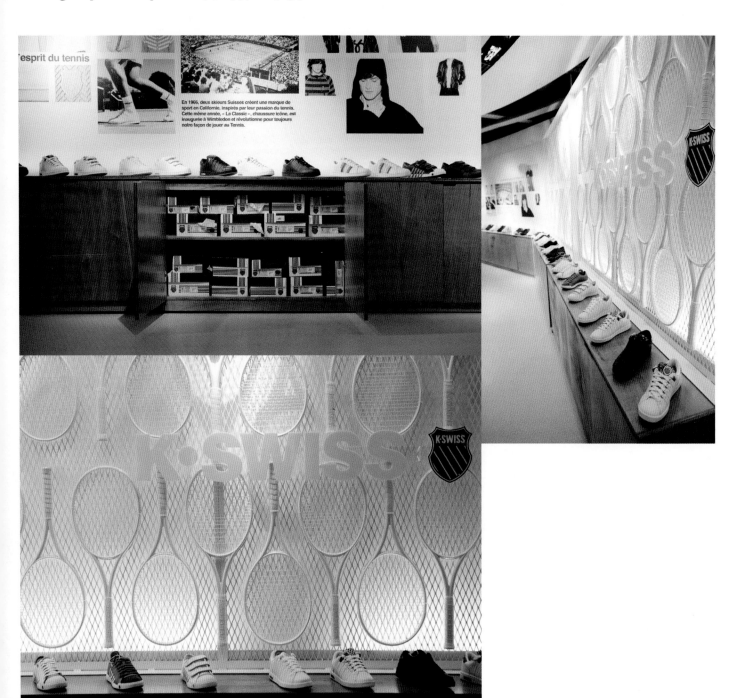

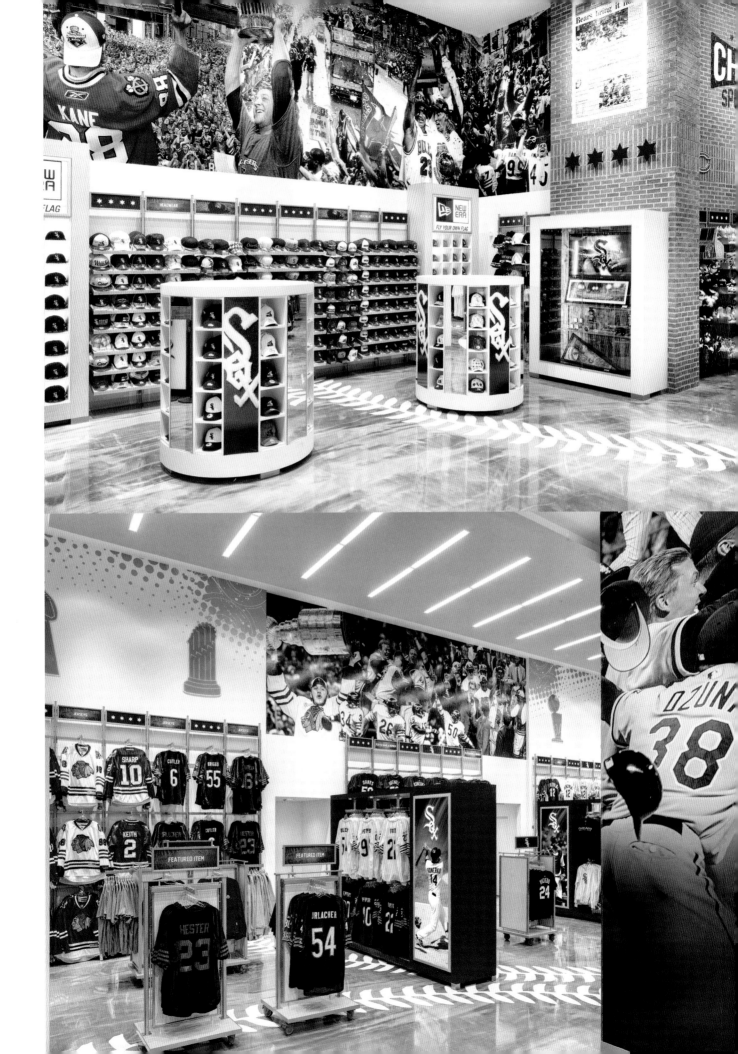

Home Goods and Furniture

The home, and products purposed for the home, tug at the emotions. It's here that people want to feel safe, and completely themselves, away from the strains and expectations of the world outside. The smart home goods and furniture retailer creates displays that represent the idealized home, a place of personal expression, peace and, of course, beauty.

 The visual merchandising will vary to best complement the merchandise, which ranges from pots and pans to sofas and carpeting, yet the best displays all relate to the consumer's desire to build the perfect "nest." Most customers shopping for home goods and furniture have already spent a considerable amount of time looking through magazines in search of that perfect room setting or decorating idea. Retailers have the power to improve upon the magazine search and create an experience within the store, bringing the photos and coveted items to life.

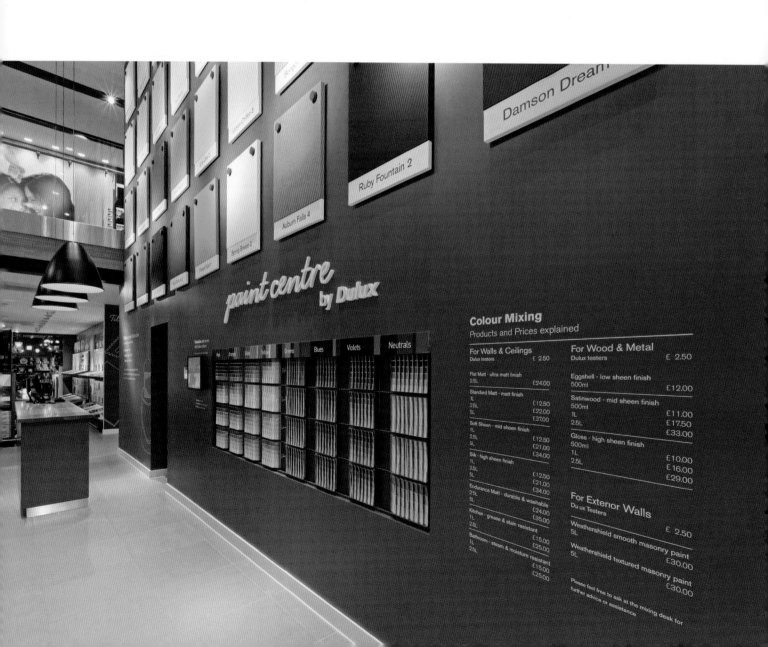

OPPOSITE PAGE: Paint samples large and small, conveniently attached to a wall, assist the customer in color selection at Next Home and Garden. On the same wall, color mixing information is divided into easy-to-follow categories. No hunting or fussing is necessary for the do-it-yourselfer, the paint and know-how are in plain sight.

Next Home and Garden
Shoreham, UK

THIS PAGE: A white, translucent structure set on the sales floor at Aura, beckons customers inside for a look. It's glowing presence contrasts with the darker, and mostly grey, surroundings and alerts the consumer to the fact that there is something special within the small room. Inside, contemporary white shelves and cases hold the select offerings.

Aura Riyadh, Saudi Arabia

Both Calypso St. Barths and Neiman Marcus offer customers idealized rooms. At Calypso St. Barths linens, pillows and decoratives are arranged in a bedroom setting that strikes at the longing for a peaceful oasis that shuts out the world, a romantic fantasy that few can resist. Meanwhile, Neiman Marcus sets a very elegant patio table. The entire collection is just waiting to be whisked away to someone's backyard.

Calypso St. Barths East Hampton, NY (opposite page)

Neiman Marcus Atlanta, GA (above)

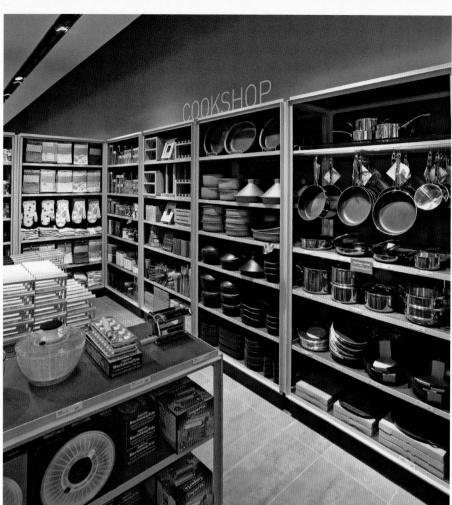

A wall of products and an abundance of choices are offered at both Habitat and La Boutique Palacio. These are the sort of displays in front of which shoppers can linger for quite some time, searching for just the right pan or the perfect color in toweling. What is considered perfect will, of course, be different for every shopper, so the wide, color-coordinated selection ensures everyone finds just the right item—or perhaps two.

Habitat Liverpool, UK (left)

La Boutique Palacio
Mexico City, Mexico (below)

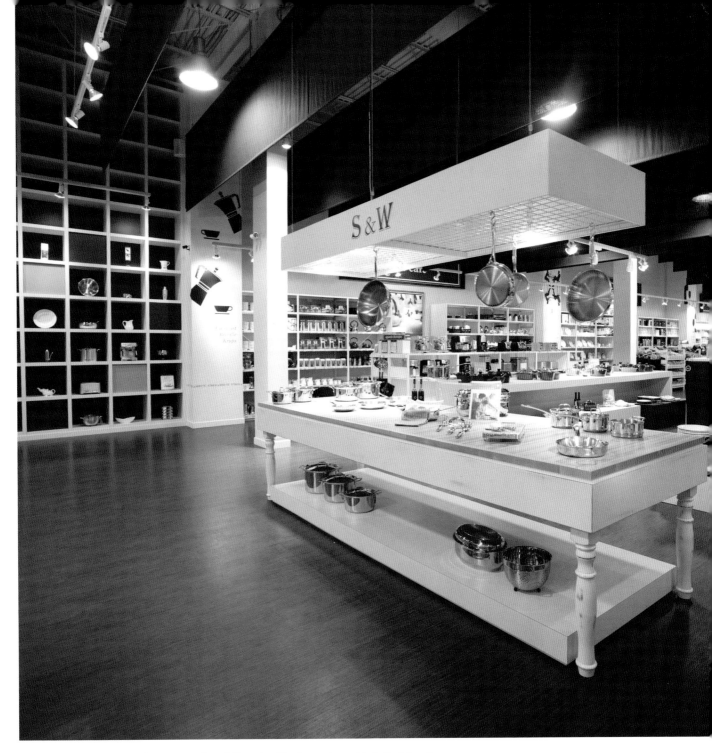

Stark & Whyte is a retailer targeted to folks who like to cook and is full of foodie temptations. A central display represents the ideal prep table, laid with a few select pieces of cookware. Along the walls, cubical cases display single items as if they were in a museum. Ambient lighting is low and the products are carefully encircled in light, many seem to glow. This effect is heightened by the dark floors and ceiling.

Stark & Whyte Montreal, QC, Canada

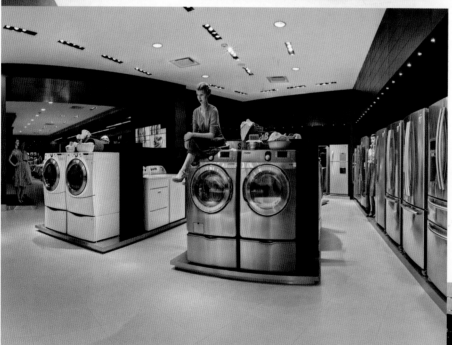

THIS PAGE AND OPPOSITE: Mannequins placed near, and even on, the home appliances invite the shopper to envision themselves owning and using the shiny new toys. The clear message is "these are not just beautiful, modern appliances sitting in our showroom, they can be yours to use in your everyday life." Elsewhere in El Palacio de Hierro's home department, a kitchen complete with bar stools and dream appliances is constructed in the middle of a vast room. The kitchen becomes the focus of the room, enticing shoppers through the space. In yet another area of the retailer's home department, an elegant table is set for a dinner party and backed by a selection of fine china and glass. A surprise around every corner could be the motto of El Palacio.

El Palacio de Hierro Interlomas Mexico City, Mexico

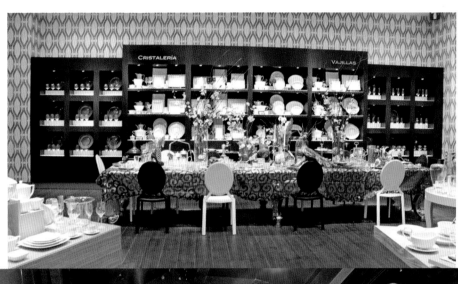

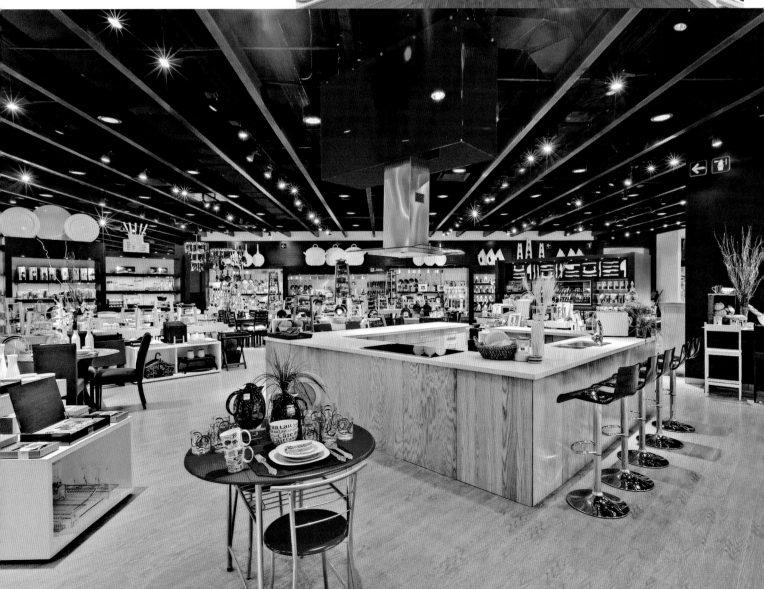

Home Electronics and Telecommunications

Selling home electronics and phone services is selling an experience as much as a product. The services available to the consumer are often confusing and the shopper faced with myriad choices. In these environments the sales associates, or customer service representatives, and how well they interact with the consumer is as important as how the products are displayed. The successful store makes the consumer feel both welcome and intelligent, with explanations that don't condescend. Much of this, but by no means all, is out of reach for the visual presentation to effect. However, signage and graphics can go a long way to educate, and the careful placement of products and service counters certainly help to bring about a satisfactory customer experience. A contemporary and energetic environment can also positively reinforce the hi-tech nature of the products.

THIS PAGE AND OPPOSITE: 3 Mobil in Denmark drapes its products over a round wooden beam that runs from the entrance to the rear of the small space. The beam, branded at one end with the company logo, is held aloft by a contemporary white stand, putting products within easy reach. Large lifestyle photos pull customers through the store and offer additional product choices—literally, the models hands are in welcoming gestures.

3 Mobil Aarhus, Denmark

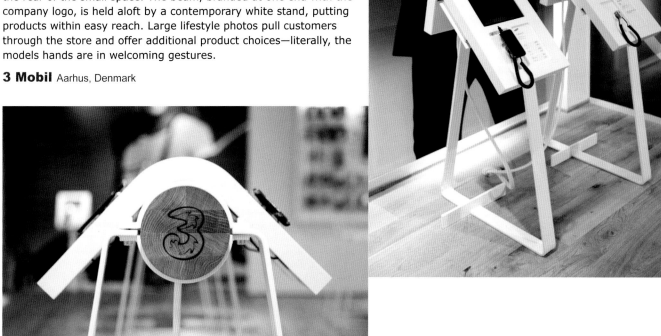

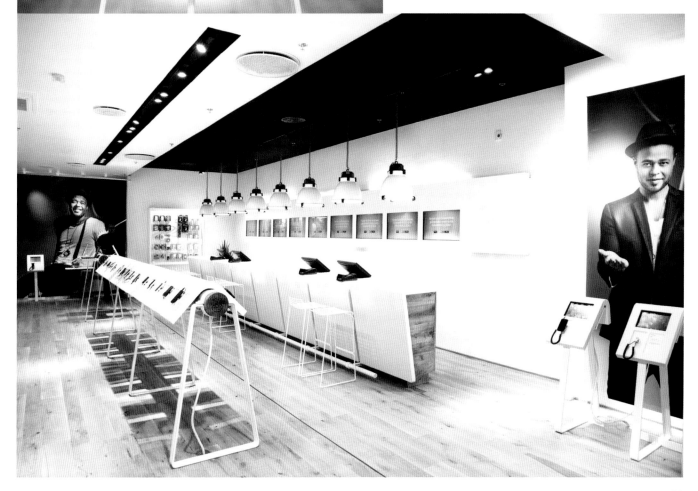

THIS PAGE AND OPPOSITE: Bold curves and stripes bring a dynamic energy to Miami's Electric Avenue and the products on offer. In front, a 16-foot wide by 12-foot high curved video screen can be seen from the busy street along which the store is located, serving as both in-store and window display. In one room everyone's dream TVs and sound systems are arranged for sampling.

Electric Avenue Miami, FL

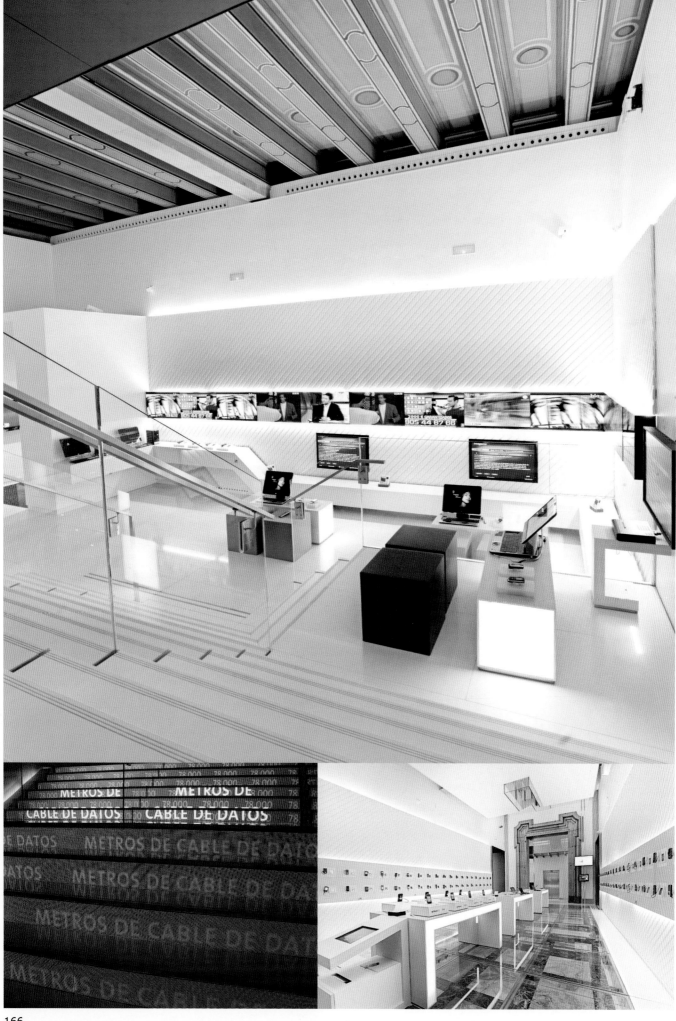

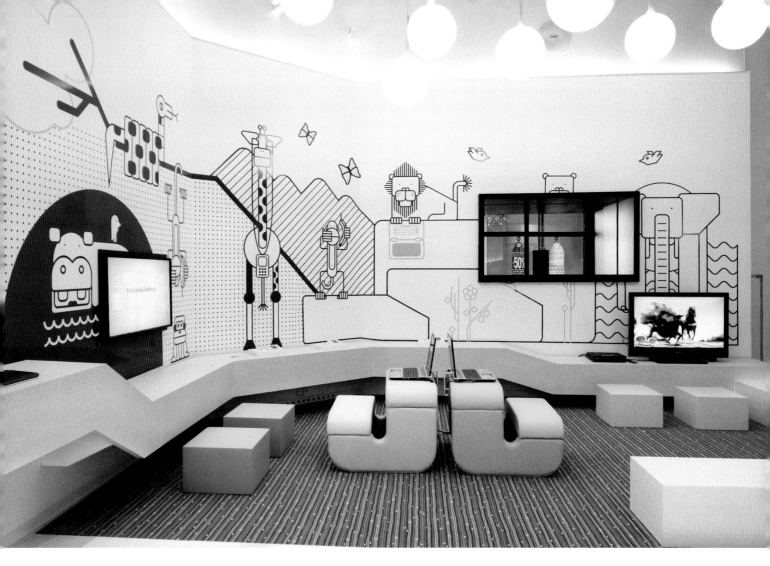

THIS PAGE AND OPPOSITE: Telefonica is part retail shop and part learning center located on two floors in a historic building in Madrid. The retailer sells mobile and fixed-line phones, TV services, telecom packages and audio-visual equipment on the ground floor. Up one level is a "house of the future," demonstrating to consumers how the latest technologies can enhance their lives. Connecting the floors is a staircase that displays branding messages.

Telefonica Madrid, Spain

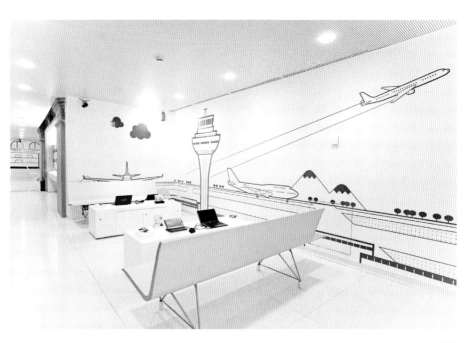

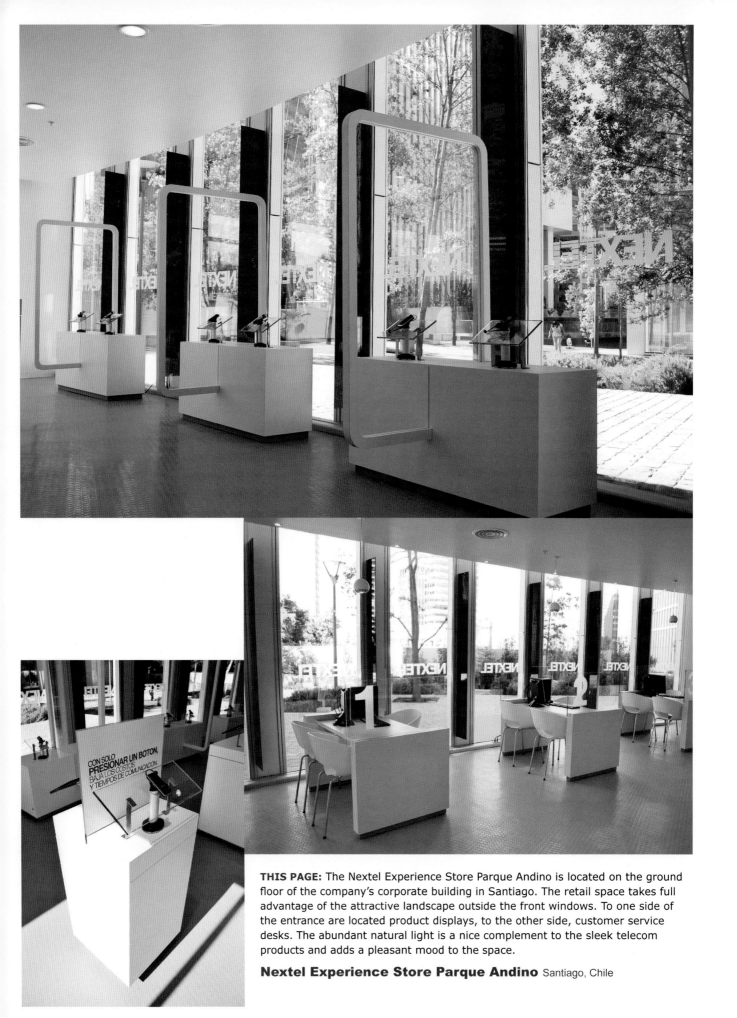

THIS PAGE: The Nextel Experience Store Parque Andino is located on the ground floor of the company's corporate building in Santiago. The retail space takes full advantage of the attractive landscape outside the front windows. To one side of the entrance are located product displays, to the other side, customer service desks. The abundant natural light is a nice complement to the sleek telecom products and adds a pleasant mood to the space.

Nextel Experience Store Parque Andino Santiago, Chile

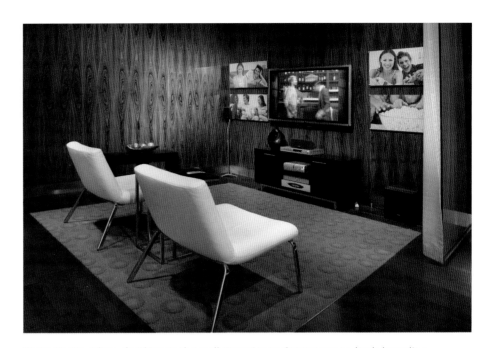

THIS PAGE: Glass dividers in the Dell Experience Center act as both branding surfaces and screens to conceal the wiring of nearby computer stations. In a "living room" outfitted with audio-visual gear, customers are invited to experience the products.

Dell Experience Center Dallas, TX

INTERVIEW:
Ana Fernandes
The Bay

Ana Fernandes, the Creative Design Manager for The Bay, oversees seasonal, in-store and window displays unique for their diversity and originality. With The Bay for the last ten years, she began her display career at Eaton's after discovering the art of visual display during a job in the shoe department of Sears. Recently Ana spoke with Michael Stewart of Rootstein Mannequins and Judy Shepard, editor of this volume.

Thank you for allowing us to spend some time with you at such a busy time of year. You just installed your Christmas windows here in the Toronto store, tell me about the theme this year and what was your inspirational starting point?
Well actually, this year we redid our in-store visuals and we decided to redo three stores with a new look for Christmas: trees, swags in the interior. When we were looking forward to where we wanted to be, one idea that constantly came out was: We're Canadian, we own Canadian Christmas. No one else can do it, no one else can say that. When we had dabbled in that in the past it was well received. So this year we decided to take a look at our in-store from that point of view and make it really fresh, clean and have a modern twist that was Canadian by using natural woods, mixed greenery, birch, etc. It was very natural... and the wolves too...and moose. This year we have moose.

I thought that I saw wolves in there, didn't I?
Huskies. We have Canadian Huskies and some moose in the windows and in the store. We had dabbled with Canadian Christmas a couple of years ago, but the twist this year was that we took it from a cottage up north point of view and tried to do an interior/exterior with the window theme.

And I notice that you have little blankets in all of the animations... that's so cute.
Yes, the animated windows launched in 2007. We pull that out every year. People look forward to seeing it. We designed it for that purpose; something that could be used every year and not appear dated. Sometimes you go for a story or a book for example. This is based on a bit of our history and that's why it shows a point blanket and HBC stripes here and there and I think that makes it fun.

Children are such a focal point of the whole holiday season, do you gear Christmas more towards the children's sensibilities and the fascination of Christmas or are you more focused on your brand image and sales projections? It really is about the kids, isn't it?
We always make sure that we have fashion windows, home windows, but we always ensure that we have a bank of windows dedicated to animation or something geared toward the kids... be it toys or something else...you have to have them.

I noticed at lunch time that there were a bunch of kids out there... moms with kids...and it is just so lovely...it's the perfect time of the year.
We get letters every year telling us that it is a family gathering and that they make the trip downtown from far away, even from outside of Ontario. They make the trip because when they were young their parents used to bring them down to see the animated windows. If I were to take those windows away I'd get so much negative feedback, and that would not be very good.

The Holiday 2011 windows brought the outdoors of the Canadian north into the store, and offered a warm invitation to passersby.

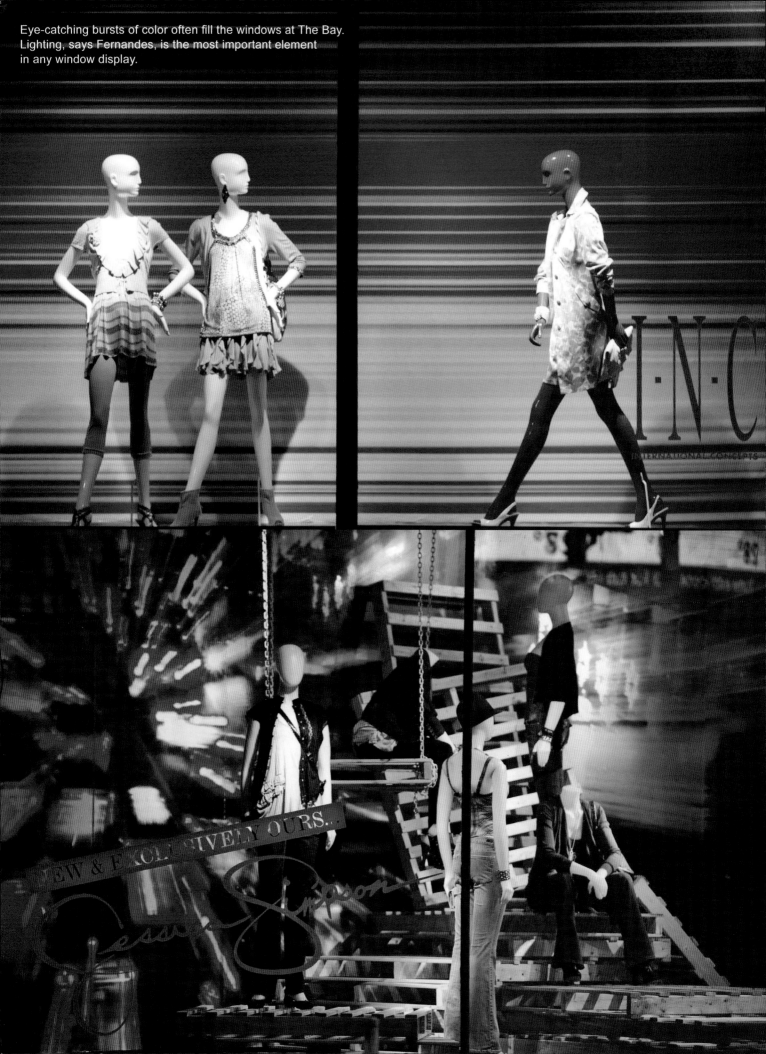

Eye-catching bursts of color often fill the windows at The Bay. Lighting, says Fernandes, is the most important element in any window display.

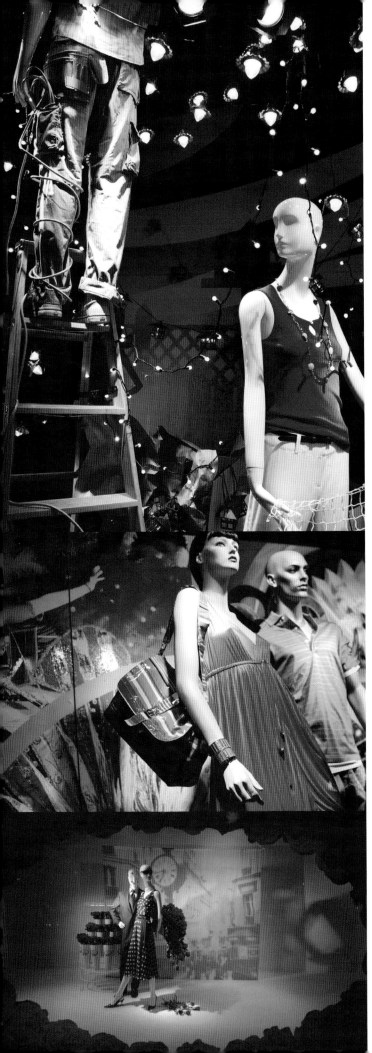

What got you into display? What first inspired you and how did you start out?

Right out of high school I started working in jobs in retail here in Toronto in department stores. Actually, my first job was with Sears in the shoe stockroom, stocking shoes and then I made my way to the front to selling them. I would notice these display people moving things around and setting up Christmas trees and seasonal displays. I would see them setting up and dressing mannequins and I thought to myself, "My gosh, that looks interesting." And then I started to ask "What is this?" How do you go about being this individual that goes about doing these things?" The next thing you know, off to school I went. That was it. I learned what it took to fill that position and informed myself more and then things seemed to open up. I started walking into other stores and observing displays and thinking, "That's what that is." Dressing up the mannequins, the seasonal aspects are the things which first drew me to it.

It pulled out your creative edge so to speak. It started with Christmas.

That is when I got bitten.

In those early days, who were your major influences, your mentors? Who taught you how to do display?

After I finished school my first job was at Eaton's, which is now gone. It was a family business that operated for a long time. When I started there they had a couple of veterans who had been in the business for years.

Do you remember any of their names?

Edward Defreitas. I'll never forget him. He was a character and a half. He just ruled the world. He was the one that was partnered with me and he taught me how to cut foam core. He taught me how to strike a mannequin. He taught me all of those tricks, not only in the windows but in the store. He taught me all those things that people think they know but they don't.

And you have to teach them all over.

And now I find myself over the years doing the same. When I was working in the store and partnered with someone new I found myself doing the same thing, teaching them the basics and all those little tidbits that he taught me.

Many of the display people that we interview talk about the lack of basic skills in new display people. Do you agree?

Don't get me started. It's unfortunate. I don't want to age myself, but when I went to school they taught me how to cut foam core, how to wire a mannequin, the basics, how to do lighting in a window. Then when I started I was partnered with Edward so I could continue my learning. You're constantly learning anyway. The minute you think you know everything, that's the minute that you're no good because there's always something new to learn. When I see new people fresh out of school I am so shocked with what they don't know — all that basic stuff is not taught. They can't cut foam core. They don't know what wiring a mannequin is. It's very sad to me that those fundamentals are gone.

No, they say the same thing here.

It's unfortunate, I don't know what it is...a lack of time. I'm not sure what they're learning. Is it because people in my field, like myself, aren't contributing enough time. Anyone can dress a mannequin. Sales associates do it all the time. Dressing one well is another thing. But the art that goes into it is also important. It's not just dressing that mannequin. It's also striking the position of that mannequin. It's lighting that mannequin.

In addition to those basic skills are there new skills that people who want to go into display need to know today?

The basics are always going to be there and that's something they should always know. I think stylizing is a really important thing right now.

What do you mean by stylizing?
Well, for me there's stylizing then there's accessorizing. Accessorizing is throwing jewelry and sunglasses and everything onto a mannequin. I'd rather stylize versus accessorize. It's not about that mannequin having every accessory in the department. It's about knowing the look you're trying to achieve and what does that look warrant. Is it a bohemian look? Is it something modern? It's about knowing styling. Too many people think it's just slap some accessories on and we're good. But thought has to be put into the stylizing. That's something that I think over the years has changed and I think that's very important.

Who are your design gurus today? Who inspires you in any creative field?
I worship Linda Fargo. I have not met her yet. I've come close. Someone wanted to introduce her to me but I was too nervous to go (laughs)... I got some one to give me an autographed copy of her book. It's like worshipping somebody from afar. And then you see them in person and you say, "Oh my gosh!"

So how long have you been at The Bay and what is your current title?
I've been at The Bay for the past ten years and my title is Creative Design Manager.

What does that encompass?
It encompasses all seasonal, all in-store and all windows corporately.

In your email signature you call yourself "Chief Adventurer," that sounds more like a motto than a title.
That was actually something that our president Bonnie Brooks introduced a few years ago. Our company's history is all about adventurers, each one of us being our own individual adventurer in our field.

I saw on the Internet that the Hudson Bay Company was founded in 1670 and is North America's longest continually operating company.
Yes, we have a huge history. Even my kids have learned about the company not from their mom, but when they started learning about it in class.

Does that history weigh heavily upon you, does that affect you?
No, not really. You can't dwell on the past, but it does give you something to pull from right now. That's the fun aspect; we have that history that we can go back to, and we've done that. If you've looked at the displays over the past ten years, once and a while we do go back there, especially for the Holidays, and play off it. Not too many retailers can do that. It's funny when you see a retailer celebrate ten years, but we've got hundreds of years to play on. It's really good to be able to have that.

You mentioned that your job encompasses all seasonal, all in-store and all windows corporately. Does that mean you're in charge of display in all of The Bay stores?
Well, not in charge, but from a visual aspect, yes.

What do you do?
From a visual aspect that role has changed over the years as we've developed and the focus has changed. But I do the in-store seasonal elements and the shops for any new brands that are introduced. I'm involved in what that shop looks like and the mannequins and so forth, and I'm also involved in the visual aspect of renovations and remodeling of stores. And then windows are a big part of my job. We don't have windows across all of our stores. We have our main flagship stores, six of them, and than we have approximately 30 other locations across the country that have windows that I take care of here.

How do you coordinate that? You obviously have a team...

Whatever the theme, no detail is overlooked.

The Signature shop references the retailers long history and Canadian heritage.

No, it's just me and my coordinator, unlike my U.S. counterparts, who I understand can have teams of 30 in a home office situation. Typically, over the last ten years, it's been just myself and a great assistant. And I do have the luxury of having a great relationship with my boss Denis Frenette. We do get some quality time to just sit down and toss out ideas. Yeah, it's a little crazy around here, but it works.

Do you plan everything in detail when you're designing the windows?
We try, and I'd love to work four to six months out, but that never happens. In order to maximize my budget and in order to maximize the look at the store level we have to customize to each store. It's not something that is cookie cut; it's not this concept times 20 with a how to sheet... no. We have to take into consideration each store and their unique windows because none of the windows are actually that cookie cut in size. But having done so over the years, we know it and our vendors know it. I've gotten to that stage now where it's much easier because I've learned, oh, no you can't do that in that window, because it doesn't have the ceiling or the depth. I've memorized it all and it's gotten easier over the years. It's not as cookie cut as I'd like it to be, but then again, if I did have it that way I'm sure it would be boring.

I'm going to start talking about some of the windows and I'm going to sound rather stupid. As I was looking through all the pictures you sent I kept trying to think of intelligent questions, but all I kept coming back to was, "Wow, that's nice, how'd they do that?"
It was like a trip down memory lane for me when I was pulling together the last ten years worth of pictures and saying, "Oh, I remember that one." I could see my work evolving and I was saying, "Wow, I can't believe I went there at that time."

I did notice that so many of your windows have a distinct mood or they evoke a strong sense of place, or even temperature. Some of the coat windows, for instance, look cold and made me think, "Oh, I need that coat," or a tropical window looks hot. In your Christmas windows for 2011 there is a dining room window that looks so warm and inviting. Obviously all intended on your part. Can you talk about that?
For me, the number one, most important thing about windows is lighting. Number one. Nothing can set me off more than bad lighting. I can spend a lot of money on a window — the best of mannequins, best of props — but if that lighting is not done well, then I've done it in vain because the outcome will not be there. If my intent is for a window to look cold, then it's all going to come through with the lighting. The props and everything can be there, but if the lighting is not done well and properly, then it won't come off. Like you've seen, wow, that's hot or I can feel that that's in a cold space, or I can feel that that's in a warm tropical space, that all comes down to the lighting.

Which come first when you're planning a window: the props, the idea, the merchandise?
It varies, sometimes we've come across a great prop and we say, "We've got to use that, what can we do around it?" And sometimes you're hit with, "You really have to feature or launch this brand," and you have to find out what the brand is all about and what is the vision. Or you have to get more information in order to build something around it. And sometimes you get a theme. We have a fashion direction office and they give us the themes for the year, and when we get the theme it's, "Ok, what are we going to do about it." Right now we're in the midst of opening windows for the theme, Embrace Color, a trend for spring that's all about bright colors and pops of color. So we're working on that right now. So, sometimes you're influenced by the trend itself. It varies.

I've noticed that color plays such an important part in so many of your windows. Do you have a color philosophy?
You know what? It's all about grabbing the customer's attention as they walk by. And it's no different here than in New York City: people

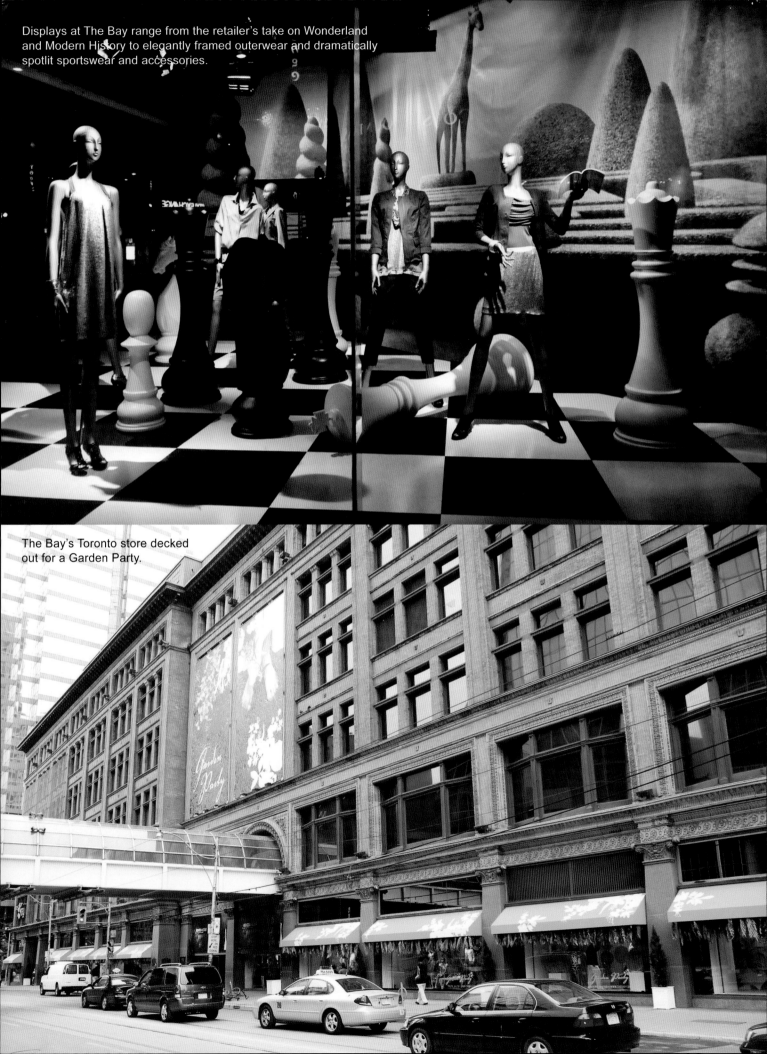

Displays at The Bay range from the retailer's take on Wonderland and Modern History to elegantly framed outerwear and dramatically spotlit sportswear and accessories.

The Bay's Toronto store decked out for a Garden Party.

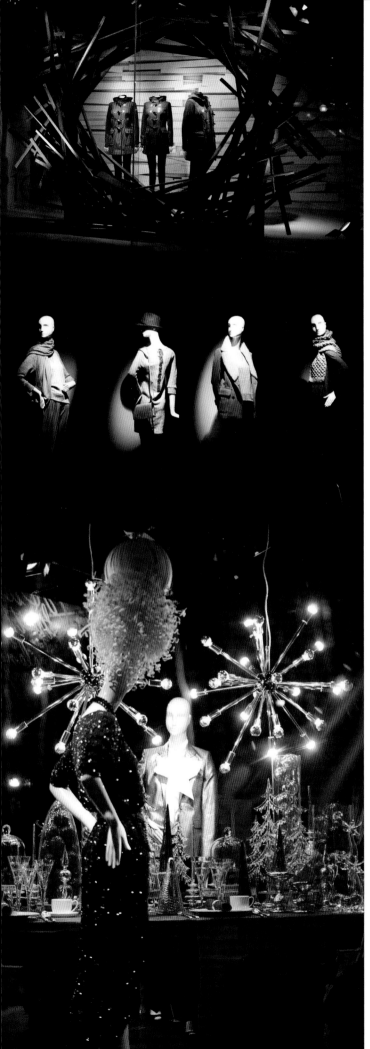

are walking with determination and not necessarily looking as they're walking. In a day and age when everyone has blackberries and everything else they're attention is elsewhere. It's all about making the window impactful, be it with the color or the lighting, so it is going to make someone stop and take a look.

And there's so many windows, there's such a sheer number that you have to do.
Oh yes, It's hard, because in this one building in Toronto we have what we call banks of windows and they are by street. And they are not the same. We want the customer to want to go around the corner and look at the other bank of windows. We don't repeat ourselves. We might have a similar background or something, but I can guarantee you the mannequins are going to be different or the props are going to change. We want the customer to walk around the complete building.

How is retailing and display different in Canada from the U.S or Europe?
I don't know about retailing, I think retailing is the same pretty much everywhere it's just what aspect or what path you take. I mean there are some retailers that have a cleaner approach and some that are more sale and clearance oriented. It's varied, everyone is different. I look to European retail quite often myself, they always seem to hit things first before we do in North America. More often than not when I'm buying magazine for inspiration and for ideas and to see what everyone is doing, I tend to go to the European magazines first only because they seem to be further ahead than we are.

What else do you look to for inspiration?
For me it's everywhere. When I started in this business I had a mentor who told me visual inspiration is everywhere. So if you're walking down the street you should always keep your eyes open. You never know when you're going to be inspired by something. I have that mentality.

Retailing has been going through a rough patch over the past few years. What is your hope for the future and how do you see it going forward successfully especially in regards to display and visual merchandising?
I have tried not to concentrate on the rough patches. There's always going to be good and bad times. You have to give everything your best, if the times are better or the times are hard. Over the years there's always been that up/down and there's always going to be an up/down. You can't control that bottom dollar in the end, but you have to make sure you do your best job either way — given that you have two pennies to rub together or a million dollars. You always have to give it your best.

Is there anything that I haven't asked you that you feel is important and that you want to share with fellow display people or people in retailing?
I started in this business because I was just wowed by visual, I didn't know what I wanted to do in this world. I had an artistic knack and I loved the arts. But I was just amazed by windows and stores with mannequins and everything. It's always been a passion of mine. In this business you have to have that passion. Retail is not an easy field to be in, because one minute you're in, one minute you're out. You're only as good as your last job. You can easily be replaced. There's a lot of negative to this field, but there's so much that's positive. The return of seeing your work in the store or the windows, there's such a great feeling of awe.

For me, creating windows is always a great experience, no matter how much work I have to put into it. But you have to be passionate to be in this field. I dislike hearing people say, "I'm so tired of this and this and this." And yeah, we can all complain and there's always going to be a good or bad day, but I think this is one of the most creative fields you can be in. There's so much that you can do; it's so limitless. It all depends on how much passion you have for it.

Thank you very much Ana.

Window Displays

Window display, as in no other, is the realm in which the visual rules. The windows must capture the eye and be understood in the split second it takes to walk by a store. Of course "walking by" is what all of these retailers are trying to prevent. This is advertising and promotion at its most basic—on the pavement, or mall corridor, right outside the store, And it still works. A great window has the power to turn a passerby into a shopper. It relates to the power of possession, what is seen and coveted will be purchased.

The merchandise on display is, therefore, a mighty and powerful component in an effective window, but what surrounds that merchandise can mean the difference between bland and bought. There is no longer a doctrine of window style and display. Visual directors are instead free to play and change and experiment. They can make a big splash or speak with a quite voice. The freedom of expression has made retailing more exciting and the long-predicted death of window display, moot.

NK GLAS PORSLIN & KÖK

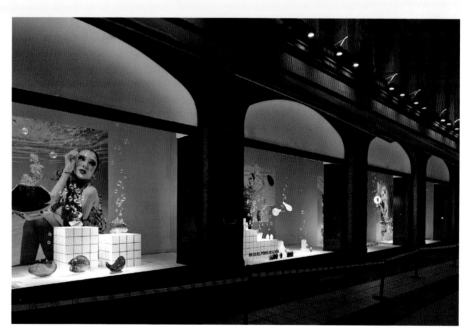

THIS PAGE AND OPPOSITE: NK Department store combines home and fashion accessories in contemporary underwater scenes. The concepts found in fashion are also integral to the presentation of home accessories. CEO of the glass, porcelain and kitchen division, Jorgen Eriksson explains, "I was frustrated by the way our type of products were shown and displayed in Sweden, and worldwide. I travel a lot and wherever I looked, it was boring. A good brand in fashion knows its customer and can last over a long period of time as it continually presents itself in an attractive way. In home accessories it is always about price and the products are shown individually. I came up with the idea of adding 'fashion' while I was accompanying a friend to the Paris fashion shows. I wanted to raise the value of the products, to say to our customer that the accessories you choose for your home are as important as the accessories you put on yourself."

NK Department Store Stockholm, Sweden

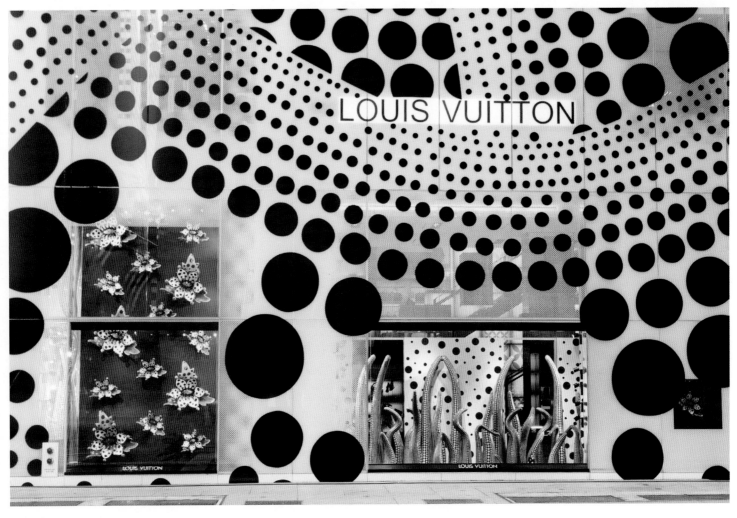

THIS PAGE AND OPPOSITE: This display at Louis Vuitton extended to the entire building. The joyous swirls of dots, the work of famed artist Yayoi Kusama, captured attention both day and night. Installation involved scaling the art and tiling the image to properly fit the building. It incorporated a total of 250 panels and covered 12,750 square feet. The warm-toned display windows, also full of dots, contrasted with the black-and-white art above.

Louis Vuitton New York, NY

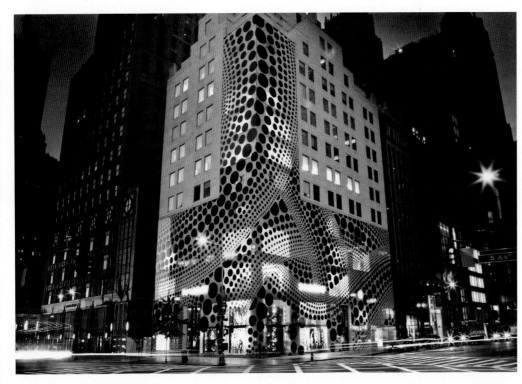

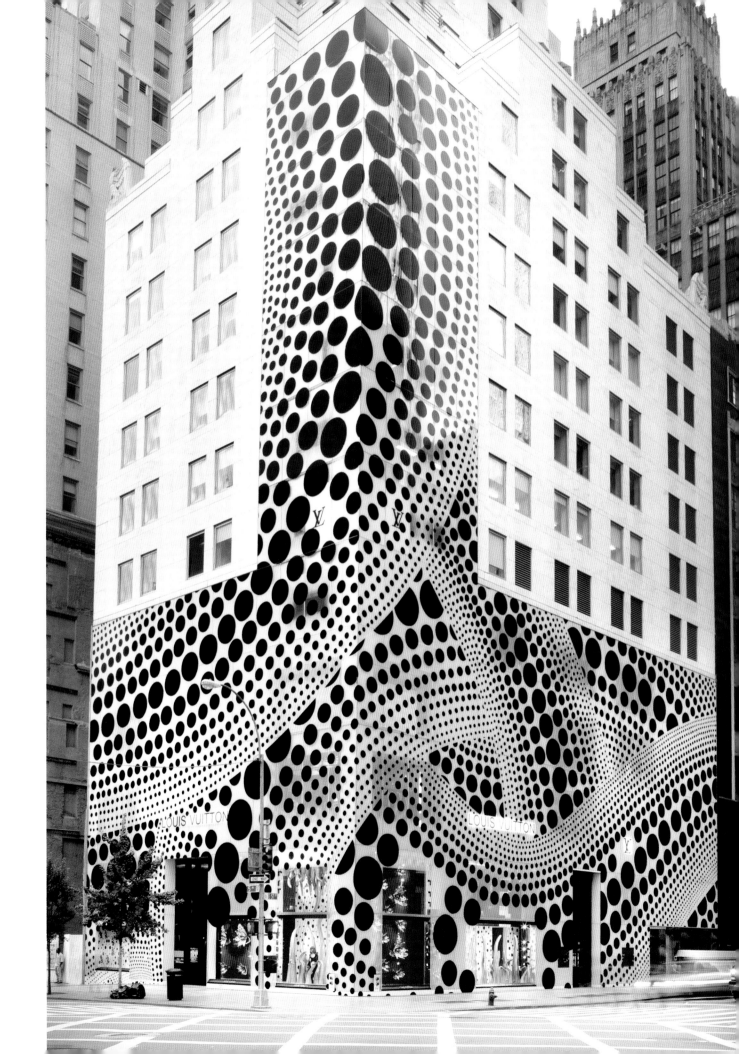

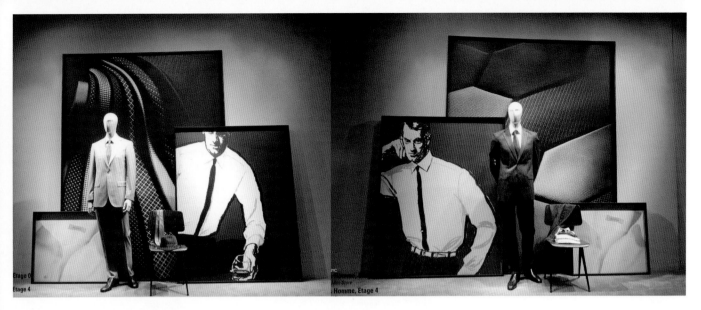

THIS PAGE: Printemps showcases Brummell, a line of menswear whose namesake, Beau Brummell, was an arbiter of men's fashion in Regency England and is widely credited with introducing the modern man's suit worn with a tie. While the windows do not reflect Regency England, they do recall an earlier age of dashingly turned out men with crisp shirts, proper ties and shined shoes. You can almost smell the aftershave. The variety of height and sizes of the large, framed pictures, and the spots of dark red/ rust keep these largely monochromatic windows visually interesting.

Printemps Paris, France

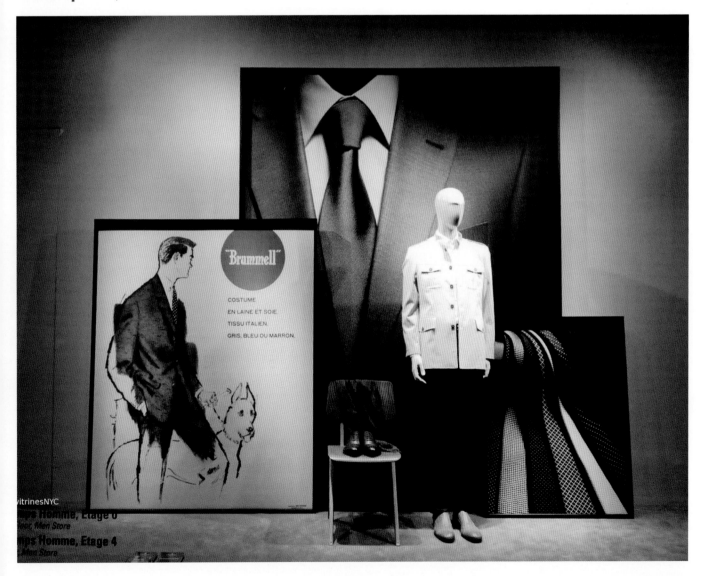

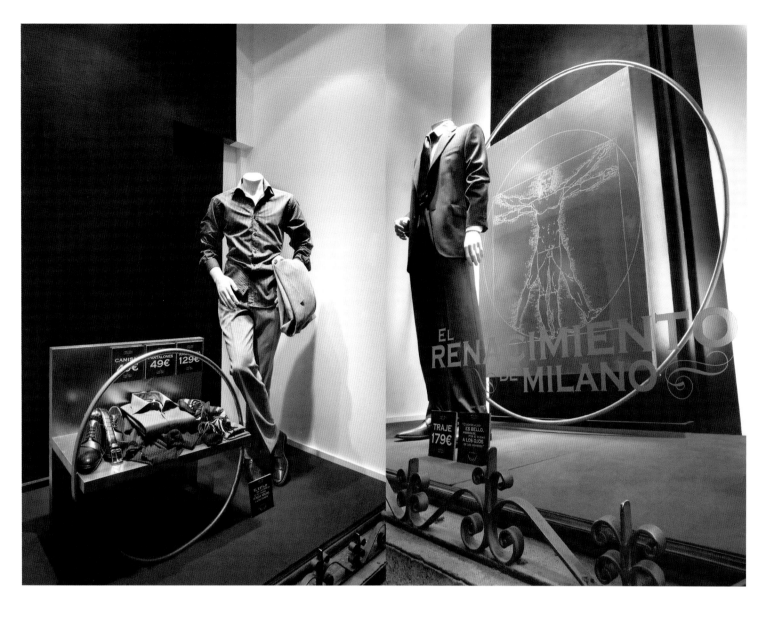

THIS PAGE: Milano, part of the Cortefeil Group, carries menswear targeted to the business customer. According to creative director Carlos Aires, the inspiration for the windows was the Renaissance with its relentless search for beauty. A well-suited mannequin is placed in front of DaVinci's symbolic Man and together, mannequin and drawing, place the suit in the center of "Man's" universe. A related window relies on only the circle to convey the message.

Milano Madrid Spain

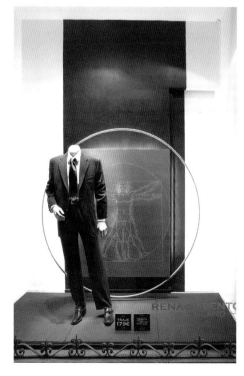

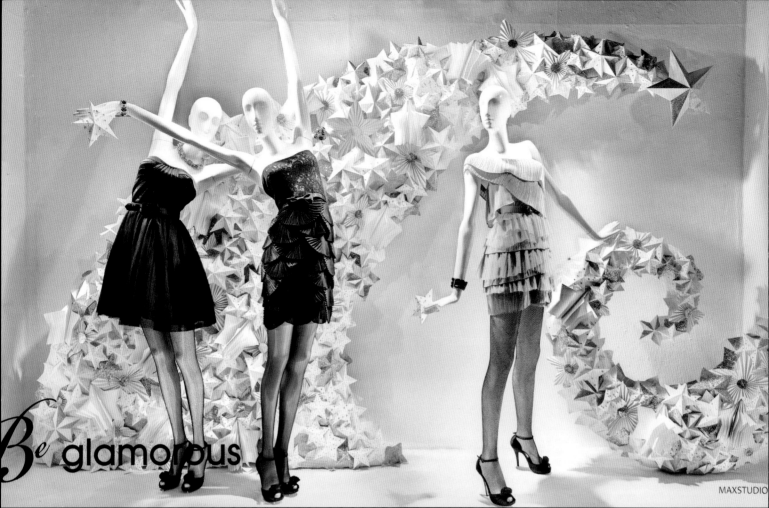

B^e glamorous

MAXSTUDIO

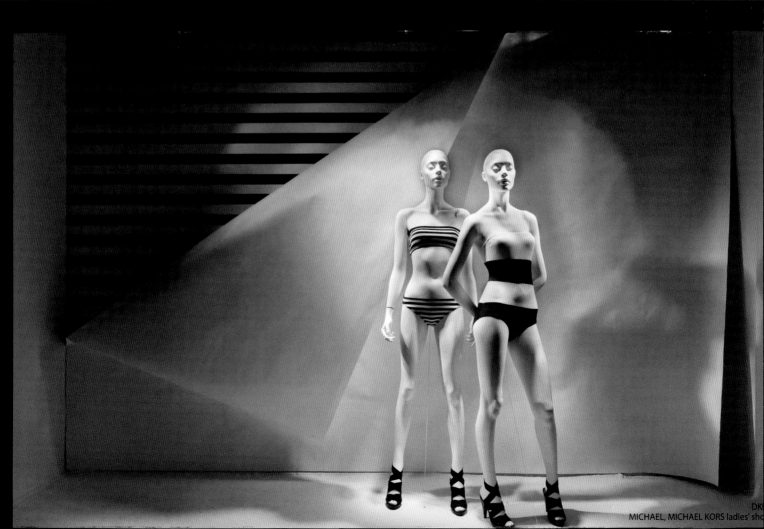

DK
MICHAEL, MICHAEL KORS ladies' sh

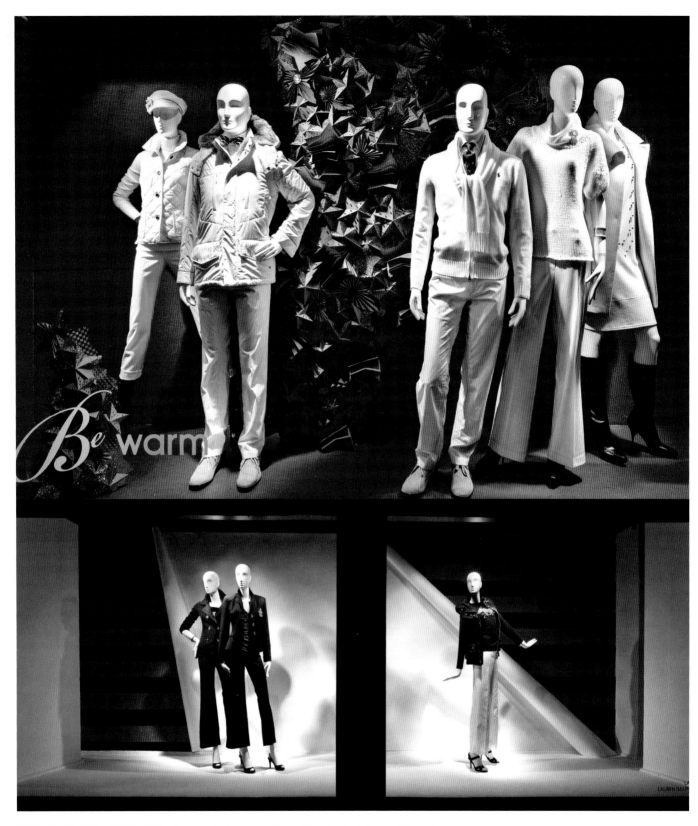

THIS PAGE AND OPPOSITE: These windows are from Macy's, but from different times, with different merchandise. Yet, it's fun to place them side-by-side to explore the possibilities of stars and stripes. The "stars" windows utilize Macy's star logo. The folded paper stars tumble through the windows, forming curves and shapes. The stripes are, of course, more linear and architectural with a minimalist quality. Hiding portions of the pattern only adds to their power.

Macy's Herald Square, New York, NY

THIS PAGE AND OPPOSITE: Shining out along Königsallee, a beautiful shopping boulevard in Düsseldorf, are these strikingly contemporary windows from Eickhoff. The displays utilize video installations to project images from the runway. Creative director Stefan Sammet explains, "Large pillars with special mirrors were placed in the display windows. Behind the mirror area a video display terminal projected larger-than-life extractions of runway shows. The special effect was that only the models on the runway, and not their surroundings, were seen on the mirror area. The result was a graceful and light installation, perfect for the spring season." The store offers a large range of designer labels including Dior, Gucci, Dolce & Gabbana, Giorgio Armani, as well as sportswear from Moncler, Woolrich, and the work of young designers such as Haider Ackermann, Miu Miu and Carven. The windows and the modern, stylized mannequins effectively communicate and reinforce Eickhoff's reputation for the highest quality fashions.

Eickhoff Düsseldorf, Germany

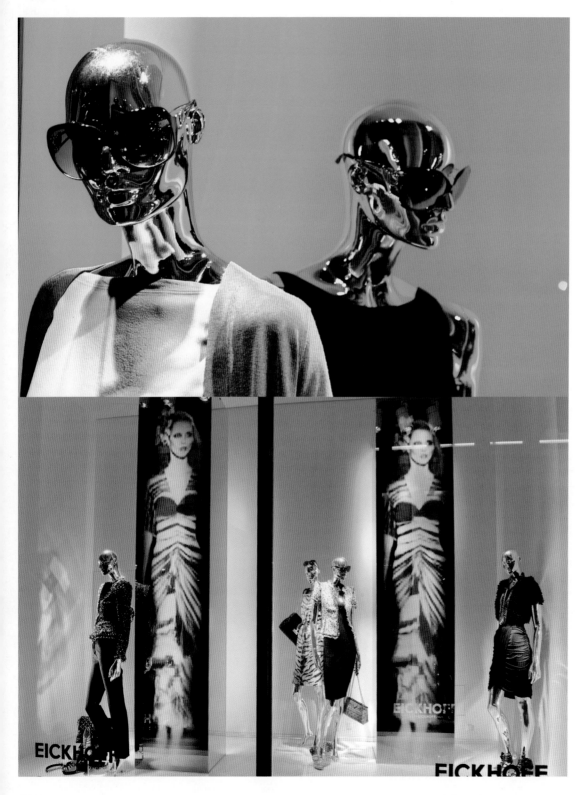

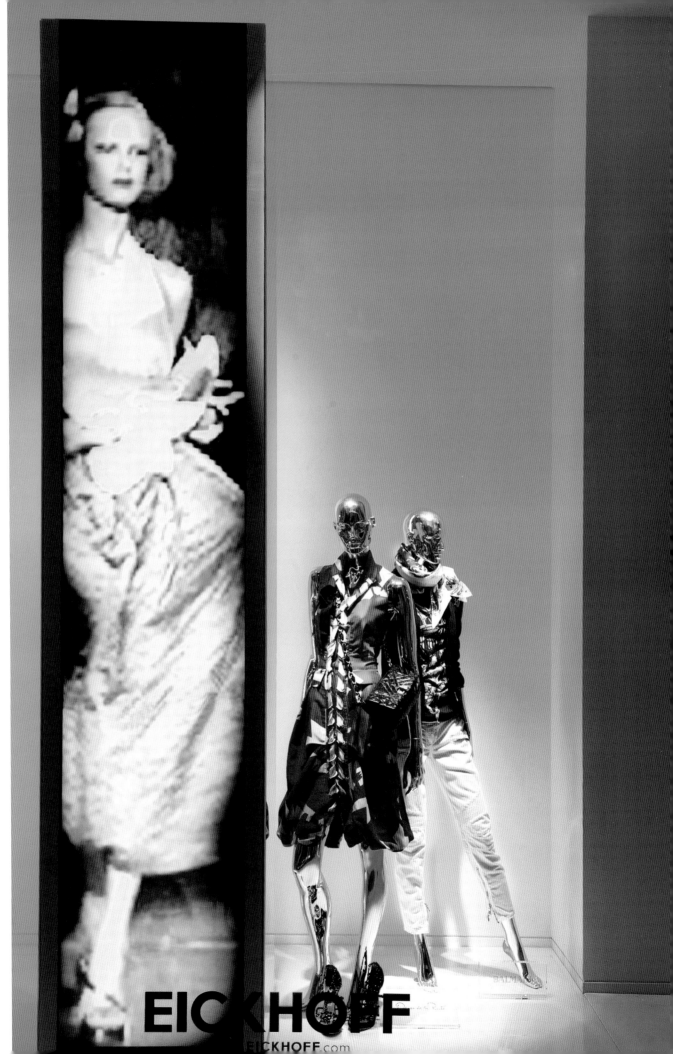

EICKHOFF
EICKHOFF.com

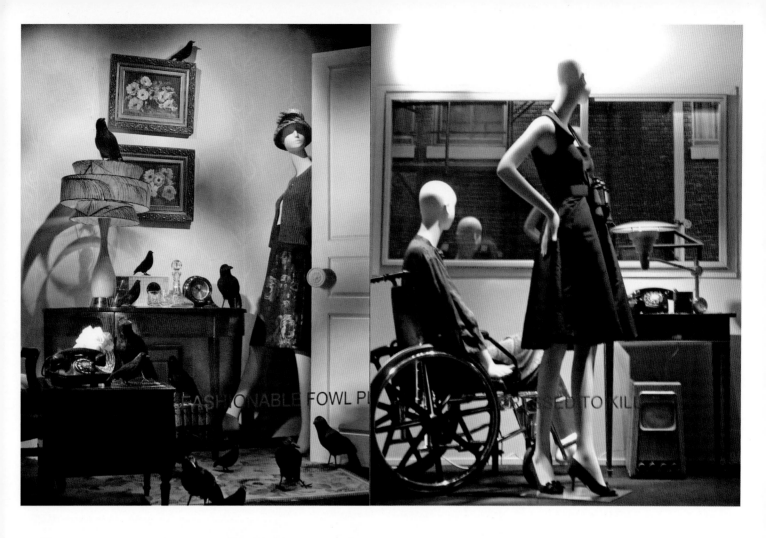

FASHIONABLE FOWL PL[...]SED TO KILL

THIS PAGE AND OPPOSITE: Miss Jackson's has a long history of original and interesting windows that, while referencing any number of outside sources, always showcase the fashions to their fullest advantage. This small sampling, from different times and seasons, demonstrates designer Stacy Suvino's range of ideas. Two windows, above, are an homage to the movies of Alfred Hitchcock, specifically *The Birds* and *Rear Window.* Evoking a different mood is the bubble gum window, left. It's a light-hearted take on the impossibility of getting rid of that piece of gum you've just stepped in. In yet another window, opposite page, Lilliputian soldiers are armed and ready to "start a revolution" as they capture the mannequin. The window is filled with attention-capturing details, but even so, it's the gown that gets all the glory.

Miss Jackson's Tulsa, OK

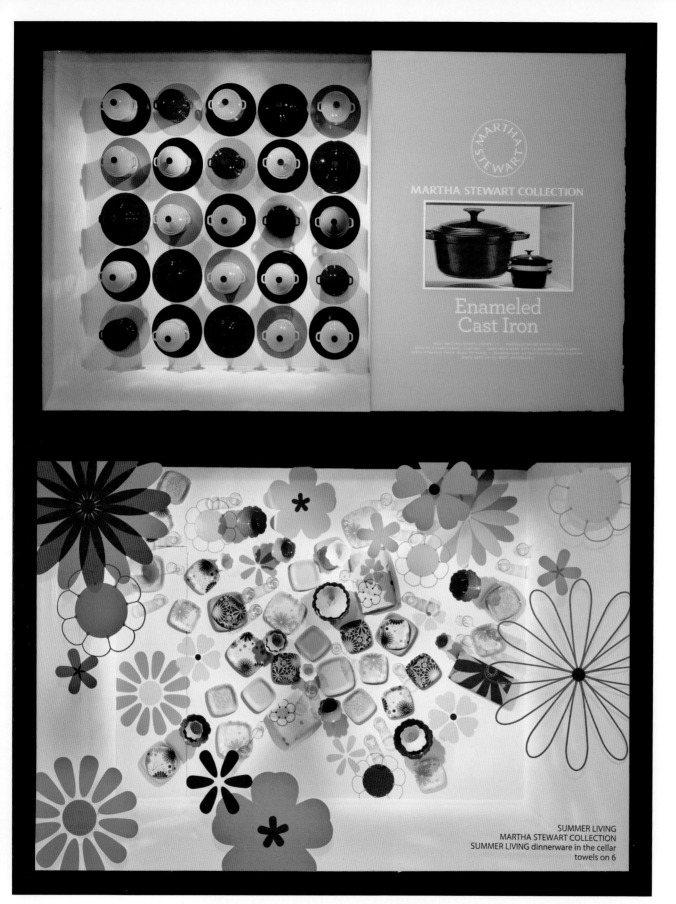

SUMMER LIVING
MARTHA STEWART COLLECTION
SUMMER LIVING dinnerware in the cellar
towels on 6

THIS PAGE: Macy's created these bright, colorful displays to promote the Martha Stewart line of home goods and housewares. Enameled cast iron pots and flowery dinnerware are shown in gravity-defying positions that raise them to the eye level of most passersby. The arrangements also result in attractive graphic patterns.

Macy's Herald Square, New York, NY

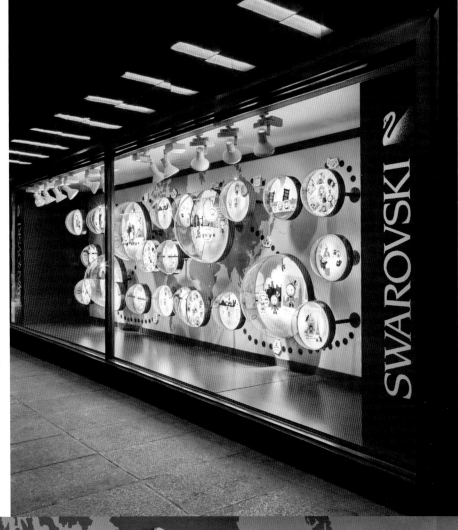

THIS PAGE: Swarovski's Madrid window, in celebration of the London Olympics, took two playful characters, Erica and Eliot, on a trip around the world. Whimsical drawings depict various scenes from the journey as the delightful pair visits such locales as New York and Paris. Transparent, half spheres—or globes if you will—enclose the drawings and focus viewers' attention, inviting them to step close. Further emphasizing the trip is a large, world map on the back wall of the window.

Swarovski Madrid, Spain

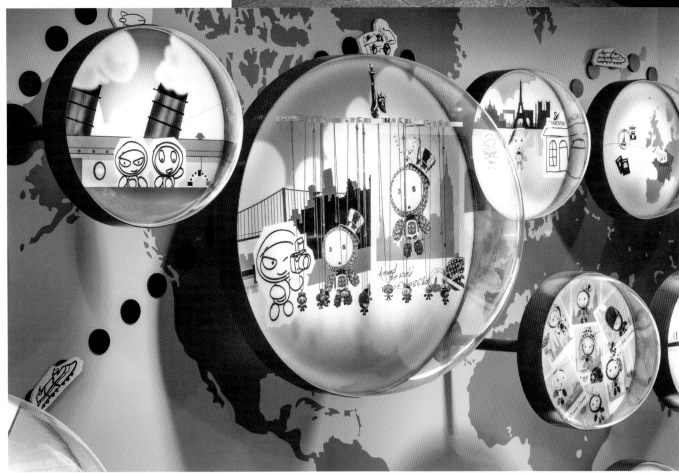

THIS PAGE: Forms, custom designed for the store, greet customers from niches on either side of the entrance at Hong Kong's ISE Jewellery. The one-of-a-kind forms, one male, one female, are utilized to showcase special items. The figures were initially modeled in clay so the designers could experiment and adjust the proportions to best showcase the items; the forms were then cast and sprayed to a metallic finish.

ISE Jewellery
The Peninsula, Hong Kong

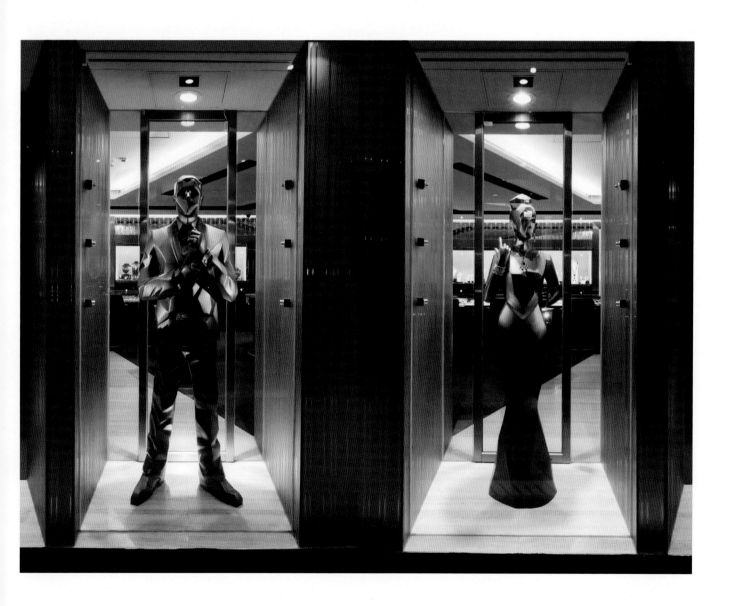

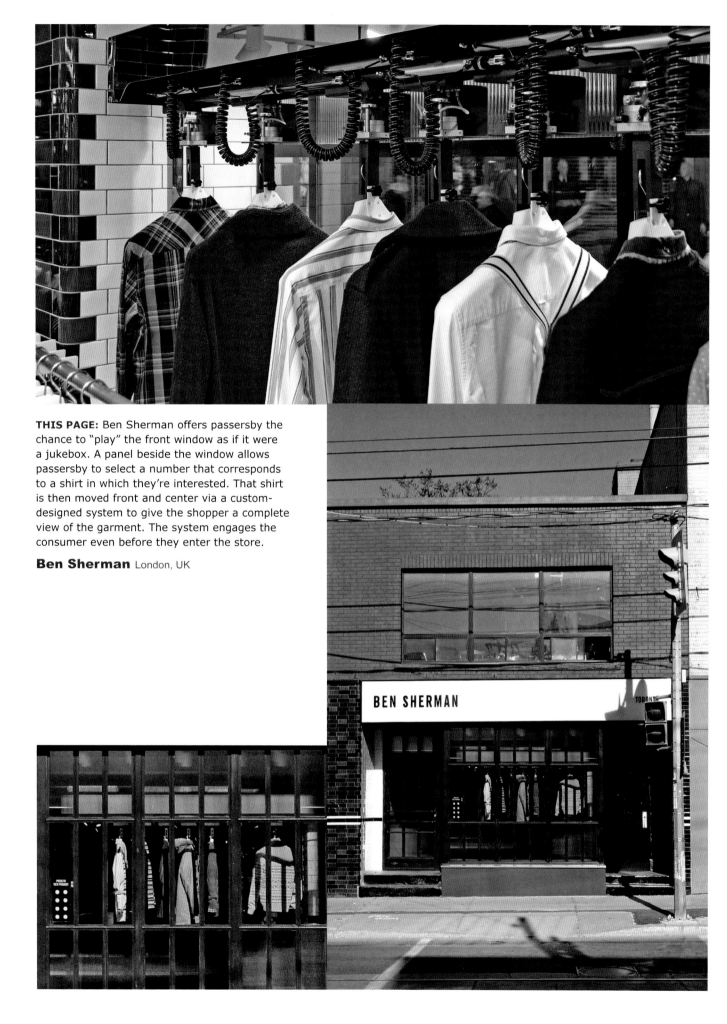

THIS PAGE: Ben Sherman offers passersby the chance to "play" the front window as if it were a jukebox. A panel beside the window allows passersby to select a number that corresponds to a shirt in which they're interested. That shirt is then moved front and center via a custom-designed system to give the shopper a complete view of the garment. The system engages the consumer even before they enter the store.

Ben Sherman London, UK

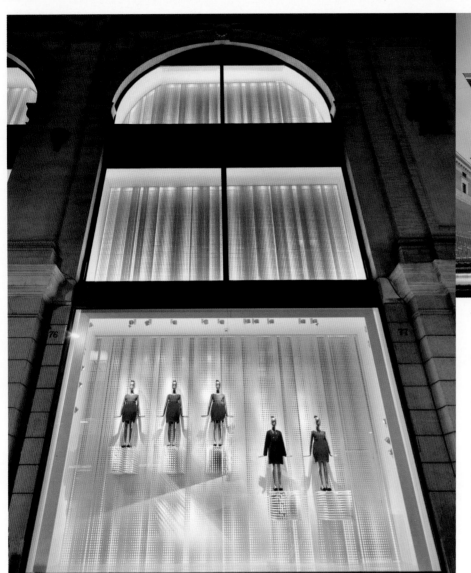

THIS PAGE: The Zara store in Rome is located in an architecturally striking building with dramatic arched windows that reach three floors high. The retailer uses understatement and subtlety to take full advantage of these glittering beacons. In front of semi-sheer curtains are placed stylized mannequins in simple, but gravity-defying arrangements. The results are consistent with the brand's image and the perfect introduction to the store's interior.

Zara Rome, Italy

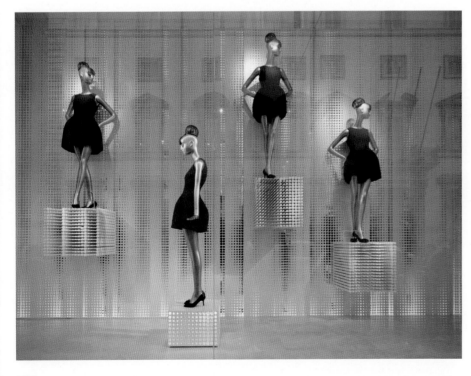

THIS PAGE: Anthropologie creates windows that sparkle with 35mm slides, items that are almost extinct. From one window, above, the slides are "projected" through the wall to display behind the form in the next window over. Against dark backgrounds the slides reflect light into the night, recalling fashion photography's earlier days.

Anthropologie New York, NY

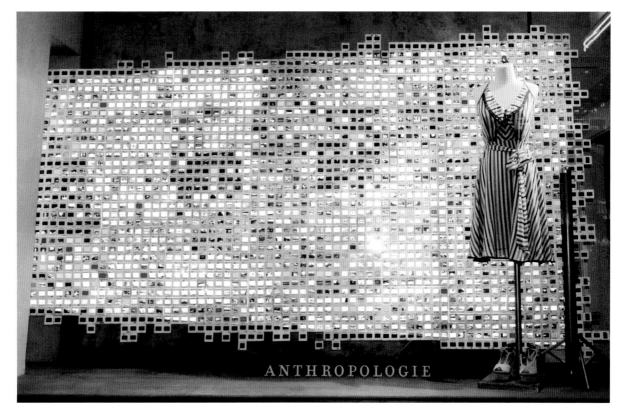

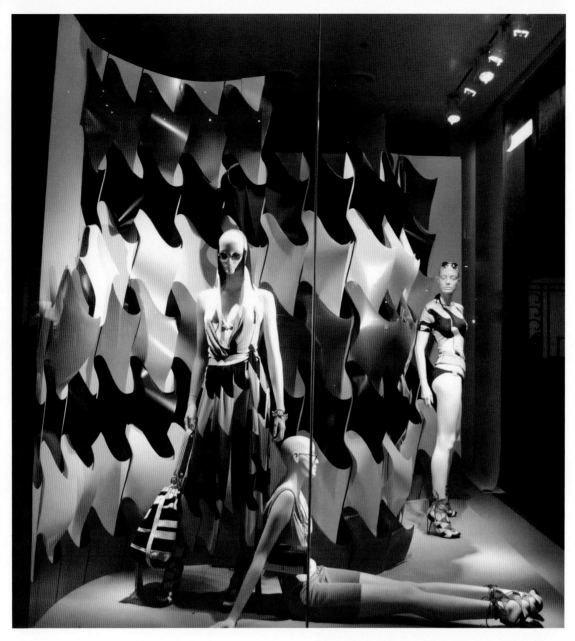

These two retailers celebrate both products and patterns. The vibrant pattern of the Diane von Furstenberg dress is enlarged and recreated in three dimensions behind the mannequins. The result is both eye-catching and relevant to the product. At Hermès large spools of thread in various colors are arranged in sculptural representations, some more literal than others, of the featured products.

Diane von Furstenberg New York, NY (above)

Hermès Paris, France (opposite page)

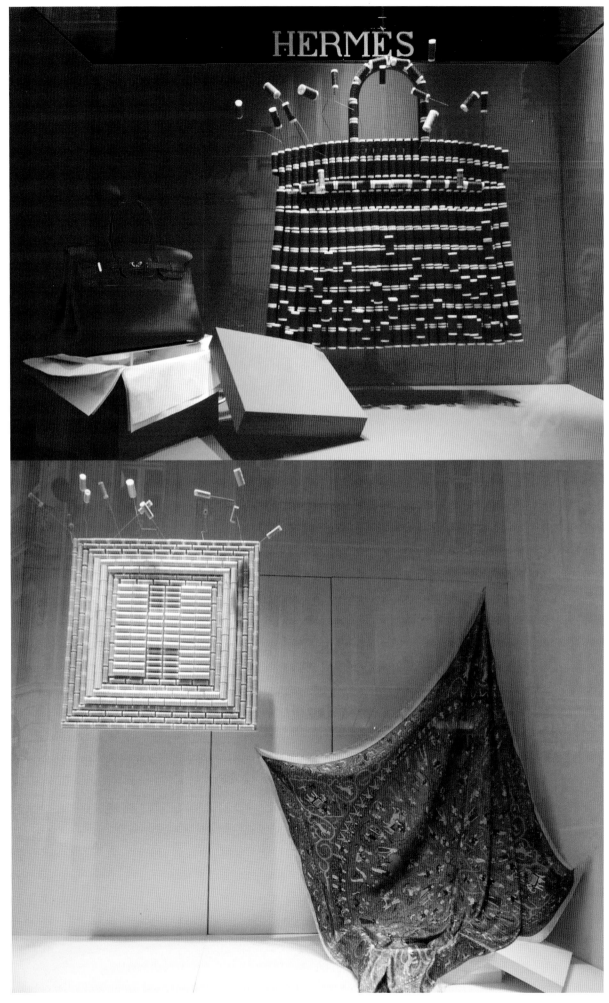

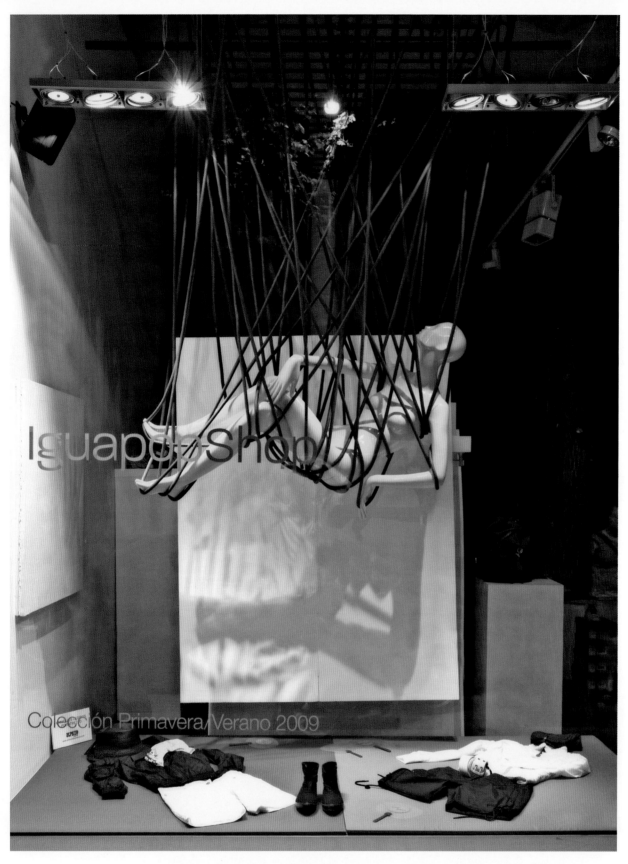

Window displays are meant to get attention and this one surely does. In an interesting twist the mannequin wears no clothing. It appears she got "hung up" before she was able to slip into the outfits carefully laid out on the floor below. Sometimes it's just fun to have fun.

Iguapop Gallery Born, Spain

THIS PAGE: Bright colors and varying heights project these colorful displays a great distance. Visual interest is always increased if the vertical space can be included in the merchandising mix.

Top Shop London, UK

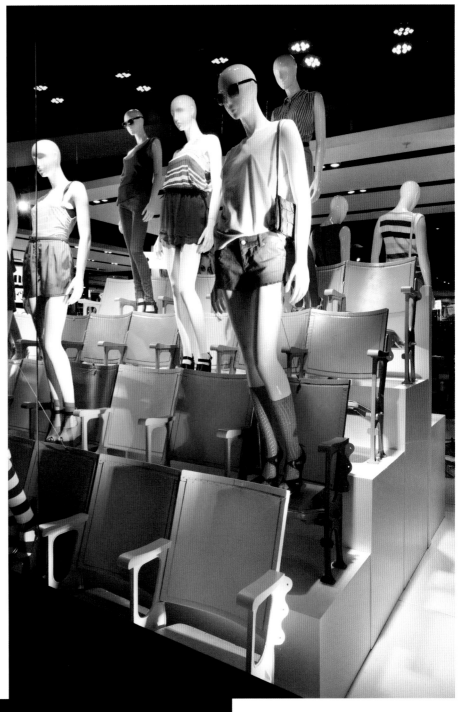

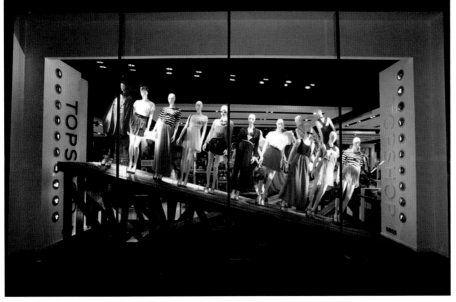

Holiday Windows

Deck the halls with boughs of holly—and anything else the display artist can dream up. Once dominated by elaborate displays aimed at families and children, many retailers now direct their holiday appeal to adults and add significant amounts of humor and sophistication. They avoid the holiday clichés while still striving to convey the spirit of the season. Retailers are all too often portrayed as cynical and criticized for commercializing the holidays. But commercialism is the retailer's reason for being. It's the industry's business. In addition—and as evidenced on the following pages as well as in countless stores and windows each holiday season—retailers, and in particular the visual directors who make retailing their life's work, do embrace the spirit of the season. Display professionals work all year long to get those holiday windows just right. The best of them communicate generosity and goodwill toward others.

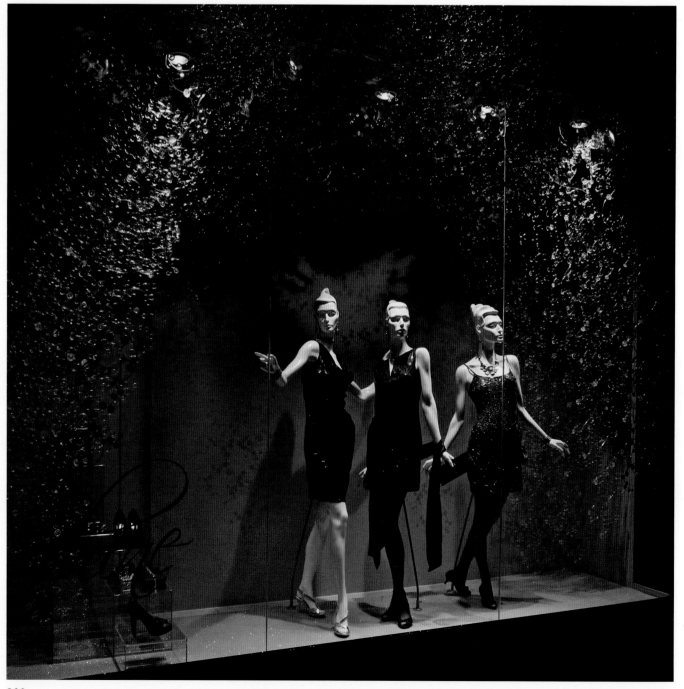

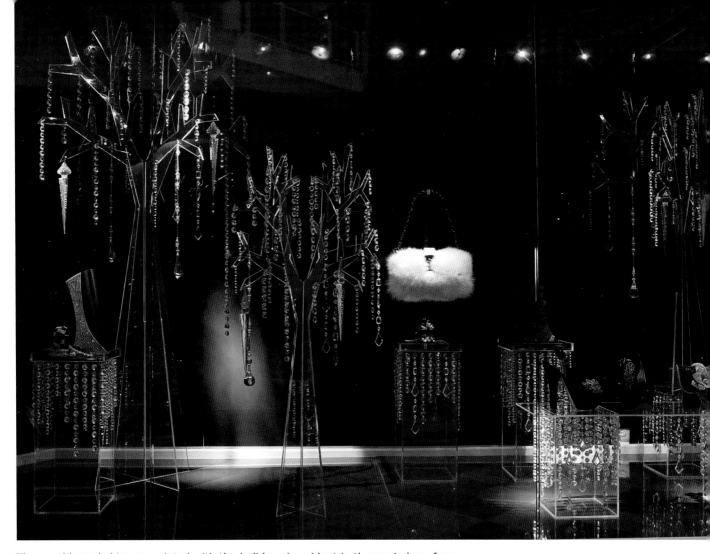

The sparkle and shine associated with the holidays is evident in these windows from Le Chateau and Galeria—located in Toronto and San Juan, respectively. The windows steer away from the traditional reds and greens and toward the dark glow of an elegant evening. Rich, dark blues, sparkling crystals and bangles define the windows and show off the fashions and accessories.

Le Chateau Toronto, ON, Canada (opposite pages and below)

Galeria Plaza Las Americas, San Juan, PR (above)

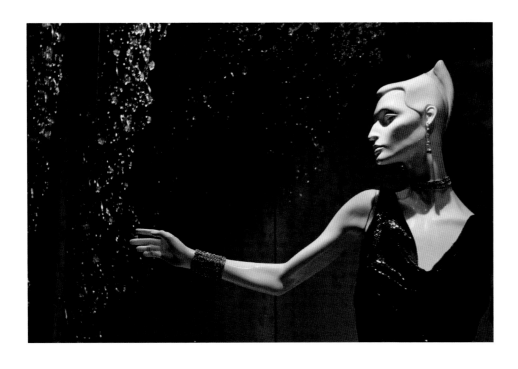

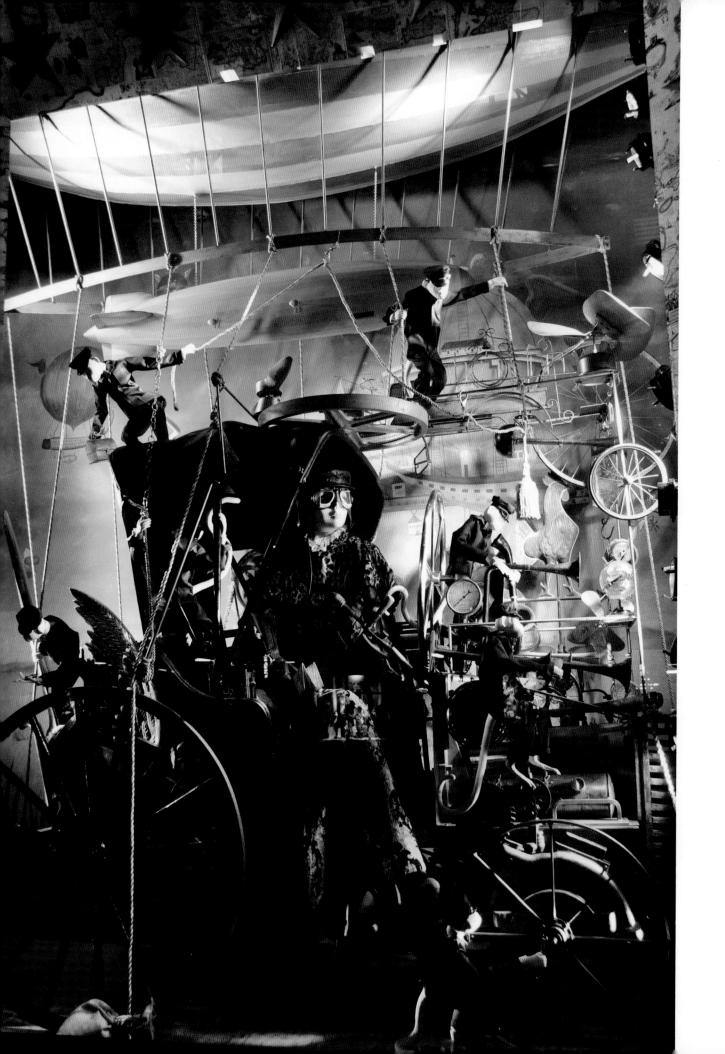

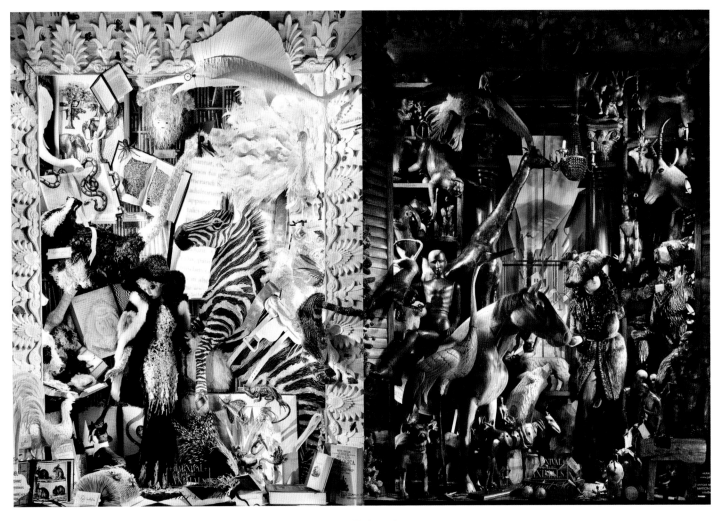

THIS PAGE AND OPPOSITE: Bergdorf Goodman's windows are filled to the brim with wonderful props, decorations and stories to discover. The depth of detail is truly astonishing. This retailer's windows have become an icon of the season, drawing tourists and locals alike to the sidewalks outside the store. The months and months and hours and hours of work pay off with viewer satisfaction, increased goodwill and the buzz of excitement.

Bergdorf Goodman New York, NY

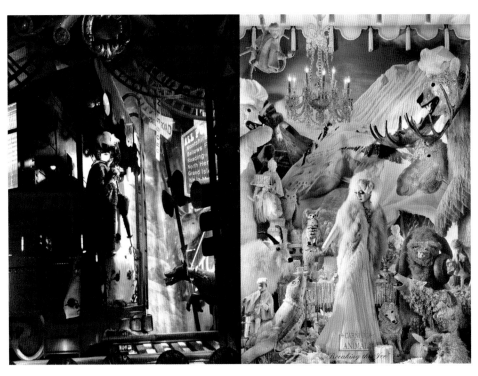

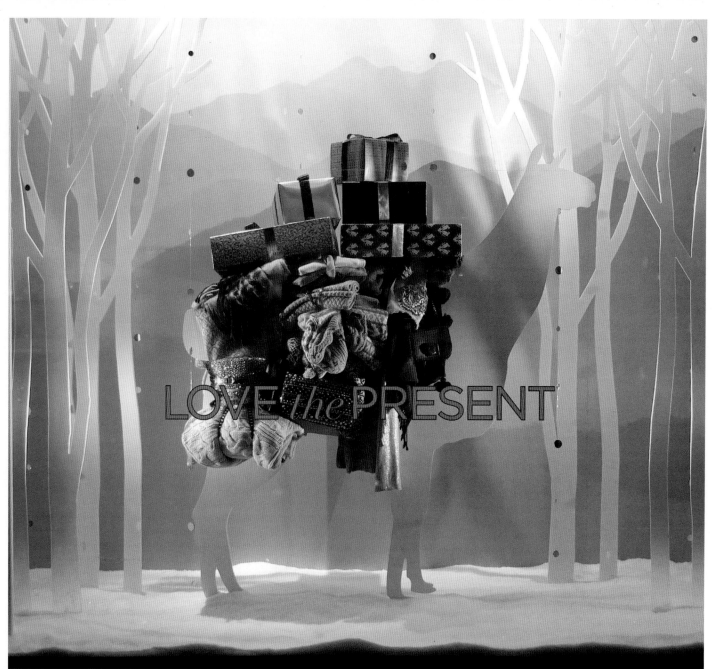

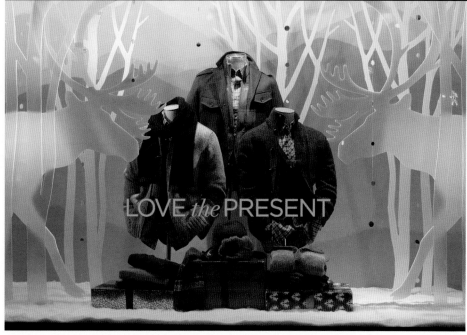

THIS PAGE AND OPPOSITE: The displays featured in Banana Republic's flagship stores relate directly to the retailer's holiday marketing campaign. The idea, according to Creative Director Harry Bader, was to create a pop-up greeting card effect. Trees and animals, frosted plexiglass and white cutouts, serve as fanciful companions for the featured products. A sprinkling of snow, diamond dust and tiny mirror garlands provide a touch of sparkle. The tag line from the campaign, "Love the Present" is written on the glass, connecting the store and campaign.

Banana Republic

New York, NY, Chicago, IL
San Francisco, CA

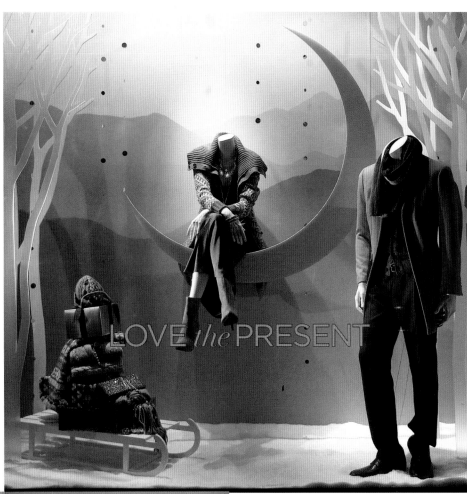

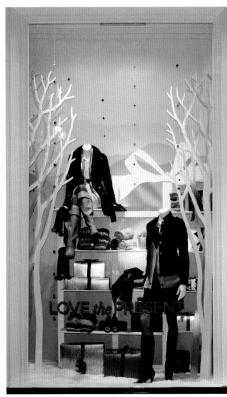

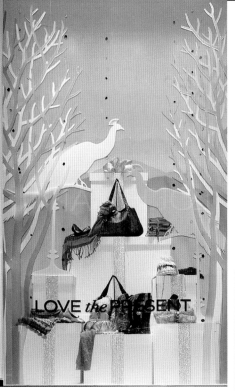

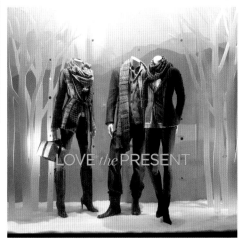

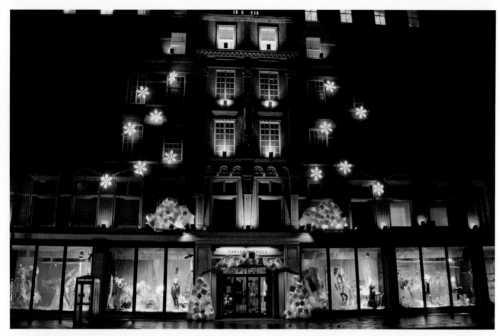

THIS PAGE AND OPPOSITE: The process of producing a holiday display was inspiration for these windows at Harvey Nichols. Head of display, Janet Wardley explains, "The idea started following a trip to our workshop where the team had been sculpting with polystyrene, it looked like it had been magically snowing inside. The workshop seemed to be frozen in time with polystyrene waste covering everything and the discarded raw pieces of polystyrene looking like giant chunks of snow. The overall effect was a contemporary Christmas-like setting, which felt like a new approach to how Christmas is normally portrayed. We developed this Frozen Christmas scheme from this scene to suggest a frozen workshop setting in which various beautiful Christmas props have been frozen in their production. Each prop reveals how they have been created showing the beauty of the basic raw materials and how each amazing prop has been lovingly handcrafted by skilled artists."

Harvey Nichols London, UK

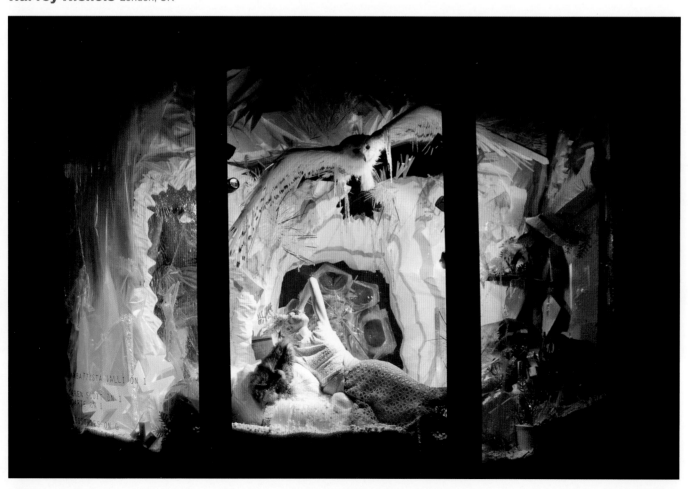

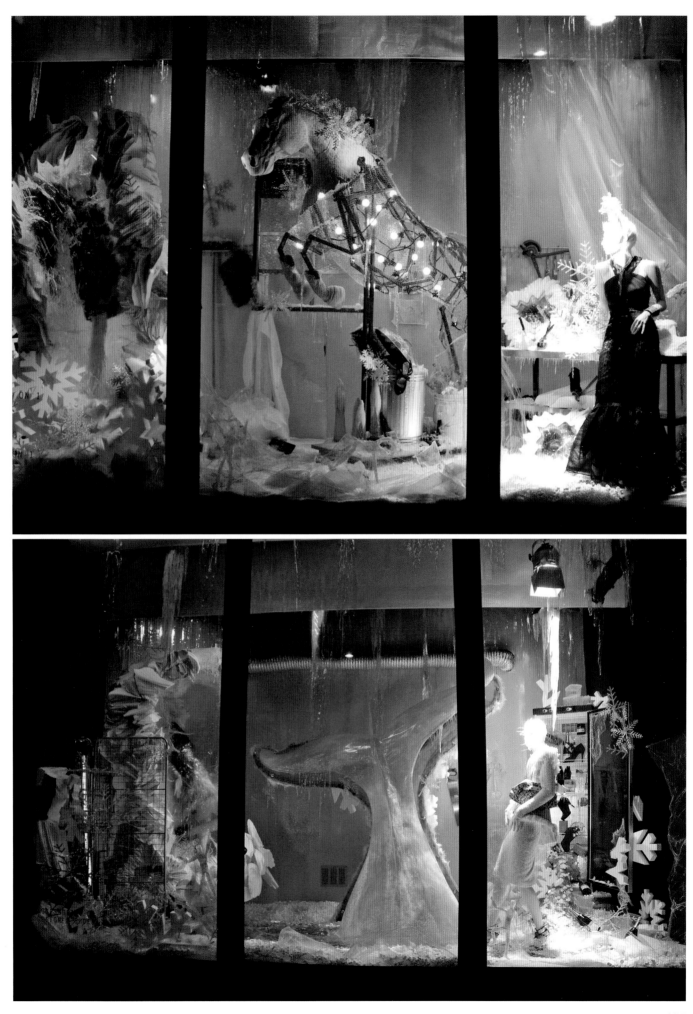

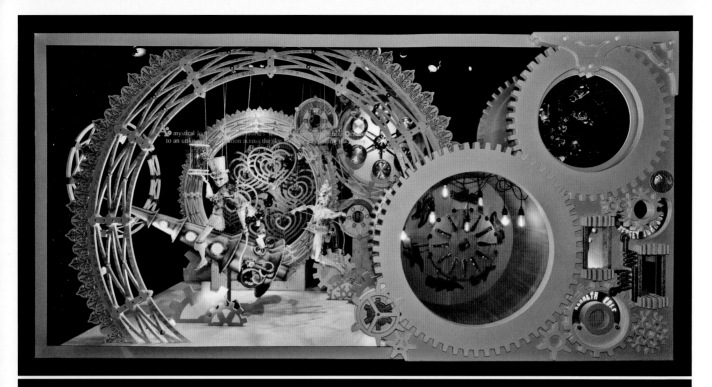

THIS PAGE: These windows promote Macy's partnership with the Make-A-Wish Foundation, in which the proceeds from celebrity ornaments were donated to the charity. Paul Olszewski, the director of windows for Macy's Herald Square explains: "Taking the theme of wishes, we decided to create an abstract world where wishes and dreams are not only granted but turned into ornaments and carried off to a magical tree at the North Pole. The style is decidedly Steampunk, 19th century styling meets sci-fi steam-powered technology. Characters are marionettes moved by strings from above to create unpredictable and unique animations." There was also a wall of screens to help tell the story and actively involve the viewer.

Consumers were actively involved in the display via interactive ornament stations that allowed them to design their own ornaments and then see the results in a window and have them sent to their cell phone or uploaded to their Facebook page.

Macy's Herald Square, New York, NY

THIS PAGE: The designers called this window "Do you hear what I hear" and filled it with retro-inspired props and mannequins in party outfits. Record album covers from the '50s and '60s create a colorful pattern on the back wall and are sure to attract passersby, perhaps hoping to pick out a childhood favorite. "Old-fashioned" record players, radios, TV sets and a fun fake Christmas tree complete the scene.

Le Chateau Toronto, ON, Canada

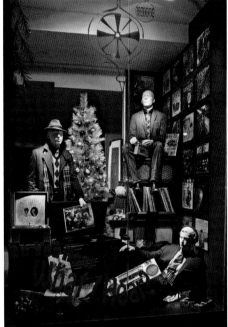

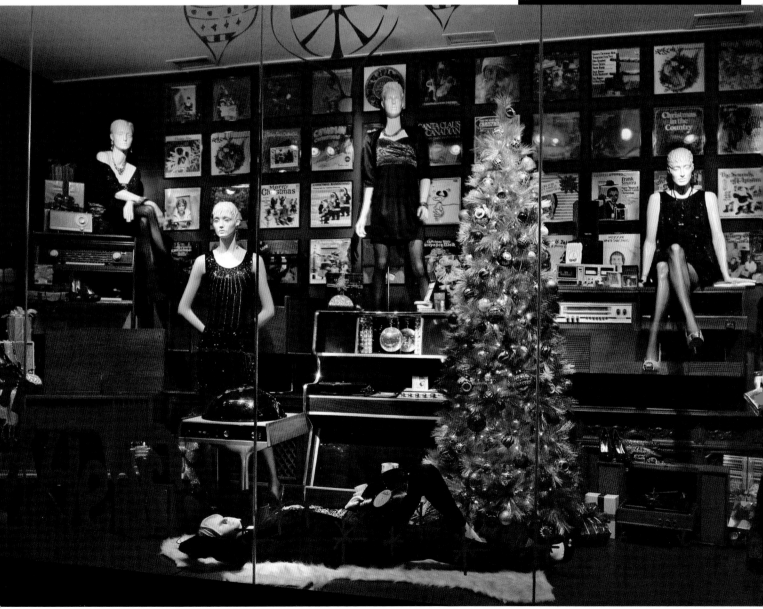

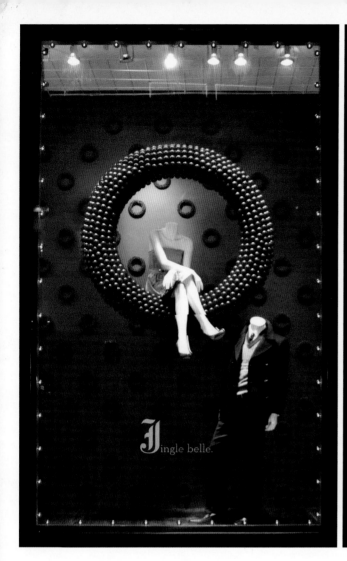

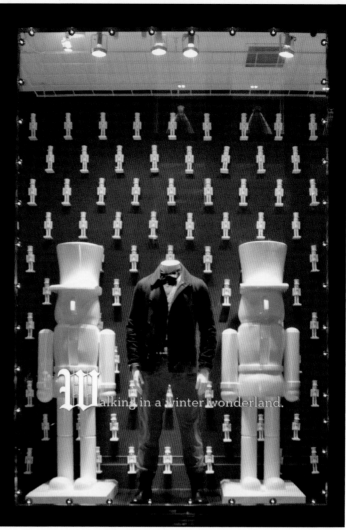

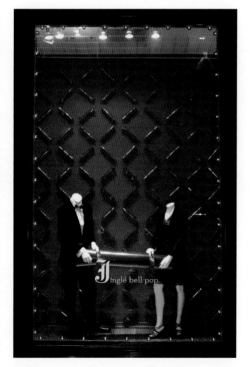

THIS PAGE AND OPPOSITE: The Gap started with fragments of traditional holiday songs and created a series of windows that stand out with bold color. Props in the windows—on the floors and attached to the backgrounds—have a playful relationship to the song fragment. The results are windows with a mixture of sophistication and fun that invite viewers to pause and make the connection between text and visuals.

The Gap Various locations

The sweetest time of year.

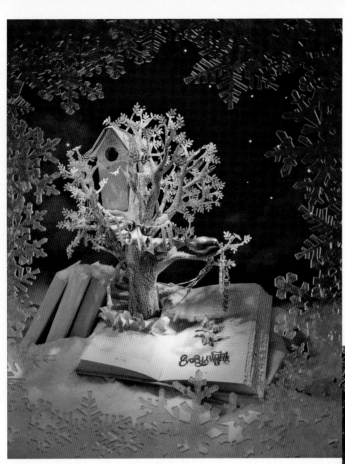

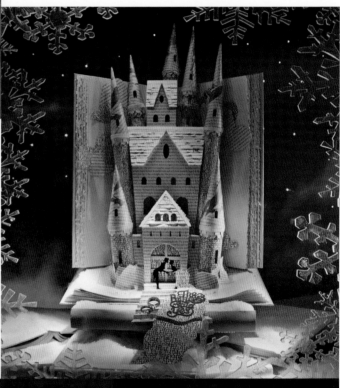

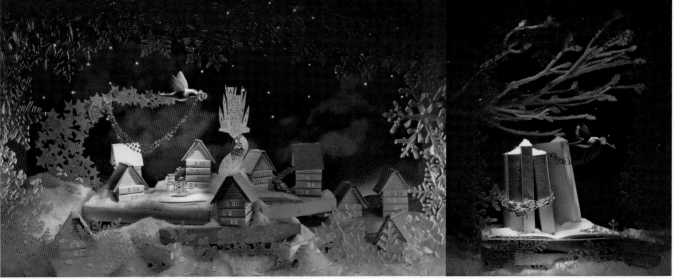

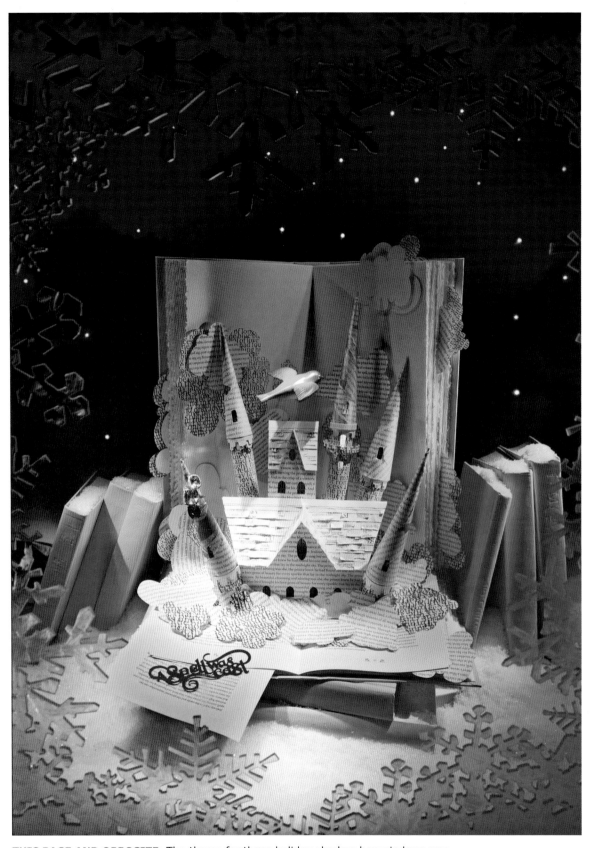

THIS PAGE AND OPPOSITE: The theme for these holiday shadow-box windows was a fanciful re-imagining of the French fairy tale of *L'Oiseau Bleu* or The Blue Bird. The story is about a prince in love with a princess, and the prince, falling prey to jealousy, is turned into a blue bird. The story tells of the many tokens of love he brings to his captive princess—now locked up in a castle—until he finally brings her a diamond that "lights up the sky." He is turned back into a prince, rescues, then marries the princess and "they lived happily ever after." The challenge for the designers was to combine the story and the retailer's gift offerings. The resulting windows are magical displays of sculpted pages, architecture and pop-up books.

Tiffany & Co. New York, NY

THIS PAGE AND OPPOSITE: In recent years Saks Fifth Avenue has utilized state-of-the-art technology to turn its entire building into a giant, awe-inspiring holiday treat. The imagery has changed over the years and what began as snowflakes has metamorphosed into first bubbles and then a feast of snowflakes, bubbles and whimsical pipes. The banks of windows below always relate to the light show above, creating complete holiday events that impress from the sidewalk and down the street. In the "bubble" year the windows followed the journey of a young girl obsessed with snowflakes and bubbles. In the next season's windows, props that match the "piping" above were placed with the well-turned-out mannequins.

Saks Fifth Avenue New York, NY

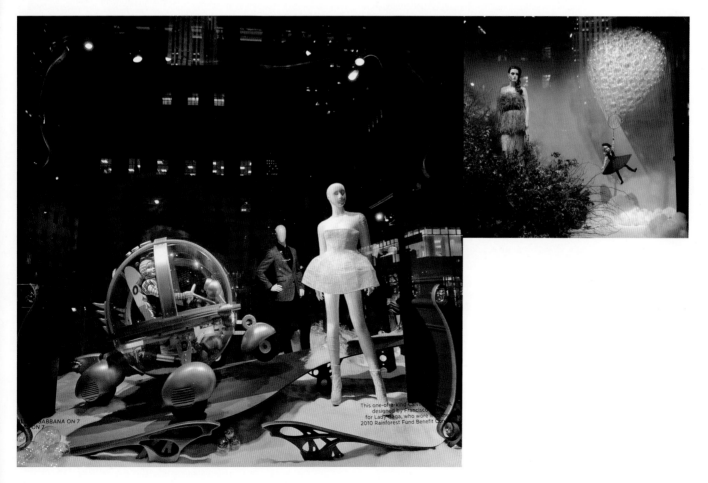

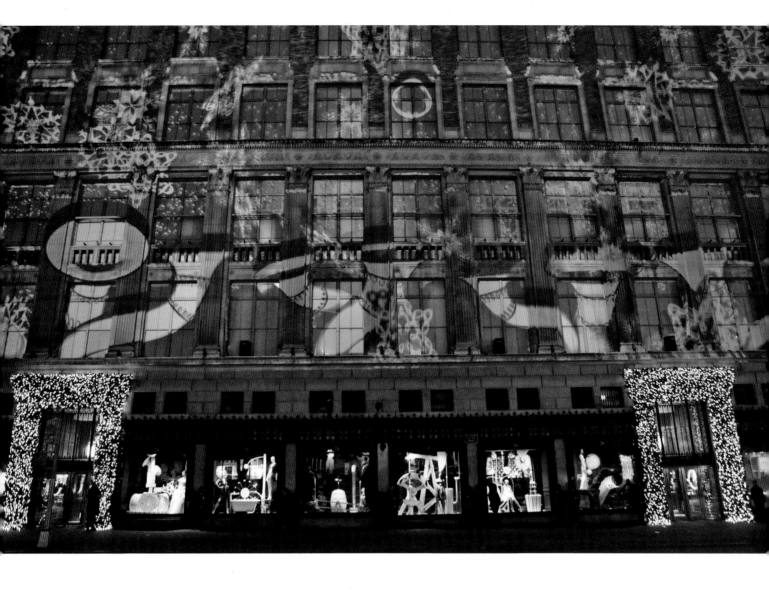

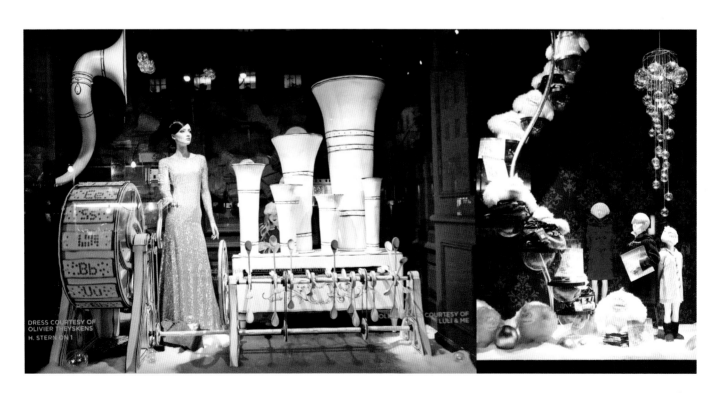

DRESS COURTESY OF
OLIVIER THEYSKENS
H. STERN ON 1

COURTESY OF
LULI & ME

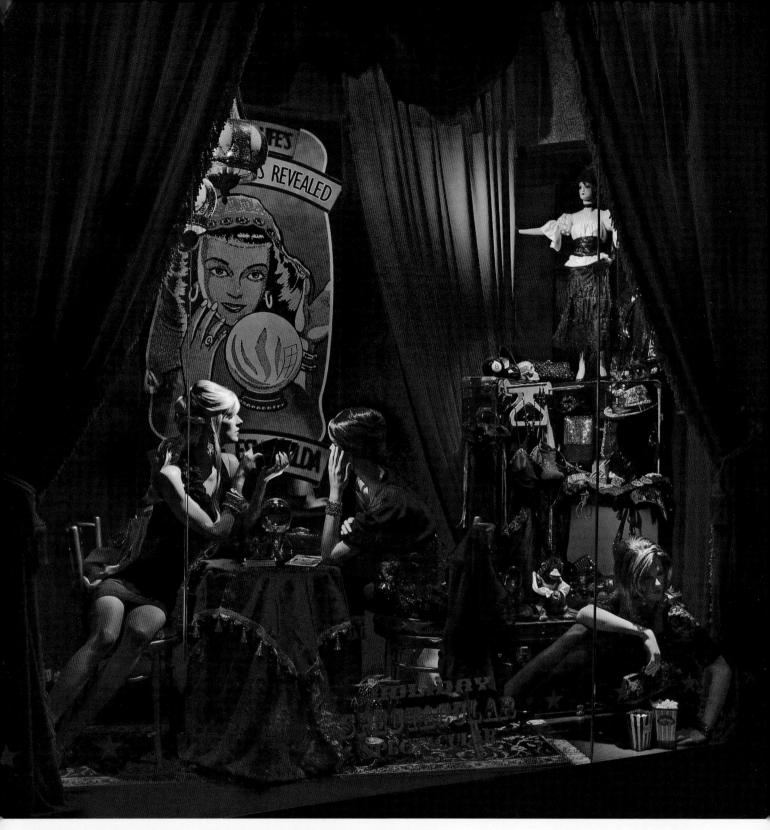

THIS PAGE AND OPPOSITE: A super-lush world of velvet drapes, vintage props, and strings of vintage holiday lights bring an old-time circus to life in the windows of Le Chateau in Toronto's Eaton Centre. The scenes pay tribute to the glory days of the circus as told in old movies and books and the results are an out-of-the-ordinary holiday display.

Le Chateau Toronto, ON, Canada

Index and Credits

Clothes Hanger, 49, 99, 105
Wetney Dr., Mangere, Aukland, New Zealand
Design: Gascoigne Assoc., (renamed Studio Gascoigne), Aukland, NZ
Clark Pritchard, Theresa Richardo (Gascoigne Assoc.)
Client's Team: Imogen Ovens, Kay Marshall of Air New Zealand
Photography: Katrina Rees, Rebecca Swan

Dell Experience Center, 169
North Park Center, Dallas, TX
Design: Fitch, Columbus, OH
Managing Partner, the Americas: Mike Bills
Creative Director: David Denniston
Senior Environmental Designer: Paul Teeples
Graphic Designer: Gabe Shultz
Account Director: Amy Theibert
Project Manager: Heather Pellegrini
Architect: AAD: Fitch, inc. d/b/a Fitch, Scottsdale, AZ
General Contractor: Shrader & Martinez Construction, Sedona AZ
Photography: Mark Steele, Columbus OH

Diane von Furstenberg, 196
New York, NY
Photography: Anne Corrons

Eickhoff, 186
Düsseldorf, Germany
Creative Director: Stefan Sammet

El Palacio de Hierro Interlomas, 145, 160
Paseo Interlomas Mall, Interlomas, Mexico City, Mexico
Architect: Grupo Sordo Madaleno, Mexico City, Mexico
Architect/Design: El Palacio de Hierro Team, Mexico City, Mexico
Design: PDT International, Fort Lauderdale, FL
Design/Store Fixtures: Jorge Puente Visual Center, Buenos Aires, Argentina
Design/Store Fixtures: Thinc, Mexico City, Mexico
Digital Signage: Content /Teran, Mexico City, Mexico
Digital Signage/Engineering: Sateliite Store Link (SSL), Mexico City, Mexico
Project Management: Grupo Rioboo, Mexico City, Mexico
Store Fixtures: ALU, New York, NY; Elevations Inc., San Francisco, CA; Stor, Mexico City, Mexico
Technology: Sharp Corporation Mexico, Mexico City, Mexico; Technology Tecnosolutions, Mexico City, Mexico
Photography: HAH Photography, Mexico City, Mexico

Electric Avenue, 164
Miami, FL
Design: P2 Interiors, Coconut Creek, FL
Owner/Creative Designer: Placido "Ponch" Herrera
Owner/Senior Designer: Patty Herrera
Retailer: Sam Benzacar
Architect of Record: Barranco Gonzalez Architecture
John Barranco & Carlos Gonzalez
Photography: Dana Hoff Photography

Engelbert Strauss, 22
Hockenheim, Germany
Design: Plajer & Franz Studio, Berlin, Germany
Photography: Ken Schluchtmann, diephotodesigner.de

Fresh, 71
Broadway and 18th St., New York, NY
Design: Mapos LLC, New York, NY
In Conjunction with Fresh's founders: Lev Glazman & Alina Roytberg
Sr. Director of VM for Fresh: Matthew Llewellyn
General Contractor: Apogee Construction
MEP: Fiskaa Engineering
Light Consultant: Schwinghammer
Fixture Fabrication: Amuneal
Photography: Daniel Martynetz, Jean-Marc Plisson, Eric C. Waite

Gala Bridal, 140
Ginza, Tokyo, Japan
Design: Nishiwaki Design Office, Tokyo, Japan
Photography: NACASA & Partners

Galeria, 201
Plaza Las Americas, San Juan, PR
Design: Frank Caballero
Photography: Pascal Fontana

Glassons, 109
Broadway Newmarket, New Zealand
Design: Studio Gascoigne, Auckland, New Zealand
Design Team: Naomi Rusher (design director), Mark Gascoigne, Theresa Ricacho, Wallace Ong
Fitout Contractor: Shears & Mac., Auckland, New Zealand
Photography: Brigit Utech and Patrick Reynolds

H&M Home Store, 51
Amsterdam, The Netherlands
Design: Uxus, Amsterdam, The Netherlands
Shop Fitting: Railston and Uxus
Photography: Dim Balsam

Habitat, 158
Liverpool One Shopping Center, Liverpool, UK
Design: Habitat In-House Design Team
Head of Visual: Lucy Engwell
Fixturing/Fittings: Umdasch Shop Concept, Amstetten, Austria
Photography: Courtesy of Umdasch

Hamashbir Department Store, 122
Kikar Zion, Jerusalem, Israel
Store Planning & Shopfitting: Umdasch Shopfitting, Amstetten, Austria
Photography: Umdasch Shopfitting

Hamley's, 52
Dubai, UAE
Design : Chute Gerdeman, Columbus, OH
Principal : Denny Gerdeman
Creative Director, Environments : Brian Shafley
Exec. VP Account Management : Wendy Johnson
VP, Brand Communications : Adam Limbach
Director, Visual Strategy : Bess Anderson
Director, Design Development : Steve Pottschmidt
Trends & Materials Specialist : Katie Clements
Sr. Designer, Brand Communications : Steve Boreman
Designer, Brand Communications : Matt Jeffries
Designer, Graphic Production : George Waite
Retailer's Team, Hamley's London
Trading Director : Paul Currie
Group Head of VM & Design : Colin Morrisey

Harvey Nichols, 206
London, UK
Head of Display: Janet Wardley
Photography: Ekua King

Hermès, 197
Paris, France
Photography: Anne Corrons

Highland Department Store, 141
Doha, Qatar
Design: Zebra Projects FZE (part of Abu Issa Holding) Doha, Dubai
Fixtures: Umdasch Shop Concepts
Lighting: Microlight
Photography: Courtesy of Abu Issa Holding

Hirshleifer Shoes, 128
Manhasset, Long Island, NY
Design: Sergio Mannino Studio, Brooklyn, NY
Sergio Mannino, Garnet Spagrud, Francesco Bruni, Francesca Scalatteris
General Contractor: CDS Mestel Construction
Lighting Design: Lido Lighting, Bill Pierro Jr.
Neon Sculpture: Patrick Nash, Sergio Mannino
Photography: Massimiliano Bolzinella, New York, NY

Iconic, 91
Dubai, UAE
Design: SFD, London, UK
Joint Managing Director: Paul Brooks
Creative Director: Andi Grant
Design: Dalziel and Pow Design Consultants, London, UK
Creative Director: David Dalziel
Team Leader: Caroline Johnston
Photography: Andy Townsend

Iguapop Gallery, 198
Born, Spain
Design: Marcelo Cofone

ISE Jewellery, 192
The Peninsula, Hong Kong
Design: HEAD Architecture and Design Ltd., Sheung Wan, Hong Kong
Photographer: Graham Uden

Jack & Jones, 34, 96
Oxford St., London, UK
Design: Riis Retail A/S, Kolding, Denmark

Jelmoli, 70
Bahnhofstrasse, Zurich, Switzerland
Architect/Designer: Blocher Blocher Partners, Stuttgart, Germany
Photography: Courtesy of Blocher Blocher Partners

Jenny Lee Bridal Shop, 100
Newport Beach, CA
Design: Richard McCormack Design, Costa Mesa, CA
Photography: AG Photography

John Lewis Kids, 14
Oxford St., London UK
Design: Dalziel and Pow Design Consultants, London, UK
Creative Director: David Dalziel
Team Leader Interiors: Neil Speller
Associate Director Graphics: Sarah Fairhurst
Photography: Andrew Townsend

Joules, 72
Covent Garden, London, UK
Design: Checkland Kindleysides, London, UK
Photographer: Keith Parry

K-Swiss, 152
Citadium, Paris, France
Design: UXUS Design, Amsterdam, The Netherlands
Managing Director/Co-Creative Director: George Gotti
Partner & Creative Director: Oliver Michell
Photography: Dim Balsem

Katakeet Kids, 52
Abu Dhabi Mall, UAE
Design: Caulder Moore, Kew, London, UK
Creative Director: Ian Caulder
Photography: Courtesy of Caulder Moore

L.L.Bean, 142
Dedham, MA
Design: Bergmeyer, Boston MA

Index and Credits

Index and Credits

JUDY SHEPARD

Judy Shepard is the author of RSD Publishing's Retail Spaces series which includes, *Small Stores under 250 m2 (2,700 sq. ft.), Food—Cafes, Markets & Eateries,* and *Restaurants and Bars.* She is also the author of *The Office Idea Book: Creative Solutions that Work.* She is the associate publisher of *Retail Design International,* the premier periodical for seeing the best in retail design, visual merchandising and display. Ms. Shepard has designed and collaborated with Martin Pegler on more than 25 books on store design, including the *Stores of the Year* and *Store Windows* series and she has authored books on visual communication, catalog design and retail branding.

MARTIN M. PEGLER

Martin M. Pegler is a leading authority on store design and visual merchandising. He has worked as a designer, manufacturer, display person, store planner and consultant during his 60 years in the business. Long a champion of excellence in store design, he has lectured internationally on the subject for industry and small business groups and has been a Professor at the renown Fashion Institute of Technology in NY for over 30 years.. He is the author of more than 80 books on store design and visual merchandising including the *Stores of the Year* and *Store Windows* book series, *Green Retail Design, Contemporary Exhibit Design* as well as the editor of the prestigious bimonthly periodical *Retail Design International.* Mr. Pegler can be contacted at mmpegler@optonline.net

ANNE CORRONS

Anne Corrons is a marketing consultant based in Paris. She has worked in Paris, Madrid and NYC in the fashion and cosmetics industry for over ten years. In New York she was a journalist for a French fashion internet magazine. She shoots fashion windows in Paris, London, and New York and comments on them at mesvitrinenyc.com.

LIFESTYLE TRiMCO